ROMANTICISM

AND

REALISM

The Mythology of Nineteenth Century Art

also by Charles Rosen

THE CLASSICAL STYLE:
Haydn, Mozart, Beethoven

ff

ROMANTICISM AND REALISM
The Mythology of Nineteenth Century Art

Charles Rosen and Henri Zerner

faber and faber
LONDON · BOSTON

TO MEYER SCHAPIRO

First published in Great Britain in 1984
by Faber and Faber Limited
3 Queen Square London WC1N 3AU

Printed in Great Britain by
Butler & Tanner Ltd Frome Somerset

All of the essays in this book appeared originally in
The New York Review of Books in slightly different form.

Grateful acknowledgement is made to University of Minnesota
Press for permission to reprint a selection from Friedrich
Schlegel's *Lucinde and the Fragments*, translated by Peter
Firchow. Copyright © 1971 by the University of Minnesota.

British Library Cataloguing in Publication Data

Rosen, Charles
Romanticism and realism.
1. Arts, Modern – 19th century – Europe
2. Arts, European
I. Title II. Zerner, Henri
700'.94 NX542
ISBN 0-571-13332-0
ISBN 0-571-13333-9 Pbk

PREFACE

Almost ten years ago in Paris, we went to the exhibition *Le Musée du Luxembourg en 1874,* Mme. Geneviève Lacambre's brilliant reconstitution of France's official museum of modern art as it had been in 1874, the year of the first so-called Impressionist exhibition in Nadar's studio. The buying policy of the French Ministry of Fine Arts from 1851 to 1874 had excluded from the museum the works of Courbet, Manet, Degas, Millet, Puvis de Chavannes, and Théodore Rousseau—in short, all the painters of the time who would be of interest to the next century. The state collection had a surprising unity of tone (with a few exceptions, of course), and the contrast with the paintings excluded from it— that is, the works of the period we are all familiar with—was striking. In trying to account for the policy of acquisition and of exclusion we had different ideas, but these ideas worked well together and complemented each other; we accepted Jean Piel's invitation to write a joint review of the exhibition for the Parisian monthly *Critique,* which was published in French under the title "L'Antichambre du Louvre, ou L'Idéologie du fini" in October 1974. The review was later translated by Paul Auster and appeared in *The New York Review of Books* in 1976, considerably revised, and with both cuts and additions.

After 1976, we wrote four more articles together that were published by *The New York Review of Books:* a review of Hugh Honour's *Romanticism* (1979), of Peter Galassi's exhibition *Before Photography* (1981), of Albert Boime's *Thomas Couture and the Eclectic Vision* (1982), and a two-part review of Gabriel Weisberg's exhibition *The Realist Tradition* (1982). All of these dealt, more or less directly, with the origins and the development of the split between avant-garde and academic art. Together, these five reviews constitute the greater part of this book: large cuts have been made, and a great deal of new material has been added; few pages were left without extensive rewriting. With a

similar amount of reworking, we adapted some parts of articles we wrote separately: Zerner's reviews of Francis Haskell's *Rediscoveries in Art* (1977) and of Iain Bain's edition of Thomas Bewick's *Memoir* (1976), his introduction to *Toute la peinture de Caspar David Friedrich* (1976), and Rosen's review of the Tate Gallery's exhibition of Caspar David Friedrich (1973). Much new material was added to these as well, and the rewriting has been done by both of us.

The original form of the greater part of this book was clearly not scholarship but journalism. We do not pretend to cover the nineteenth century, or even to give a balanced and comprehensive view of Romanticism, Realism, or official art. The book presents a critical account of only a few of the most interesting developments in recent studies. The past twenty years have seen an explosion of interest and research in nineteenth-century art. Our knowledge of this period has been altered and enriched—to a greater extent, perhaps, than that of any other century. Only in the last few years has the nineteenth century seemed sufficiently distant from us to make objective study credible, and nineteenth-century studies have finally become an important academic industry. Much of the work is naturally uneven in quality, but some of the most interesting critical minds today have turned to this field.

Some of the recent research has tended to minimize the opposition between avant-garde and official art, attempted to ignore it or even to claim that it did not exist. Some historians have discovered, with apparent surprise, that many of the painters rejected by the official juries of the Salon were not avant-garde at all but merely incompetent, and even that a few conservative academic painters might have been found disguised as avant-gardists at exhibitions like those of the Impressionists. Other historians have emphasized that some avant-garde painters, like Manet, hoped for nothing so much as official respectability and acceptance, and that avant-gardists and academic painters were often on very friendly personal terms. None of this is likely to shake anyone's faith in the traditional view of history, yet it has become more and more evident that the contradictions and weaknesses of the textbook ac-

counts of nineteenth-century art can no longer be glossed over. The new studies have made it all too clear that much of the accepted view is too naïve, and that the terms of the opposition— avant-garde versus official art—are badly in need of redefining.

We have tried in this book to redefine both avant-garde and official art, to demonstrate and even to exploit the ambiguity of the relations between the two terms, to indicate briefly how the polarization came about, and, above all, to demonstrate that it was so built into nineteenth-century thought and art that it cannot be exorcised or even bypassed. We have also tried to show that the opposition is not the one between competing styles familiar from past history, an opposition that allows succeeding generations to step back from the fray and appreciate both points of view without prejudice, but a more dynamic and troubling relationship that makes any hope of historicist objectivity an illusion.

The current reevaluation of nineteenth-century art has much in common with Sir Lewis Namier's notorious attempt in the 1930s to banish political philosophy from the history of eighteenth-century English politics, to ignore all distinctions of party, and to concentrate on the day-to-day workings of Parliament, the personal motivations of individual M.P.s, and so forth. The brilliance of his work justifiably dazzled most scholars; Namier's view of history was profound as well as brilliant, and it has consequently taken a considerable effort by recent historians to reconsider the role of political philosophy and ideology in the movement of history. Art historians, somewhat tardily, have taken a leaf from Namier's book and similarly tried to get rid of ideology, to study the day-to-day workings of the Salon, the transactions between artists and patrons, artists and dealers, artists and government bureaus. Most of this research, like Namier's, is of extraordinary value, but we hope that it will not require as much labor to return artistic ideals and ideologies to their rightful place in history.

A great part of the reconsideration of nineteenth-century art now under way is not only admirable but inevitable; our criticism affects only a small aspect of it—and even that aspect seems to us largely salutary. In fact, conversations with some of the scholars and critics most active in the revision of accepted accounts have

revealed that the differences between our view and theirs are min-
imal and sometimes even nonexistent—so much so that in reread-
ing our essays we often had the feeling of battering down open
doors. We felt, however, that some familiar truths needed refor-
mulation in the light of new knowledge; so that the familiar and
the obvious would not appear too bland, we have not edited out
the provocative and polemical tone of several of the pages in this
book.

A second unifying theme runs throughout these essays, in addi-
tion to the polarity of avant-garde and official art in nineteenth-
century history. (We might add in passing that attempts to read
this polarity into other eras are almost always forced.) This second
theme is the distinction between high art and the rest of art—low,
popular, commercial, applied, or whatever. Art historians, only
too willing nowadays to throw the avant-garde out of the window,
cling almost instinctively and unthinkingly to the concept of high
art. For the nineteenth century, this is the wrong choice.

The nineteenth century did indeed believe passionately in high
art, in the superiority of painting, sculpture, and architecture ex-
ercised as pure arts. A history of nineteenth-century art that re-
stricts itself to "high art," however, eliminates some of the most
important and powerful developments in the creation of visual im-
agery and, furthermore, makes what happened in the "high arts"
themselves largely unintelligible. The traditional relegation of
caricature, journalistic art, photography, book illustration, and
commercial art to minor and subsidiary roles has little justification
after 1800, whatever defense can be made for it in earlier periods.
It is especially unfortunate in view of the present revival of inter-
est in the academic painting of the century. As the inheritors of
the great Renaissance and Baroque tradition of history painting,
the *pompiers* cannot be taken seriously: not even their contempo-
rary conservative critics thought that academic painting was an
adequate representative of that tradition, although the more opti-
mistic hoped it might one day become so. But as part of more gen-
eral developments in art, the *pompiers* are often interesting
figures. In spite of the embarrassing claims sometimes made on
their behalf, the study of their neglected works is a promising new

enterprise. It may end up by smashing once and for all the mold of
art history conceived of as only the dating, attribution, and inter-
pretation of major and minor masterpieces. This form of history
worked for the Renaissance and Baroque, and only too well for the
avant-garde of the nineteenth and early twentieth centuries, which
succeeded in sustaining the continuity of high art while affecting
to destroy it. But the limitations of the old historical method are
now only too apparent, and fruitful innovations may well take
place in nineteenth-century studies.

These essays were written over a period of eight years; our
ideas changed in that time, but our preoccupations remain the
same and we hope that we have given a coherent shape to the ar-
rangement of this book. During these eight years, many people
helped us with their advice, and we cannot hope to thank all of
them. In their conversations with us about the subjects of these
essays, Sir Isaiah Berlin, Professors Meyer Schapiro and Theo-
dore Reff of Columbia University, Professor Anne Hanson of
Yale, Professor Jacques de Caso of the University of California at
Berkeley (who very graciously read the entire manuscript), Pro-
fessor Oleg Grabor of Harvard, Professor Catherine Wilkenson
Zerner of Brown University, and Professor Jean-Claude Lebens-
ztejn of the University of Paris inspired many changes and addi-
tions, although, of course, no blame can be attached to them for
the way their suggestions were carried out. We are also grateful
for the friendly help we received from Professor Françoise Choay
of the University of Paris, Françoise Cachin of the Musée d'Orsay,
Paris, James Cuno of Vassar College, Professor Anne Wagner of
M.I.T., and Jeremy Strick. Donna Hunter gave invaluable advice
on J.-L. David, and we have a particular debt to Louise d'Argen-
court, who allowed us to mention and discuss the results of some
of her as yet unpublished work. M. Jean de Sainte-Marie, Director
of the Museums of Troyes, gave us very generous help. We also
want to thank Elisabeth Sifton at The Viking Press for her exci-
sion of some lamentable passages, her inspiringly good-humored
help with the illustration and revision of the text, and her insis-
tence that it be turned into a book rather than a collection of dis-

parate reviews. She made us do much more work than we had ex-
pected. Finally, to Robert Silvers and Barbara Epstein of *The New
York Review,* who generously published our very long articles and
who continually insisted on revisions to make them intelligible and
more readable, we wish to express our gratitude for their sympa-
thetic encourgement.

<div align="right">

CHARLES ROSEN
HENRI ZERNER

</div>

CONTENTS

THE FINGERPRINT: A VIGNETTE

Newcastle 1st October 1818

To Thomas Bewick & Son Dr

To an Imp Copy of Esop's Fables 4. 4. 6

Received the above with thanks

Thomas Bewick, Robert Elliot Bewick

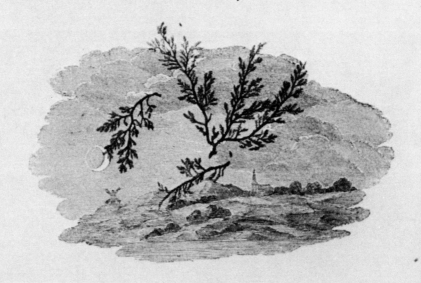

Thomas Bewick

his mark

Thomas Bewick, Receipt.

One of the illustrations in Thomas Bewick's *History of British Birds*, published in 1797, is a small picture of a country scene, about two inches wide and one inch high, almost obliterated by a fingerprint:

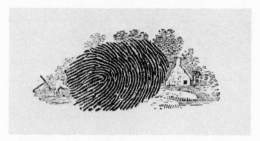

The fingerprint, which is actual size, draws attention to the smallness of the microcosmic work of art, which can be canceled by one finger; we can also read the engraving as a landscape seen through a window, with a dirty fingerprint on the glass pane. Since the picture field is not outlined, we cannot assess our exact relation to the image. The vignette can be read in different ways and in the end remains ambiguous.

The fingerprint was understood as a mark of identity long before its legal recognition as such and its semi-scientific status in the late nineteenth century. That Bewick so understood it is clear from one of his greatest works, the receipt given to purchasers of his illustrated edition of *Aesop's Fables*. Only the price and the signature are handwritten; everything else, including a thumbprint and the words "his Mark," is engraved. Once again, the scene is partially obliterated, this time by a representation, in sepia against the black-and-white landscape, of small ferns, which seem as if they have been sentimentally pressed between the leaves of a book and become brown with age. This engraving is as ambiguous as the tiny vignette obscured by a fingerprint. The receipt is a double representation of a real landscape and a printed landscape, an

imitation of nature blurred with an imitation of art—and it is also a commercial document.

Pressed ferns are a symbol of memory, and this page is a receipt for a new, unread, unopened copy of a book. The two-color printing is exceptional for Bewick, but the sepia of the ferns establishes the intrusion of a process from the world outside the work of art and its absorption into the image. A similar play of meaning is made by engraving the fingerprint, while the signature, Thomas Bewick, is added by hand. ("His Mark," although engraved, simulates handwriting and adds to the visual ambiguities.)

The receipt authorizes us to interpret the vignette of the fingerprint from the *History of British Birds* as a gigantic signature that overlays most of the picture. The artist wipes out, by his own identity, his representation of a scene from nature. Perhaps the most tiresome of all the clichés about Romantic art is that the objective view of the world is displaced by the subjective identity of the artist. Bewick has provided us with the most strikingly humorous symbol of this commonplace. What makes it impressive is less the conceit of the subjective cancelation of the natural world than the virtuoso accuracy and objectivity of Bewick's representation of that world.

Most surprising about the receipt is its ambition. The scene is not only larger than most of Bewick's vignettes, but also elevated in conception: the landscape is stormy and dramatic. The interpenetration of the outside world and the artistic image is both grand and subtle: the pressed brown ferns of the reader's world blend with the engraved scene, a printed fingerprint is set next to a handwritten signature, a commercial transaction is transformed into a work of art.

We might say, about the vignette and the receipt, that even works from minor genres like book illustration and commercial documents are rich with the significances and the problems of a period. We would be wrong. These are not, for a connoisseur of Romantic art, minor works, any more than one of Blake's Songs of Innocence is minor in comparison with one of the large epic poems of the eighteenth and nineteenth centuries. It is not only that Bewick is, historically, a major figure, as some of the most perspi-

catious of contemporary critics already understood, but also that early Romantic art from 1790 to 1825 was in great part an attempt to evade the traditional distinctions between major and minor genres, between tragedy and comedy, between the sublime and the ordinary, between art and the worlds of nature and human affairs. The artists of that time handed over as a legacy to the rest of the nineteenth century a permanent opposition to any authority that tried to uphold these hierarchies.

I

ROMANTICISM:
THE PERMANENT
REVOLUTION

1

In 1849 the young sculptor Jean-Baptiste Carpeaux, who was later to execute the famous group *The Dance* for the façade of the Paris Opera, regretfully abandoned his studies with François Rude, the greatest of French Romantic sculptors. Carpeaux went to work with Francisque Duret, a less inspired teacher, but one much more representative of the doctrines of the Ecole des Beaux-Arts. He gave the reasons for his break with Rude in a letter of January 1850 to a friend:

> Mr. Rude, as I must have told you in my discussions about art, has a method which consists of a way of doing sculpture quite different from that of the Beaux-Arts. For example, he claims that sculpture—and I think he is right—can be done well only by mathematical aids: that is, using compasses, rulers, plumblines, etc. . . . Finally, he turns his students into practitioners, while at the Ecole, everything is done only by eye.
>
> The Institute prefers to say that the arts in general exist more in emotions than in measurements, which make us cold copyists with only the material spirit of what we are doing, while they . . . I think what they say is very pretentious, but still I have to listen to them, and to talk and do as they do. And since there is a great difference between these two methods and one cannot serve two masters at once, I said to myself: let's make a choice, the Ecole is a question of my future and my existence. . . .

At first sight, this may appear to stand Romanticism on its head. For Carpeaux, it is the official academic doctrine that asserts that art is essentially a matter of emotion; by contrast, Rude, the Romantic artist, creator of the violent, gesticulating figure of the *Marseillaise* on the Arc de Triomphe (which for many of Rude's contemporaries far overstepped the bounds of the permissible in emotional expression), emphasizes the importance of measurement and exact proportion. The academic establishment

teaches the young artist to work subjectively, "by eye," while the revolutionary Romantic artist teaches by means of objective mathematical tools. For the academy, the sculptor was an artist; for Rude, the contemporary of Géricault and Delacroix, the sculptor was first of all a skilled workman, a "practitioner."

The oddity is not a matter of overcompensation on both sides, but of date. By 1850 many of the Romantic attitudes, vitiated and trivialized, had become respectable: the superiority of inspiration, emotion, and subjective judgment over tradition, rules, and skill was now official. The primacy of emotion was, of course, passionately believed in by Rude, but he took it more seriously than the Ecole des Beaux-Arts, and he did not think it could be taught. Rude's insistence on objective classical training (never abandoned by his generation) became a new form of Romantic rebellion.

2

From the beginning, the opposition between Romantic and Classic had a political aspect. No one articulated this better than Stendhal. After the violent attack on Romanticism by the Académie Française (which by 1824 had finally reached "R" in its revision of the dictionary), Stendhal wrote, in the preface to *Racine et Shakspeare* (second version), about the anti-Romantic tirades in the Académie:

> "You must understand that academic phrases are official, and hence produced in order *to fool someone:* therefore it is improper to read them to a small group, and above all to people with similar incomes [*à fortunes égales*]" (author's italics).

In other words, the academic discourse was an instrument of oppression, to be used properly only against someone with less money. Not that the Romantics were exactly poor—or at least not very often. They were, however, not in office, and this point is made explicitly with great precision, again by Stendhal:

The classics control the theaters and all the posts of which the salaries are paid by the government. The young cannot get those posts which become vacant except through the offices of older men who *work in the same party.* Fanaticism is a recommendation. All the servile minds, all those with petty ambitions for a professorship, a position in an academy, a librarian's post, etc., *have an interest* in presenting us every morning with a classical article [in the press] (author's italics).*

The battle of the outs against the ins must be older than history, but the idiosyncratic psychological coloring of the Romantic struggle came from the Romantics' passionate pride in being out—while, of course, they were struggling to get in.

The origin of this pride is complex, but some of the rationalization for it is suggested in a letter by one of the greatest and most influential young German painters, Philipp Otto Runge: "Art must be despised and considered to be completely worthless before anything can be derived from it again, or else it must be applied to everything. It is therefore ridiculous to try for any kind of personal success" (June 19, 1803). The choice is between an art that is rejected and despised and an art that disappears, becoming so much at one with all of life that it is no longer felt as separate—life has become art, totally poeticized. The second term of the choice is so obviously utopian that artists were bound to fix upon rejection and contempt—a choice made easier by the religious implications of this path of suffering. If artists never abandoned the hope of ultimate success, it is clear that many courted immediate failure—or, if not failure, then shock and dismay. This fits well with some of the violence of the times; a few years after, Runge was to write:

Was not that art which is perfect merely the messenger of something to come which is better? You say you cannot understand that it would be a great future for art if all works of art were now to perish. It would be good not for art but for us. I know well how beautiful art is and how wonderfully it occupies man. And yet I do not

* Letter VIII of *Racine et Shakspeare* II.

want to be an artist in this respect. I know what I give, but I also know what I receive. If it were necessary to destroy the works of art now, they would be destroyed.

These are not the words of a simple iconoclast: few artists respected tradition and loved its works more than Runge. Nevertheless, in his extremism, he represents a new attitude toward the development of art. His letter comes from a postrevolutionary period when the great buildings of the Middle Ages and the Renaissance were being plundered in France and used as quarries for commercial purposes, and when England was beginning to feel the effects of industrial development: much of the art of the past was already being destroyed. The Revolution, too, had held out a promise for renewal in all aspects of life, a promise that had quickly turned sour.

With the Revolution in such recent memory, getting in was not enough for the most extreme Romantic outs (and many writers and artists were drawn to Romanticism because of its extremism): a destruction of what was in so that something new could be built in its place was what they proposed. Their art and their philosophy appeared consequently as an act of provocation. This resulted in a stimulating paradox: in the attempt to condemn the past and replace it, an art was produced that itself explicitly courted an initial condemnation. It became a commonplace of nineteenth-century criticism that the first appearance of a great work generally aroused contempt and misunderstanding. Artists with any pretensions to originality expected and even hoped for resistance; an immediate success was grounds for suspicion; only a hack won his laurels easily.

John Constable, among many others, expressed the difficulty any genuinely original painter encountered in convincing the public and critics of his worth. When Champfleury quoted Constable's remarks toward the opening of his book *Le Réalisme* (1857), he prefaced the quotation with an odd claim: "The painter Constable, who is, in a manner of speaking, the father of the school of painting in France since the 1830s (people do not realize the enormous influence he had on Delacroix), left a volume of letters in which he

demonstrates the difficulty that awaits the lovers of truth in reaching the public." Constable as the father of the French school after 1830 is more than a little absurd: presented in a book that serves partly as publicity for Courbet, the claim asserts for Courbet a genealogy that goes back through Delacroix to Constable. This is the genealogy of the struggling, difficult artist, and as it was built up by contemporary critics through such texts (one could multiply them *ad nauseam*), the concepts of originality and initial misunderstanding gradually became inseparable. "My honors are misunderstanding, persecution and neglect, enhanced because unsought," wrote Thomas Eakins in a letter of 1894.*

The grand claim that Champfleury made for these painters, that they were "lovers of truth," depends on this genealogy, on the idea that the frontiers of discovery in art as in science are gradually pushed back by a very few artists in successive generations. The claim effectively separates all artists into single sheep and many goats: the unsuccessful and original genius against the crowd of artists of lesser rank who sell out for academic honors and public acclaim. It is a genealogy of rebels that Romanticism founds. "Force of mind is developed only by attacking power," Mme. de Staël wrote, and Byron translated her freely as, "All *Talent* has a propensity to attack the *Strong*" (his emphasis).†

This genealogy of artist-rebels is obviously inadequate as a description of the facts of life in the nineteenth century. If it very often turns out to be true, that is largely because the ideology it embodied was so powerful that everyone from time to time contrived to make it come out right. The artist created works that would produce an outcry because of their difficult originality, and the state cooperated by refusing to buy his pictures, the critics by ridiculing him in the press (this is why the "Classical" Ingres refused to exhibit at the Salons). Against such a seductive ideology, it must have taken a certain courage for painters like Paul Delaroche and Horace Vernet to have rejected obscurity and neglect

* Quoted in the preface to the catalogue of the Thomas Eakins exhibition in Philadelphia, 1982, p. xvi.

† *Byron's Letters and Journals* IX:152 and footnote (May 2, 1822).

and aimed for acceptance and popular success. Avant-garde crit-
ics (who were, naturally, in the minority) came down on them for
it like a ton of bricks. "I hate the painting of Mr. Horace Vernet,"
wrote Baudelaire in the *Salon of 1846*, "because it is only an agile
and frequent masturbation of the French epidermis." No one
thought this a fair evaluation of Vernet, not even Baudelaire, but
then, fairness was not his goal. He wanted victory, the annihilation
of the middlebrow official style and its replacement by Romantic
art, above all that of Delacroix.

The example of Delacroix shows the complexity of the situa-
tion, the inadequacy of the myth of the avant-garde, and yet the
impossibility of exorcising it if we wish to do justice to the move-
ment of thought and style in the nineteenth century. At the very
inception of his career, Delacroix was praised to the skies by Louis
Adolphe Thiers in the most official journal, and his work was
bought for the official museum of modern art when he was only
twenty-four, an honor that did not fall to the much older Ingres
until a year later. He also received some of the most important of-
ficial commissions early in his career. This was partly due to the
accommodating policy of the government of Louis-Philippe,
whose reputation as a moderate bourgeois monarch is not a mod-
ern judgment but one carefully built up by the king's own publicity
machine: his reign attempted to conciliate all the middle-class ten-
dencies (although the government drew the line at attacks that
really stung, and Daumier had to spend some time in prison for his
cartoons of the king). Among other official works, Delacroix did
the magnificent set of mural decorations for the National Assem-
bly, the Senate, and an important chapel in Saint-Sulpice.
No other painter was more honored.

Yet in spite of all this official recognition, he was always consid-
ered a controversial painter. It was only very late in life that he
was finally admitted to the Académie des Beaux-Arts, and the
election was so bitterly contested that it created a scandal. He had
his supporters among the critics, particularly Baudelaire, Gustave
Planche, and Théophile Silvestre; but the way his admirers set up
his work in opposition to academic painting exacerbated the ill-

feeling. It is hard to resist the idea that Delacroix had a hand in orchestrating the controversy: he despised critics, he once remarked, and then added that he had made use of two or three of them.

The measure of the controversy can be taken by the story of the publication by Robaut of Delacroix's drawings in facsimile soon after Delacroix's death, when his glory was at its height, his immortality assured. In 1864, Robaut went to the minister of Fine Arts to ask for support of the project. The minister, Nieuwerkerke, replied: "Look, you see this plate. Well! A ten-year-old child at school who did that, we would throw him out. And this plate! And this! That's to tell you right away that you must not hope for our support. We only encourage high-class works [*oeuvres d'une haute portée*], and all this emanates from a demented mind." Nieuwerkerke was not simply incompetent; the opposition had hardened after Louis Napoleon's *coup d'état* of 1851, and Nieuwerkerke was only acting out the role that the ideology of the avant-garde had assigned to him.

It is sometimes hard to realize that work that appears today as notable for its simple beauty seemed radical at the time. The mild-mannered *faux-naïf* Corot was a controversial artist, and later in the century Fantin-Latour had to wait until he was fifty-six years old before the state would buy one of his paintings. Some writers and artists—Flaubert, Baudelaire, and Manet, most notably—expressed, somewhat disingenuously, their surprise at having caused any controversy. After the publication of *Madame Bovary*, however, Flaubert's evident satisfaction breaks through the irony in a letter of October 3 or 4, 1857, to Jules Duplan:

> Now I have been attacked by the government, by the priests, and by the newspapers. It's complete. Nothing is lacking for my triumph.

The scandal was a guarantee of the quality of his achievement and the possibility of its permanence. He had become, willy-nilly, a member of the avant-garde.

3

The history of Romanticism is—to a far greater extent than the history of any other artistic or philosophical movement—a history of redefinitions. For some decades after Friedrich Schlegel's first essay at definition in 1798, artists and writers seem to have had a profound need to clarify the ideals and goals of Romanticism as a revolutionary movement—and then, of course, a little later to deny indignantly that they could ever themselves be labeled as Romantic. (Delacroix, for example, claimed that he was not a Romantic, just as Marx, somewhat later, was not a Marxist.) What is most interesting about these successive definitions is not that they contradict each other but that they are intentionally self-contradictory, deliberately inconsistent and unstable, fluid and expansive.

It is only simple justice to start at the beginning, with Friedrich Schlegel's famous Fragment No. 116 of the *Athenaeum*, the literary magazine he edited for two years in Jena with his brother August Wilhelm:

> Romantic poetry is a progressive, universal poetry. Its aim isn't merely to reunite all the separate species of poetry and put poetry in touch with philosophy and rhetoric. It tries to and should mix and fuse poetry and prose, inspiration and criticism, the poetry of art and the poetry of nature; and make poetry lively and sociable, and life and society poetical; poeticize wit and fill and saturate the forms of art with every kind of good, solid matter for instruction, and animate them with the pulsations of humor. It embraces everything that is purely poetic, from the greatest systems of art, containing within themselves still further systems, to the sigh, the kiss that the poetizing child breathes forth in artless song. It can so lose itself in what it describes that one might believe it exists only to characterize poetical individuals of all sorts; and yet there still is no form so fit for expressing the entire spirit of an author: so that many artists who started out to write only a novel ended up by providing us with a portrait of themselves. It alone can become, like the epic, a mirror of the whole circumambient world, an image of

the age. And it can also—more than any other form—hover between the portrayed and the portrayer, free of all real and ideal self-interest, on the wings of poetic reflection, and can raise that reflection again and again to a higher power, can multiply it in an endless succession of mirrors. It is capable of the highest and most variegated refinement, not only from within outwards, but also from without inwards; capable in that it organizes—for everything that seeks a wholeness in its effects—the parts along similar lines, so that it opens up a perspective upon an infinitely increasing classicism. Romantic poetry is in the arts what wit is in philosophy, and what society and sociability, friendship and love are in life. Other kinds of poetry are finished and are now capable of being fully analyzed. The romantic kind of poetry is still in the state of becoming; that, in fact, is its real essence: that it should forever be becoming and never be completed. It can be exhausted by no theory and only a divinatory criticism would dare try to characterize its ideal. It alone is infinite, just as it alone is free; and it recognizes as its first commandment that the will of the poet can tolerate no law above itself. The romantic kind of poetry is the only one that is more than a kind, that is, as it were, poetry itself: for in a certain sense all poetry is or should be romantic.*

This famous manifesto speaks for itself only too eloquently and at too great length; our commentary must be limited. Schlegel is the first, elsewhere in the *Fragments,* to use the terms "Classical" and "Romantic" as an opposition, and to apply "Romantic" to a specific artistic style. Yet from the beginning his Romanticism "opens up a perspective upon an infinitely increasing classicism." In this fragment, Romantic poetry is explicitly related to the *Roman,* the novel. For the early Romantic authors, the novel contains poetry, passages of dramatic dialogue, literary criticism, philosophy, familiar letters, and anything else the author can think of: the theory is set out here by Schlegel. The novel is less a genre than a fusion and confusion of genres.

Not only barriers between genres are broken down, but the

* *Friedrich Schlegel's Lucinde and The Fragments,* trans. Peter Firchow (1971), pp. 175–76. (Translation slightly altered.)

barrier between art and life: Romantic poetry "embraces every-
thing that is purely poetic," specifically including things that have
nothing to do with art, even actions and critical systems. It is only
one step from this to include everything, whether purely poetic or
not. It is a step more or less foreseen, or at least already accommo-
dated, by Fragment No. 116, since the Romantic kind of poetry is
always in the state of becoming and never in that of being.

Romantic poetry is not, for Schlegel, a purely personal vision,
as it was later to be vulgarized by both practitioners and theorists.
It stands midway between a personal vision and the objective
world, can "hover between the portrayed and the portrayer" and
reflect back the world's view of the artist's vision: it is not a mirror
of the world, but a multiplication of mirrors. It is also a systematic
program for total expansion, and the eventual appropriation of all
other forms of art and life. Since "other kinds of poetry are fin-
ished," Romantic poetry is all we have left: it is specifically mod-
ern poetry.

It is this aspect of modernity that Stendhal seized upon some
twenty years later, in *Racine et Shakspeare*, where he defined Ro-
manticism simply as the art of pleasing one's contemporaries and
Classicism as the art of pleasing their grandfathers. By 1823 the
German terminology had reached France and had divided French
criticism into two opposing camps. The most amusing conse-
quence of Stendhal's definition is the assumption that everything
Romantic (or modern) will automatically become Classical in two
generations. Stendhal's pamphlet is almost purely polemical; this
is not exceptional, but symptomatic—a great deal of the best liter-
ature and art of the early nineteenth century is a prolongation of
the revolutionary polemics of the 1790s, a transformation of poli-
tics into aesthetics.

The polemical character is also clear enough in the fundamen-
tal Romantic manifesto of the next French generation, Victor
Hugo's preface to *Cromwell* (1827). This pugnacious work illumi-
nates one aspect of the revival of medieval art so central to the
Romantic movement. The grotesque—derived from the medieval
gargoyles and the marginal illustrations of manuscripts dear to
Romantic hearts—becomes the ugly:

The beautiful has only one type: the ugly has a thousand. This is because the beautiful, speaking humanly, is nothing but form considered in its simplest relation, its most absolute symmetry, its most intimate harmony with our organism. Therefore it always offers us an ensemble that is complete but limited as we are. What we call the ugly, on the contrary, is a detail of a larger ensemble which escapes us, and which harmonizes not with man, but with the entire creation. That is why it presents us forever with new but incomplete aspects.

The ugly is dynamic where the beautiful is static: the beautiful is always directly related to the human organism and the ugly alone offers man a means of transcending his nature. The ugly is, in art, the essential agent of development; it represents everything that is non-art which can be incorporated into art, a frontier that can be endlessly pushed back. Hugo's position shows that the premises of mid-century Realism (immediately attacked, and with some justice, as the representation of the ugly) are already implied by early Romantic doctrine.

An amusing if trashy work of Alfred de Musset written in 1836, *Letters of Dupuis and Cotonet* (two culturally ambitious small-town bourgeois),* provides an excellent summary of the development of the Romantic movement in France during the years from Stendhal's *Racine et Shakspeare* to the more diffuse situation of the 1830s. We give some ruthlessly abridged extracts:

As I said, we did not understand the meaning of the word "romanticism." . . . It was, then, around 1824 or a little later, I forget: there was a quarrel in the *Journal des Débats*. It was about the *picturesque*, the *grotesque*, landscape introduced into poetry, history dramatized, drama emblematicized, pure art, broken rhythms, tragedy and comedy fused together, the middle ages revived. . . .

. . .We believed at first, for two years, that romanticism in literature applied only to the theater. . . . But we learned (it was, I think, in 1828) that there was romantic poetry and classical poetry, the romantic novel and the classical novel, the romantic ode and the

* Surely this work has already been suggested by someone as a source for Flaubert's *Bouvard et Pécuchet*.

classical ode; indeed, a single line of poetry, dear sir, one single line, could be either romantic or classical, according to the way it felt.

When we heard this news, we couldn't sleep all night. . . . we must tell you, sir, that in the provinces, the word "romantic" has, in general, an easy meaning to grasp: it is a synonym of "absurd," and there is no other fuss about it. Happily, the same year appeared an illustrious preface, which we devoured at once, and which almost converted us forever. There breathed an air of confidence that was reassuring, and the principles of the new school were explained in great detail. It was said decisively that romanticism was nothing else than the alliance of the mad and the serious, the grotesque and the terrible, the farcical and the horrible—in other words, if you prefer, comedy and tragedy. Cotonet and I believed it for the space of a year.

We happened upon a newspaper which contained these words: "Romantic poetry, daughter of Germany . . ." "My friend," I said to Cotonet, "that's what we were looking for: romanticism is German poetry. Madame de Staël was the first to tell us about this literature, and the madness that has seized us dates from the appearance of her book. Let us buy Goethe, Schiller and Wieland; we are saved, everything comes from there."

We believed, until 1830, that romanticism was the imitation of the Germans and we added the English, on the advice we got. . . .

From 1830 until 1831, we believed that romanticism was the historical genre, or, if you like, the mania that authors had for calling the characters of novels and melodramas Charlemagne, François I or Henri IV instead of Amadis, Oronte or Saint-Albin. . . .

From 1831 to the next year, seeing the historical genre discredited and romanticism still alive, we thought it was the intimate genre, about which there was a lot of talk. . . .

From 1832 to 1833, it came to mind that romanticism could be a system of philosophy, and political economy. In fact, in their prefaces (which we always read above all, as the most important part of the book) writers were fond of talking of the future, social progress, humanity and civilization; but we thought it was the July Revolution of 1830 that caused this fashion—and besides, it's not possible to believe that it was new to be republican.

From 1833 to 1834, we thought that romanticism consisted in not shaving, and in wearing vests with large heavily starched lapels. The following year, we thought it meant refusing to serve in the National Guard. The next year we didn't think anything, as Cotonet had to make a short trip to the south for an inheritance, and I was busy repairing a barn damaged by heavy rain.

The inevitable and no doubt deplorable price of being modern is being fashionable, and Musset sardonically goes through all the changes of fashion called "Romanticism," giving a useful account of the various topics intimately associated with the movement. He astutely remarks that through all these alterations of mode, "Romanticism" remained alive—at least as a slogan. The fashionable has existed throughout history, while the idea of the modern—of progressive, continuous, and inevitable change—has appeared only infrequently.

Almost ten years later, in his *Salon of 1846*, Baudelaire reformulated Stendhal's absolute equation of Romanticism and modernism and defined that now almost out-of-date word "Romanticism" summarily as *"l'expression la plus récente et la plus moderne de la beauté"* ("the most recent and most modern expression of beauty"). The second part of his *Salon* is entitled "What Is Romanticism?" and extends this idea at length:

> Few people today will want to give a real and positive meaning to this word; would they dare maintain, however, that a generation agreed to battle for many years on behalf of a flag which is not a symbol?
>
> Romanticism is precisely neither in the choice of subjects nor in exact truth, but in the manner of feeling. . . .
>
> There are as many conceptions of beauty as there are habitual ways of seeking happiness.
>
> . . . Romanticism will not consist in a perfect achievement but in a conception in keeping with the ethical values of the age.
>
> . . . one must therefore understand above all the aspects of nature and of man's situation that the artists of the past have disdained or ignored.
>
> To say "romanticism" is equivalent to saying "modern art"—

that is, intimacy, spirituality, color, aspiration toward infinity, ex-
pressed by every means known to the arts.

It follows from this that there is an evident contradiction be-
tween romanticism and the works of its principal exponents.

The contradiction between Romanticism and the works of its
principal exponents is inevitable if "Romanticism" is exactly
equivalent to modernism, as Baudelaire claims here: it is not a de-
finable ideal but a progressively changing one that can never be
completely realized. By saying that Romanticism is to be found
neither in the choice of subjects nor in exact truth but in the man-
ner of feeling, Baudelaire admits retrospectively the importance
that new subjects (medieval and exotic scenes, for example) and
realism have played in the first half of the nineteenth century, but
claims that they do not reach the essential—the harmony of artis-
tic feeling and contemporary life, a harmony that must of neces-
sity be continually reformulated.

By 1846 "Romanticism" was no longer a word that could rally
the avant-garde, no longer a battle cry, and it would soon be re-
placed by others. Its durability for half a century was remarkable,
however. All the attempts at definition we have quoted are expan-
sionist: they describe nothing fixed, and they leave room for future
manifestations to embrace almost anything whatever. They are all
calculated for growth, all planned to allow the appropriation of
anything human or even nonhuman. Romantic theory from 1798
to 1848 can seem maddeningly vague and fluid, but at least it is
precisely plotted for unforeseeable change.

The next rallying cry was Realism, and we can partially mea-
sure the success of the Romantic program by the violence of the
Realistic opposition to it. The debts were, however, acknowledged
at once. In the introduction to his book of 1857, *Le Réalisme*,
which served as a manifesto for the movement, Champfleury
quotes a passage of George Sand written seven years earlier:
"There will be a new school which will be neither Classic nor Ro-
mantic, and which we may not live to see, for everything takes
time; but there is no doubt that this new school will come out of
Romanticism, as truth comes more directly from the agitation of

the living than from the sleep of the dead." Champfleury com-
ments, "This kind of legacy is not received without litigation, dis-
cussions, and quarrels."

Realism is both a direct outgrowth of Romanticism and a reac-
tion against it, a reaction that, as we have seen, is predicted and
accommodated by Romantic theory. If one wished (the question is
academic), one could even consider Realism as simply a normal
development of Romanticism, which had been constructed to ab-
sorb and appropriate just such extreme changes; besides, as we
have seen, many of the premises of mid-nineteenth-century Real-
ism were already explicitly laid down early in the century.

It is this measureless ambition of the Romantic artists to appro-
priate all forms of art,* break down all barriers, that sometimes
makes them seem so modern today, even anachronistically so. The
most radical of all the French Romantic sculptors was Auguste
Préault, admired by contemporary poets like Charles Baudelaire
and Théodore de Banville. His great ambition—no one ever let
him carry it out—was reportedly to sculpt a mountain, to turn one
of the peaks near Le Puy into a work of art.

4

Like every other movement, Romanticism started as an opposi-
tion to what had existed just before it. In most of its original mani-
festations around 1800—the Jena circle of the brothers Schlegel,
Novalis, Schleiermacher, and others; the "Lake poets" in
England; the young French painters who turned away from the

* John Finch has pointed out that if Wordsworth's *Recluse* had ever been
completed on the scale partly carried out, it would have been more than
three times as long as *Paradise Lost*. Beth Darlington, who quotes Finch (in
her edition of *Home at Grasmere* [1977]), goes on to remark, "The grand
design proposed to synthesize mankind's philosophical, scientific, historical
and political knowledge in poetry that would move man to realize on earth
the Utopian vision confined for centuries to his hopes and dreams."

Neoclassical tradition of David—Romanticism presented itself as a break with a previous "Classical" style, however variously conceived (either Greco-Roman or French)—a Classical style that was understood as normative. This, too, is not without precedent; there have been other anticlassical styles before—early Christian art and Rococo decoration are two examples. What set off many of the early Romantics from all previous innovators is that they proposed not a new set of norms, but an abolition of norms, an artistic freedom inspired by the political ideals of the recent French Revolution.

The true originality of Romanticism, however, lies in a still greater ambition: a claim not only to destroy the Classical tradition and replace it with something better, but eventually—in the near, or far, or infinitely distant future—to arrive at a higher form of Classicism. Previous artistic revolutions had naturally implied that bad art was now being replaced by good, or even (as the Renaissance architects felt) that a barbarous, false non-art would at last make way for a revival of true art. No revolution before Romanticism had promised a universal synthesis—even a critical synthesis—that would incorporate all the achievements of the past. The final Romantic pretension was the poeticizing, or "romanticizing," of life itself. The tearing down of barriers between art and life began systematically with early Romantic theory of the late 1790s, although there had been sporadic hints of it before, above all in Diderot.

The fragment and the novel were the main forms of Romantic poetry for the Jena circle, the first and most influential of the avant-garde Romantic groups. Both forms attacked the integrity of the classical work and the classical genres, the fragment because it escaped any ordering in a hierarchy of genres, and the novel because it blended all the genres together—the early German Romantic novel combined autobiography, lyric poetry, drama, history, and fairy tale. (The best example is *Franz Sternbald's Travels* [1798] by Ludwig Tieck, the story of a pupil of Dürer's; it was a work that impressed many young German painters, particularly Runge.)

The Romantic fragment is not, as one might think, an incom-

plete work—or, at least, it is incomplete only in a peculiar way. Schlegel's definition in the *Athenaeum* is once again the best place to start:

> A fragment should be like a little work of art, complete and perfect in itself, and separate from the rest of the universe, like a hedgehog.

The Romantic fragment is, therefore, an inner contradiction—an oxymoron is the pedantic term in rhetoric, but the more familiar expression is having one's cake and eating it, too. Ideally, the Romantic fragment implied a unity larger than its own. The hedgehog is a useful image: when threatened, it rolls itself up into a sphere, a form that is at once perfectly geometric and yet organic, and satisfies the main Romantic desires; the edges of this sphere are a little irregular, blurred, and point outside the sphere in a way that is provocative, piquant.

For a number of years early in the nineteenth century, there was a monstrous fashion for writing fragments: hundreds of writers published thousands of little clever observations. The fashion of the fragment was related on the one hand to the contemporary taste for ruins, and on the other to the growing appreciation for sketches and the sketchy finish, a finish that made visible and exploited the individual brushstrokes. The fragment in the visual arts is not the result of a literary doctrine, however, but actually precedes the literary fashion in time.*

The Romantic fragment, complete and unfinished at once, is contradictory in another way as well: it is both metaphor and metonymy. To use Roman Jakobson's well-known division of all figures of speech into these two types: metaphor is a displacement of meaning in which the substituted meaning is related to the original one by resemblance; metonymy is a displacement in which the relation is one of contiguity or association. "To make a pig of oneself" and "to ply the knife and fork" are, respectively, metaphor and metonymy for "to be a glutton." The most common meton-

* See below, Chapter III, The Romantic Vignette and Thomas Bewick.

ymy is synecdoche, where the part signifies the whole ("He got himself wheels" for "He bought a car"). The fragment is the synecdoche *par excellence* and therefore a metonymy: but the Romantic fragment is paradoxically intended, by its apparent completion and in many other ways, to resemble the larger unity that it implies. Coleridge wrote that the perfect symbol "lives within that which is symbolizes and resembles, as the crystal lives within the light it transmits, and is transparent like the light itself."

This passage inspired René Wellek to say that Coleridge's idea of symbol was a misunderstanding, as it was not a metaphor, like a proper symbol, but a metonymy; but it is clearly and intentionally both. (Coleridge is perfectly aware that a proper symbol, like a metaphor, is based on resemblance—he starts by rejecting anything opaque as a symbol of light.) Roman Jakobson has claimed that metaphor is characteristic of Romanticism and metonymy of Realism; but much of Realism appears at once as an integral part of Romanticism, and the typical Romantic figure of speech can best be described as a fruitful confusion of metaphor and metonymy.

The new kind of symbolic language in the visual arts that arose from this new approach to rhetoric can be seen at its greatest in Géricault's *Wounded Cuirassier Leaving the Battle* of 1814, a picture of ambitious dimensions: the symbolism is new, diffuse, powerful, and inextricably tied to a sense of physical reality. The image has the sharpness and specificity of a portrait, but the gesture and the physiognomy, as much as the title and the setting, tell us that this episode is only a part of a large battle scene. It opens outward toward a small section of the battle, and the officer looks out of the picture as if toward the main part of the engagement. The picture has, therefore, a metonymic function as a fragment of a whole, and the single wounded officer stands for all the thousands of defeated soldiers. Yet the cuirassier, painted larger than life, takes on a metaphorical sense by his dimensions and by the extraordinarily expressive character of the setting: he becomes a symbol of suffering and heroic defeat, a personification rather than a single example. (This must have been even more poignant

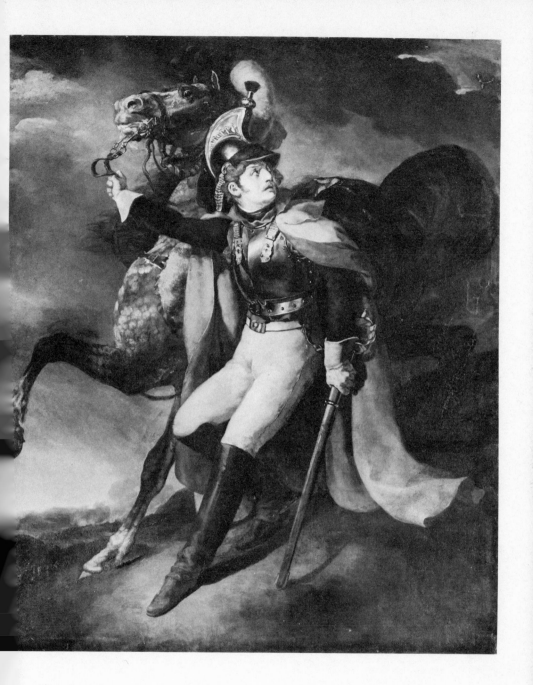

Théodore Géricault, Wounded Cuirassier Leaving the Battle. *Exhibited at the Salon of 1814. According to a pupil of Géricault, the picture was painted very quickly in the two weeks before the exhibition. What little critical attention it attracted at the time was almost all negative.*

when the picture was presented, in its first exhibition, as a pendant to Géricault's *A Charging Hussar* of 1812.)

<div align="center">5</div>

The revolutionary character of early Romantic art was generally a matter of defiant pride, but it was basically unstable. The young Astolphe de Custine, that shadowy figure on the margins of Romanticism in France who was later capable of a penetrating book on Russia, wrote in 1814 in a letter from Vienna:

> These denominations of romantic and classic that the Germans created some years ago were used to designate two parties who will soon divide the human race like the Guelphs and the Ghibellines in the past. The romantic spirits understand each other at the first word: their opinions in literature, in politics, and I would almost say in religion, in spite of the different sects, are the same. . . . They form the new German school. The classics are equally consistent, but they do not understand the others, while the others understand them quite well. . . . This is what prepares us for a great revolution in literature, politics and religion. . . . I, for example, am essentially modern, and therefore romantic.*

Sixteen years later, moved partly by personal dislike of Victor Hugo, Custine was to write that he hated the distinction of Romantic and Classic:

> There is classic in Shakespeare and romantic in Racine. . . . I love romantic poetry, but I detest, for the present at least, the romantics. Their intrigues, their coterie spirit, their ill-founded pretensions to genius, their innovations which are nothing but impudent imitations, all this disgusts me with their circle, which does not prevent me at the same time from being bored with the classical party.

This increasing ambivalence—having a distaste for Romanticism while holding tight to much of the early Romantic heritage

* Quoted in the preface to Custine's *Lettres inédites au Marquis de la Grange*, ed. de Luppé (1925).

and doctrine, the new broader tolerance even for the once-hated French classical style and the way it is annexed to Romanticism—is paralleled in many other examples. Delacroix, too, partly turned away from his earliest work and set out deliberately to reappropriate the grand tradition of mural painting: the label "Romantic" made him nervous in later life. Wordsworth's growing conservatism, Keats's attempt at the end of his short life to recapture the high Miltonic style, Schumann's abandonment of his early forms after the age of thirty and his concentration on the Classical genres of symphony and quartet—all these are analogous developments.

They have a double aspect: they are partly betrayals of the early Romantic faith and partly attempts to carry out its explicit program, present from the beginning, for a move to a new Classicism, or, more precisely, to a synthesis of Romantic and Classical ideals. The early Romantic style was hard to sustain: it needed either young nerves or a deliberate assumption of madness (that was Blake's strategy). Many artists and writers of the first Romantic decades either died young or wrote themselves out at an early age. The synthesis of Romantic and Classic, however, presented even greater problems: few examples of it escape a sense of inflated and unmotivated grandeur.

An account of Romanticism always demands a sense of this irregular and constantly sustained movement, which can be traced both in the lives of the individual artists and in the general artistic and social development of Europe in the nineteenth century: it is the history not of the success or failure of a program, but of a series of programs and ideals continuously redefined. The consistency and integrity of Romanticism lie not in the resemblance of these programs to each other but in the specific ways they were redefined and consistently expanded. In a brilliant epilogue to *Romanticism* (1979), much the best book available on the subject in the visual arts, Hugh Honour has a beautiful sentence that sums up both the constant change and the peculiar integrity of the Romantic movement, and the way it extends into our own time: "The Romantic revolution which began in the 1790s was like the battle which 'men fight and lose' in William Morris's *A Dream of John*

Ball: 'and the thing they fought for comes about in spite of their defeat, and when it comes turns out not to be what they meant, and other men have to fight for what they meant under another name.' "

An understanding of the instability and variability of meaning—of words, styles, actions—is central to the Romantic movement, which both exploited this instability and suffered from it.

6

Contemporary definitions of Romanticism, like the ones examined above, are proposals for the future. ("Definitions of poetry," Friedrich Schlegel wrote, "are not descriptions of what poetry was, or is, but what it should be; otherwise the best definition of poetry would simply be everything that has ever anywhere been called poetry.") But for us today, Romanticism is a movement through past time, a recommendation for possible modes of understanding, not for new productions. In neither case is it a settled body of doctrine. Unfortunately, most historians try to define Romanticism almost as if it were an object, however fuzzy, and then throw up their hands in despair when it refuses to sit still for its portrait. We can see an example of this failure when Hugh Honour juxtaposes Géricault's *Wounded Cuirassier* of 1814 with Friedrich Overbeck's portrait of Franz Pforr of 1810. He contrasts the "sweeping brushstrokes and splashes of pigment dashed on with apparently exuberant spontaneity" by Géricault with Overbeck's forms, "precisely, coolly articulated with firm outlines"—the dynamic, open structure of the one with the other, "static and claustrally closed" (although Overbeck's picture seems much more open than Honour maintains). Honour goes on to claim that in view of such contrasts "there is no Romantic 'style' in the visual arts, if by that is meant a common language of visual forms and means of expression, comparable with the Baroque or Rococo." He takes refuge in the easy formula that what the Romantic artists had in common was that each was different, and adds that it "is

therefore impossible to write about Romanticism as about Neo-classicism or any earlier international style" (pp. 14–16).

This distinction between Romanticism and earlier "styles" is not tenable except with a certain amount of juggling and no little confusion. It works only by a narrow definition of, say, the Baroque and a wide one of Romanticism: it would be difficult to claim that a picture by Vermeer and one by Pietro da Cortona provide less of a contrast than the one Honour finds in the work of Géricault and Overbeck. A "common language" for Baroque art could be arrived at only by resolutely excluding anything that does not fit, and casting it out as non-Baroque. The problem here is a naïve methodology, which defines a style by listing the characteristics that a given number of roughly contemporary works have in common.

Underlying this method is often an even more naïve belief that works that belong to the same style ought to look alike. Anthony Blunt, for example, defined Baroque architecture by the Roman style of Bernini and Borromini; he admitted as Baroque anything that resembled their works or was obviously derived from them, and disqualified everything else. This kind of definition is distinguished by its consistency, rigidity, and poverty. It does not stimulate understanding but leads to pigeonholing, to a dead end of classification, of no use as a tool of analysis. Works are disposed of as Baroque or non-Baroque, Romantic or non-Romantic, as if these were categories that had some objective historical reality. But terms like "Baroque" and "Romantic" do not designate well-defined entities or even systems. They are primitive shorthand signs for long-range historical developments that one feels nevertheless to have a certain integrity. These terms proclaim a confidence that all the various phenomena of the period, including the most eccentric and exceptional, are interrelated and interdependent in ways that can be indicated and represented by the historian.

This may help to explain why Ingres is rarely given his proper place in Romanticism (except, paradoxically, by a historian like Louis Dimier, who hated and admired him at the same time). The literature on nineteenth-century art is still afflicted by the tradi-

tional view of the "Classic" Ingres opposed to the "Romantic"
Delacroix, in spite of the ineptness of this myth, invented and en-
forced by Ingres himself in his later years. Ingres's critical disas-
ter at the Salon of 1819, where he fared much worse than
Géricault, and the defiant pose of his early self-portrait, ought to
destroy this myth. In life Ingres was almost the prototype of the
Romantic artist, consistently rejected and misunderstood until he
was well into his forties. The self-pity that pervades his letters
during his long years of isolation in Rome is boundless.

Most historians have no trouble accepting the linear primiti-
vism of the German painters called the Nazarenes as a strictly Ro-
mantic alternative to a painterly style, but they are not able to take
the same step with Ingres, perhaps because Ingres's art does not
seem so obviously neo-Gothic to us. But his contemporaries
thought that it was, and the Gothic label stuck to the painter of
Jupiter and Thetis until the 1820s, when Ingres reintroduced a
greater degree of modeling and three-dimensional depth to his
painting.

Honour sensitively observed that Ingres's work, in its rendering
of space and surface quality, is radically opposed to the Neoclassi-
cal principles advanced by David. But one should add that Ingres's
enamel-like finish is another way of attracting attention to the sur-
face of the picture, a striking alternative to the bold brushwork of
Delacroix and other Romantic "colorists"; in some ways, it served
a similar function. Furthermore, Ingres's anti-Davidian attitude
also affected his choice of subject matter and his manipulation of
genres. For many years, the artist survived by drawing the pencil
portraits we all love but which he himself considered as demean-
ing work. To one who sought him out and inquired whether this
was the home of the portraitist, he proudly answered: "He who
lives here is a history painter." In spite of his declaration of prin-
ciple, however, Ingres's art steadily undermined Neoclassical
standards. He painted very few canvases with subjects that would
have been judged entirely appropriate to history painting by fol-
lowers of David. The subject of the vast *Jupiter and Thetis*, one of
the most idiosyncratic works ever painted, was criticized by the
Academy as too trivial for such a large composition; it lacked the

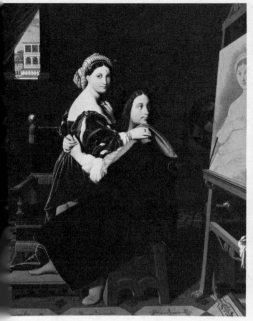

ABOVE LEFT, *Jean Auguste Dominique Ingres,* Raphael and the
Fornarina. *Ingres painted several versions of this subject.* RIGHT,
Eugène Delacroix, Michelangelo in His Studio. *This small but
significant painting was sketched in 1849 and completed in March
1853.*

kind of moral message that would have justified such an expanse
of paint. *The Dream of Ossian* would probably have fared no bet-
ter if submitted to Davidian criticism.

Most of the time Ingres painted what is usually known as "his-
torical genre," smaller paintings of historical episodes treated as
genre scenes—historical reveries rather than historical examples.
Such costume pieces, whose subjects were often taken from liter-
ary works, were popular with collectors and were despised as a
bastard kind of painting by critics who held to the grander Neo-
classical standards of history painting. Ingres's (and for that
matter Delacroix's) efforts to elevate such costume pieces by
increasing their expressiveness and investing them with a
projection of the artist's own situation and feelings (Ingres's *Ra-
phael and the Fornarina* and *Aretino in Tintoretto's Studio,* De-
lacroix's *Michelangelo in His Studio*) are characteristic of the

tendency to blur categories. Ingres, of course, did paint a few real historical paintings, although not always with equal success, but even in later life his fierce Classical position is largely a mystification, a Romantic paradox or irony. His final masterpiece, *The Turkish Bath,* is a self-indulgent extravagance.

Only a sense of history as movement rather than as a series of solid states can restore significance to the words and images of the early nineteenth century. E.T.A. Hoffmann in 1810 wrote that Beethoven was "a pure Romantic composer" because his music "sets in motion the lever of fear, of awe, of horror, of suffering, and awakens that infinite longing which is the essence of Romanticism." To understand this often quoted passage, one must also know that for Hoffmann the first "Romantic" composers were Haydn and Mozart—and one can then see that his characterization of Beethoven was part of a double program that he held with many of his contemporaries: first, to appropriate an already acknowledged Classicism and assimilate it into Romantic art; and, second, to take pure, instrumental music, the most abstract of the arts, as a model of Romantic poetry, and to claim for poetry the ability of music to create an independent world of its own—a visionary world, whose relation to the real world is always ironic, as the absolute purity of instrumental music is finally unattainable for the poet. It is unattainable for the painter as well, unless he is willing to move toward nonrepresentational art: there were even proposals to do so in the late eighteenth and early nineteenth centuries.

"Paintings without subjects"—"like music"—these were the reproaches thrown at Constable by the conservative French critics alarmed by the sensation his work created in 1824 among the young artists in Paris—and Constable welcomed these reproaches as if they were the highest praise. His landscapes, indeed, have no "subject" in the early nineteenth-century sense: all narrative content has been removed and most of the sites chosen have no intrinsic interest. For the Romantics, music as a model for the visual arts came up specifically in relation to landscape, along with the abolition of subject and the hesitant proposals for abstraction. It was in landscape that the two extreme tendencies of Romantic

style—realism and art for art's sake—could be reconciled. This synthesis gave landscape its supremacy among the genres of the time, and eventually allowed it to push history painting out of the center of art.

7

With few exceptions, historians of nineteenth-century art discuss and reproduce large finished works, "important" statements. For most periods, this is the preferable course, the significance of art being defined by the major projects and in the major cities. The art of the seventeenth century, for example, is shaped in Rome and at Versailles. Wonderful as they are, the etchings of Benedetto Castiglione, a charming artist from Genoa, can safely be ignored in a study of seventeenth-century style. The caricature drawings of Bernini, too, are fascinating, but it is St. Peter's Square and the great sculptures that matter. But with the early nineteenth century, minor or marginal phenomena become essential to an understanding of the period, because an inescapable aspect of the art of that time is the undermining of the main tradition and of the centers of power. One might say of Romanticism that the destruction of centrality is at its center: "Any line is an axis of the world," as the poet-philosopher Novalis put it. The Romantic movement might with some justice be defined as a progressive abolition of the hierarchy of genres and of the distinction between central and marginal forms.

The most extreme statements, where Romantic doctrine finds its purest expression in the visual arts, were often made by amateurs, craftsmen, eccentrics outside the accepted centers of professional activity. It took a dilettante like Victor Hugo to produce large totally abstract drawings and to give material expression to the theory of abstraction more than a half-century after Alexander Cozens's attempts to do so. Cozens's "blots," or semiabstract landscape drawings, were largely disregarded; in fact the advocacy of abstraction in his extraordinary "New Method" of 1785

Alexander Cozens, A Blot. *This aquatint from* A New Method of
Assisting the Invention in Drawing Original Compositions of
Landscape *(1785) is described in the text as "the top of fields or
mountains, the horizon below the bottom of the view."*

was practically suppressed and disappeared altogether in the nine-
teenth century, but it had a significant impact on Constable.

In prints and book illustrations, Romantic artists were freer and
in fact more consistently successful than in painting. Not only was
printmaking considered a "minor art" and consequently less
governed by conventions, but the new media of lithography and
wood engraving encouraged innovation. Lithography was espe-
cially important, if only for the extraordinary flowering around
1830 of French caricature. It was on the basis of his prints, not his
paintings, that Baudelaire considered Daumier one of the greatest
artists of his time.

In fact, even before Daumier began, the great Romantic school
of comic art was already established. Grandville (1803–47), for
example, is a major figure who confined himself to caricature and
book illustration. He and Henri Monnier (1799–1877), drafts-
man, actor, writer, and altogether a highly picturesque figure,
perfected a new style of comic art in the late 1820s. But it was
Charles Philipon, less an artist than an organizer, who fully real-
ized the potential of this kind of art for political opposition. He
made images the major attraction of his short-lived periodical *La
Caricature* (1831–35) and then of the long-lasting daily *Le Chari-
vari*. It was within the pages of these popular publications, far
away from the official institutions of art, that the genius of Dau-
mier matured.

Caricature was essential to Romantic art. The Romantic idea of
immediate expression pushed in two directions. If expression was
not conventional, it had to be natural, but it was not exactly clear
what that implied. One possibility was to follow the model of
music, which seemed to affect people so directly, in order to make
art as independent and self-sufficient as possible. This turned art
toward abstraction, and explains how the theory of art for art's
sake developed within Romanticism. But another tendency led to
Realism. Natural forms taken by themselves were believed to be
inherently expressive, and taken directly into art, they would con-
vey their meanings without any appeal to convention: this was felt
to be particularly true of physiognomy, which provided the basis
for the new type of caricature, Grandville's as well as Daumier's.
Caricature had the further advantage of being a genuinely popular
medium that gave some substance to the libertarian aspirations of
the "Romantic revolution."

8

Although Romanticism has been described largely in terms of
themes and subject matter, particularly by such critics as Honour,
Henri Focillon, and M. K. Abrams, the concept of genre is essen-

tial to a coherent view of the radical transformation of artistic ex-
pression during the Romantic era. The separation of genres is not
simply a matter of specialization or division of labor but implies
that different subjects are to be treated in particular ways. It is a
specific application of the concept of *decorum,* the idea of appro-
priateness. Perhaps an even better definition of Romanticism than
the progressive destruction of centrality would be a progressive
destruction of decorum—not, we must emphasize, the absence of
decorum but the *process* of its destruction.

A very large format and a great elevation of style were consid-
ered appropriate only to what was called history painting, which
meant compositions with several human figures, dealing with a se-
rious subject, such as allegorical, religious, or historical topics,
and conveying a great lesson. Subjects of daily life, known as
"genre painting," implied a smaller format but also a less severe
handling and less tightly constructed composition. This basic and
mostly tacit convention was flexible and underwent considerable
adaptation at different times and in different places, but it became
most explicit and rigid with the Neoclassical painting that just
preceded Romanticism. In their assault on this tradition, Roman-
tic artists followed two principal courses: on the one hand they at-
tempted to blur the distinctions, although capitalizing on the
potentials, of the tradition; on the other, they developed the sup-
posedly minor, or "inferior," kinds of art, such as landscape or,
even more drastically, book illustration, and gave new significance
to "sketches" and "studies," which began to compete with fin-
ished official works.

This assault on the hierarchy of genres was particularly violent
in France, where its authority was most strongly established. In
Germany and in England, landscape developed with less con-
straint, and also very much earlier, although as late as 1829
Thomas Lawrence told Constable, when he was finally elected to
the Royal Academy toward the end of his life, that he was lucky to
get in when there were several history painters among the candi-
dates.

The attack on the genres by the Romantic artists betrays one of
their deepest ambitions: the achievement of "immediacy," of

forms of expression directly understandable without convention and without previous knowledge of a tradition. This was no doubt an unrealizable ambition, but it goes back to Jean-Jacques Rousseau, to his deep distrust of language and the way it betrayed and deformed one's inmost thoughts and feelings. The Romantics wanted an art that would speak at once and to all. The attack on the system of genres challenged a tradition that made intelligibility dependent on connoisseurship. Above all, the immediacy of statement was best achieved not in history painting but in the inferior genres of landscape and portrait. For this reason, too, the immediacy of the sketch and the study took on an importance it had never yet had in the history of art, although they had certainly been appreciated before.

Géricault, as much as any artist of the century, is at the origins of the modern tradition in the way he undermined the hierarchy of genres, sapped the norms and the conventions of painting, in search of a mode of expression that was personal and immediate. This is as much a part of Géricault's "Romanticism" as his powerful exacerbation of sentiment, which is nevertheless very real. Dying young at the end of a passionate life, he is the painter who is the purest incarnation of Romantic art in France. He had, it is true, a profound feeling for Classical and ancient art, but that is not a contradiction, as has sometimes been believed—quite the contrary. (It would be as absurd to claim that Byron was not Romantic because he adored, defended, and often imitated the Augustan prosody of Alexander Pope.)

Géricault exhibited very little during his short lifetime, only four pictures, one of them now lost, in the Salons from 1812 to 1819. (By the age of thirty, Delacroix had shown many more works, a dozen at the Salon of 1827–28 alone.) In 1812 Géricault presented the *Equestrian Portrait of Mr. D. . . .* , now at the Louvre. It had a great success and won a medal, but it provoked some interesting criticism: the finish was somewhat too sketchy, there was too much dramatic movement, and the horse was represented moving away from the viewer—all of which violated the conventions of the equestrian portrait. Reexhibiting the picture two years later, Géricault implicitly admitted the partial justice of

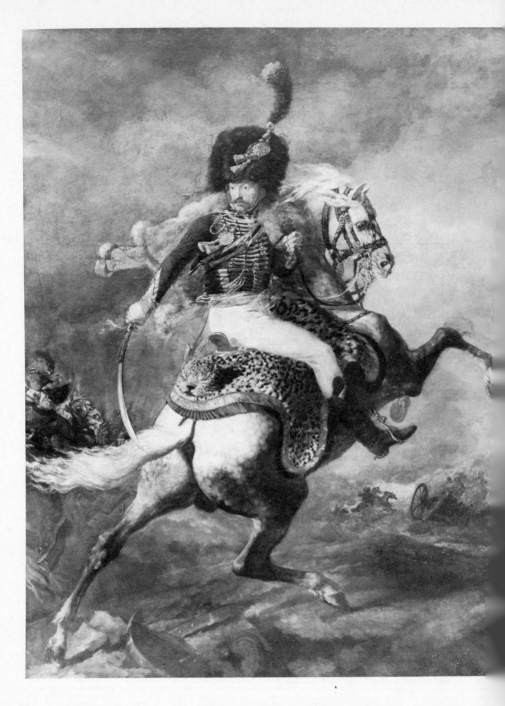

Théodore Géricault, A Charging Hussar. *First exhibited at the Salon of 1812 as* Equestrian Portrait of Mr. D., *then again as a pendant to the* Wounded Cuirassier (*see page 27*) *under the new title.*

the criticism by changing the title. It became a pendant to his new *Wounded Cuirassier* and was no longer called a portrait: the title was now *A Charging Hussar.* This retrospectively alters the meaning as well as the genre, and justifies the interpretation of the historian Jules Michelet many years later in his extravagant eulogy of Géricault: "This genius, extraordinarily firm and severe, painted the Empire from the first and judged it: at least the Empire in 1812: nothing but *war,* no ideas." The juxtaposition of the two canvases, besides, must have brought out the contrast between the brilliant brushwork of the *Hussar* and the more summary, harsh, almost brutal technique with which the *Cuirassier* was painted. The handling of the new picture carried even further what critics had objected to in the first one: this one, it was said, should not have been called a picture at all but a sketch.

By its size, force, care of execution, and intensity of expression, Géricault's *The Raft of the "Medusa"* (1819) is a part of the succession of grand historical compositions of the school of David. The picture was violently attacked by many critics, but it created a great deal of interest at the Salon, and it had considerable success from the first, entering the Louvre by 1824. The artist's ambition was immense and encompassed a renewal of the tradition of Rubens and Michelangelo. The boldness of a large historical painting without a hero should not be underestimated, however, and it is even more impressive when one remembers that the choice of subject could only embarrass the government. (The shipwreck of the *Medusa* was a sensational episode and had caused a considerable scandal, as the liberals accused the government of having appointed an incompetent captain solely on the basis of his loyalty to the Bourbons.) Géricault's political intention is not in doubt: before settling on the subject of the *Medusa,* he had considered the murder of Antoine Fualdès, a sordid crime that had also been blown up into a political scandal.

In an excellent monograph on the painting ("Géricault's *Raft of the 'Medusa,'* " 1972), Lorenz Eitner tried to minimize its political significance. It is true that in the course of its elaboration, modern dress partly gave way to the heroic nude, and that the scene took on a more universal meaning as an expression of

human suffering. To support his thesis that Géricault decided against a political gesture as he worked on the picture, Eitner quotes a letter in which the artist declared to a friend:

> This year our journalists have reached the height of the ridiculous. Each picture is judged first of all according to the *spirit* in which it was composed. Thus one can read a liberal article praising the national brushwork in a picture. The same work judged by a right-wing critic is simply a revolutionary composition with a general tint of sedition. . . .

Here Géricault is attacking the art criticism of the time, which was indeed phrased almost entirely in political, or at least politically slanted, terms. Liberalism and sedition were not, for Géricault, characteristics of brushwork or coloring, nor were they valid criteria of artistic excellence. But that does not mean that he had given up expressing his political and social interests. We have only to remember the subjects he planned on treating after the *Medusa:* the slave trade, and the opening of the doors of the Inquisition.

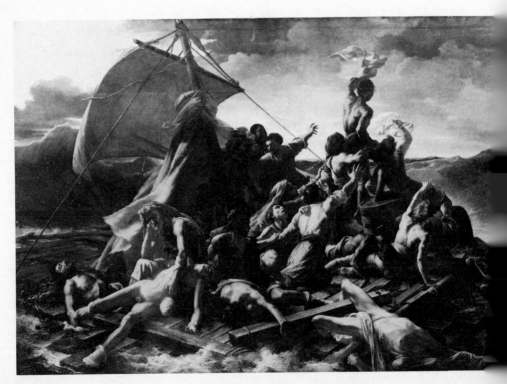

On the other hand, Paul Joannides has rightly asked how it came about that the picture created so little offense, and that Louis XVIII could have graciously complimented the painter.* Between the time when Géricault chose his subject and the time the finished picture was exhibited at the Salon, the right wing had been pushed out of power, in particular out of the Ministry of the Navy. The government could show itself tolerant and magnanimous on the subject of the *Medusa;* it could even be seen thereby as dissociating itself from the event. (It is interesting to note here that in 1822, when an attempt was made by Forbin, the head of the Louvre, to buy the picture for the national museums, he failed, as the right wing had now returned to power; the sale did not take place until after Géricault's death.)

These few pictures that were exhibited during his lifetime would assure Géricault a distinctive place in the history of nineteenth-century painting, and they show how he had begun to undermine the system of genres. Nevertheless, it is the rest of his work that most profoundly transgresses the pictorial language of his time and makes of Géricault one of the principal artists of the modern tradition. One can see a wonderful imagination in movement in the profusion of his drawings and sketches, but the same

* See *Burlington Magazine* (1975), pp. 171–72.

LEFT, *Théodore Géricault,* The Raft of the "Medusa." *Exhibited at the Salon of 1819 under the title* Scene of a Shipwreck (*a title probably forced on the artist*). *The sinking of the* Medusa *was a disaster that became a political scandal. The painter must have settled on the subject sometime in the summer of 1818. In November he rented a larger studio that would accommodate the immense canvas, which was completed in July 1819 for the opening of the Salon. The large figure at the lower right was added at the last minute when the painting had already been moved out of the studio. The critical reception was mixed but by no means entirely negative, and the picture was a sensation, unlike Ingres's* Grande Odalisque *of the same Salon, which was generally derided.*

is true of his older contemporary Anne-Louis Girodet. The essential originality of Géricault is to be found in a number of paintings that call into question the distinction between public and private work, and that defy the traditional classifications of genre. For example, *The Cattle Market,* now at the Fogg Art Museum, is a summary of Géricault's Roman experience; the subject could have been easily adapted as a genre painting, but the picture does not have the necessary careful finish; on the other hand, the elevation of style and the expressive intensity of the coloring raise the theme, as has often been remarked, to the level of myth.

In the same way, Géricault's ten paintings of insane people do not fit into any of the traditional categories of painting. They cannot be considered scientific illustrations, as those would have been drawn or engraved, not painted. Their handling does not have the care of a "finished" portrait; and in spite of the extreme roughness in the rendering of the costumes and subsidiary parts, they are too imposing to be portrait studies. The concentration on expression instead of on physical and psychological individuality—especially the emphatic insistence on certain pathological traits, like the redness of the lower eyelids—is indicative of a concern different from that of the portrait. The most apt term would be *"étude,"* or "study from the model," a category that evaded the formal conventions of the portrait and was often used to represent picturesque characters (for example, Delacroix's *Young Greek Woman in the Cemetery*). But Géricault gave the series a monumentality that largely transcended the traditional study. These pictures are disturbing as they attack at the same time our preconceptions about the nature of painting and of sanity.

The difficulty of understanding nineteenth-century art, and Géricault in particular, if one neglects the hierarchy of genres is apparent in a passage as perceptive as the following one from Honour's *Romanticism* about *The Raft of the "Medusa"* and its relation to the work of Géricault's older contemporary Baron Gros:

By stressing the realistic, at the expense of the idealistic or classic, elements in David's work, Gros evolved a new style eminently suit-

Théodore Géricault, The Madwoman (Gambling Monomaniac). *This was one of a series of ten similar pictures, five of which have disappeared. The circumstances in which they were painted are not known. Géricault gave them to Etienne-Jean Georget, a famous psychiatrist and alienist (it is not clear whether or not he first met him in a professional capacity). It seems probable that the date of execution is after Géricault's return from England, around 1822.*

able for pictures of modern subjects. And although Géricault made a more decisive break with tradition in his choice of themes, he was in other respects more faithful than Gros to Neo-classical principles. Working in the approved academic manner, he proceeded systematically from numerous swiftly drawn sketches, in which he gradually determined the general composition, to wonderful nude studies of individual figures drawn with a precision of outline and volumetric clarity equalled by few Neo-classical draughtsmen. In the pursuit of truth he frequented dissecting rooms and made the extraordinary paintings of heads and limbs of corpses which Delacroix was to call "the best argument for beauty as it ought to be

understood." Yet, in the final work, he followed the conventions of the grand style by endowing the survivors on the raft with the healthy physique of Greek athletes, rather than depicting them as they appeared when rescued—bearded, emaciated, covered with sores and wounds. (P. 45)

If Honour appears here to brush aside the revolutionary break with the Classical tradition in favor of the more conventional aspects of the finished work, it is partly because of what he leaves out. He glosses over the relation between the studies and final work, and his account leaves unexplained his quotation of Delacroix's enigmatic characterization of the wonderful oil studies of severed limbs: "the best argument for beauty as it ought to be understood." Why so describe these magnificent but repellent works? We must turn to Delacroix himself for an explanation. In 1857 he made a note for an article on "Subject" intended for a projected dictionary of fine arts: "Painting does not always need a subject. The painting of arms and legs by Géricault." It is clear that Delacroix understood how radical was Géricault's accomplishment: the abolition of the traditional subject in favor of a new symbolism, immediately comprehensible and seemingly independent of culture and convention. Perhaps more than any other artist Géricault realized this Romantic ambition, and with the abolition of subject, painting took a first step toward abstraction.

Géricault's severed limbs do not release their full significance when they are considered only as studies for *The Raft of the "Medusa."* Although they may have been painted in connection with that work—even that is not certain—they are not preparations for particular motifs in the painting but studies in mood, exercises in horror, with no anecdotal justification. Thousands of sketches of arms, hands, and legs made as preparation for larger works or simply as exercises have come down to us over the ages, some of these elaborately worked out in oils. But the *Severed Limbs* in the Musée Fabre in Montpellier is not simply a study of limbs; we see *hacked-off* limbs, composed and balanced into a full picture, a still life, a gruesome pun on the idea of a *nature morte.*

It is the "best argument for beauty" because of the abolition of

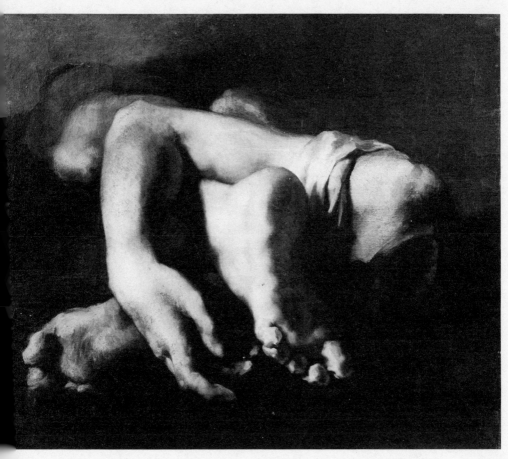

Théodore Géricault, Severed Limbs. *This is the most important and accomplished of a group of such "studies," which, it is usually thought, were painted in 1818–19 during the elaboration of the* Raft of the "Medusa," *although this is not entirely certain.*

subject: what is beautiful comes entirely from the composition, the paint, the light, the handling. The amputated arm is carefully arranged with expressive and classical grace. The canvas is rather large, with the limbs slightly over life-size; it has none of the casual feeling traditional in an *étude* (for the *étude* had its rules and conventions, too). The lighting is dramatic, and the dark background fully worked out. The objects portrayed repel, and in so doing demonstrate the supreme power of the act of portraying.

Far from being a simple exercise in observation, the picture is staged, a "theater of cruelty" in which Romantic art reaches one

of its limits. Géricault gave this aspect considerable weight. A companion piece is the *Two Decapitated Heads* in Stockholm. The artist got the man's head from the morgue, but for the woman's head he had a live model: her head is nonetheless represented as having been cut off. These paintings were already considered important enough at the time to be copied with the greatest fidelity by admiring followers. More generally, the quantity of studies painted by Géricault compared with the small number of his "finished" works, and the fact that the studies were so often copied, are clear signs of their new significance.

A marginal work, the study, attained in these paintings a form of the sublime to which the central, finished work could not pretend. The process that would end with the Impressionists, when the "finished" work, the "sketch," and the "study" collapsed into each other to form a single category, began with the Romantics.*

It is interesting that so much of the significance of Romantic art for the artists themselves can be discovered by looking ahead at what was to come out of what they had started. No doubt the artists would have been, at the very least, disconcerted at the future of their innovations, but they were the first to comprehend that artistic work partially escapes the intention, control, and understanding of the artist. The greatest English architect of the early nineteenth century, Sir John Soane, when he designed the Bank of England, sent three oil sketches to the governors of the bank. The first showed the bank brand new, shiny and gleaming; the second portrayed it when it had weathered a bit, acquired some ivy and a mellow patina; the third imagined the bank in a thousand years, as a noble ruin.

* Of course, there are unfinished Impressionist pictures, too—that is, pictures the artists never got around to completing.

II

CASPAR DAVID
FRIEDRICH

AND THE

LANGUAGE OF
LANDSCAPE

1

One of the most radical aspects of early Romanticism was the attempt to replace history painting—large formal depictions of historical or religious scenes—by landscape. It is not that painters turned their attention to landscape and away from the large-scale painting—frescoes and oils—of scenes from the Bible and the lives of the saints or from ancient or modern history, but that a few of them had great and astonishing ambitions. They wished to make pure landscape without figures carry the weight, attain to the heroic and epic significance, of historical painting. Landscape was to be the vehicle of the Sublime.

In the seventeenth century, the landscapes of Poussin and Claude reached their full dignity as depictions of Classical Nature, with figures in antique dress, and often a mythological subject discreetly integrated into an ideally "Arcadian" countryside. The Romantic artists wanted to make the elements of Nature alone carry the full symbolic meaning. Their project was, in fact, identical with the contemporary attempt by Wordsworth and Hölderlin to give pure landscape poetry the force and gravity of Milton's and Homer's epic style.

That the replacement of history painting by landscape had an ideological purpose directly related to the destruction of traditional religious and political values at the end of the eighteenth century cannot be doubted. The artists were themselves acutely conscious of this. In 1802, the most brilliant and articulate of the young German painters, Philipp Otto Runge, identified the greatest achievements in art with a decline of religion:

How can we even think of trying for the return of the art of the past? The Greeks brought the beauty of their forms and shapes to its height when their gods perished. The modern Romans brought historical representation to its farthest point when the Catholic re-

51

ligion was ruined.* With us again something is perishing, we stand at the brink of all the religions which sprang up out of the Catholic one, the abstractions perish, everything is lighter and more insubstantial than before, everything presses toward landscape art, looks for something certain in this uncertainty and does not know how to begin. They grasp mistakenly at historical painting [*Historie*], and they are bewildered. Is there not surely in this new art—landscapery, if you like—a higher point to be reached? Which will be even more beautiful than before?

In one sense, the Romantic landscape was a return to the serious tradition of the seventeenth century and a revulsion from the largely picturesque styles of the eighteenth. An essay by Schiller in 1794 (on the landscape poetry of a very minor versifier, Matthisson) prepared the way. Landscape painting and poetry for Schiller could be raised to the dignity of major arts only by the awakening of sentiment and by the representation of ideas. We demand, he wrote, that the art of landscape should work upon us like music. Sentiment is stimulated by the analogy of sounds and colors with the movements of the emotions. Ideas are stimulated in the imagination of the reader or spectator by the form of the work of art, and this form *controls* the imaginative response. For Schiller, as later for Freud, the symbolic function of the imagination follows certain laws and can be both interpreted and predicted.

In 1808, a patron of the thirty-four-year-old Caspar David Friedrich asked him to turn a landscape into an altarpiece. The picture created a scandal, was fiercely attacked and as fiercely defended. The frame, with its angels that look down on the scene and with the ear of wheat and the wine branch below as symbols of bread and wine, the body and blood of Christ, firmly defines the work as a picture intended for an altar. Yet the crucifix in the landscape, the only piece of traditional religious symbolism in the picture itself, is clearly not a representation of a historical event, but almost a part of Nature, a crucifix upon a moun-

* Runge is alluding here to the exact coincidence of the High Renaissance style of Raphael and Michelangelo with the beginnings of the Reformation.

Caspar David Friedrich, The Cross on the Mountain, *also known as* the Tetschen Altarpiece. *Recent research has shown that this painting of 1808 was started not as an altarpiece but as a landscape to be presented to the Protestant king of Sweden, and it was only later that Count Franz Anton von Thun-Hohenstein convinced the artist to complete it as an altarpiece for his chapel at Schloss Tetschen. The frame, executed by Karl Gottlob Kühn, was designed by Friedrich.*

tain such as one may still see today in the German countryside. Moreover, the figure of Christ is turned away from the spectator toward the setting sun, and ivy grows around the stem of the crucifix.

In this, Friedrich's first important oil painting, the firm rock upon which the crucifix stands and the evergreen trees that grow round it are symbols only too easy to read. The symbolism of his later works is far less intrusive, more nuanced, and more dependent on the structure of the work—although even in this altarpiece an essential part of the effect comes from the perspective, which seems to place the spectator in midair before the scene, a sensation about which early critics complained.

"Here is a man who has discovered the tragedy of landscape," said the French sculptor David d'Angers after visiting Friedrich in his studio, and indeed Friedrich was one of the first European artists to restore landscape to the status of a major genre. The contemporary development in England, with Constable and Turner as the major figures, took place in a more empirical atmosphere, and gave landscape painting an explicitly scientific dignity as a means of investigating the visual aspect of Nature. The moral gravity is the same, however, and the explicit symbolism of Turner's work is comparable to Friedrich's. In return, the exactness of natural appearance is an essential aspect of Friedrich's art.

Few paintings by Friedrich are to be seen outside Germany. An exhibition at the Tate Gallery in London in 1972 was, astonishingly, the first large-scale showing of his work outside his native land. The entries in the catalogue for this exhibition were by Helmut Börsch-Supan; here and in his succeeding books on Friedrich, he has imposed a doctrinaire reading that does the paintings a disservice and distorts the tradition of Romantic symbolism. Börsch-Supan claims that "if one is to decipher Friedrich's pictorial symbolism, one has to look at his entire *oeuvre,*" and it is with this apparently reasonable proposal that he goes astray. A study of the entire *oeuvre* may bring a deeper comprehension of Friedrich's art, but his symbols are to be read (not deciphered) within the individual works. That is, the meaning of the elements of

Friedrich's style are revealed in each picture and are not an eso-
teric, private code accessible only to the initiate.

Perhaps the masterpiece of Friedrich's last years is *The Great
Reserve*, a picture of inundated meadows where the Elbe over-
flows its banks. In the foreground is the water, with a very small
ship that drifts near the edge of the mainland. The point of view of
the observer is from far above, so that the body of water seems to
have a gentle curve as if it were the curvature of the earth, and
small plots of land stand out from the inundating water like conti-
nents on a globe. The inverse curve of the horizon responds sym-
metrically to the gentle curve of the foreground: the land between
appears only as a few clumps of trees on a thin strip between the
water and the immense sky. The broken, agitated forms of the
water are unified by the evening colors of the sky reflected in-
versely so that the cool, distancing blue is in the foreground.

Caspar David Friedrich, The Great Reserve. *Exhibited at the Dresden
Academy in 1832.*

The painting is a religious meditation, an image of the relation of heaven to earth. It has a significance, but no message: the concentration is visual, and the meaning is general and inexhaustible, diffused through the forms; the strange symmetry and the unusual perspective force a reading upon us; Börsch-Supan's catalogue entry, however, is egregiously specific. We give it complete:

> Painted in 1832, this picture marked a high point in Friedrich's development as a colourist. It recreates with great vividness the atmosphere of the time of day just after the sun has set. The striking perspective of the foreground may well be the result of the view being taken from a bridge. Both the ship drifting over the shallow water where it is in danger of being stranded, and the abruptness with which the avenue of trees comes to an end in the open country, are images of approaching death.

In similar fashion Börsch-Supan goes through the other works: every distant view represents paradise; every blade of grass, the transience of life; every birch tree, resurrection; every river, death.

There is no evidence that in this picture Friedrich intended a break in an avenue of trees or a boat in shallow water to be an image of death. Even if we discovered—improbably—he actually believed this, we would have to say he was wrong: these symbols do not function that way within the total form of *The Great Reserve*, whatever they may do in other paintings.* The speculation about the view being taken from a bridge is gratuitous. We know that many of Friedrich's pictures were not drawn from life but constructed in his mind; one might even say that he followed his own metaphorical advice to painters and closed his eyes before he began to paint. The suggestion of a bridge serves only to obscure one of the characteristic effects of Romantic painting and poetry: the sense of being suspended in space, detached and poised over

* A ship approaching a port has the natural connotation of the end of a voyage, and an association of this with death is clearly made in other pictures by Friedrich, but the meaning there is brought out by the pictorial context.

emptiness, so that what is seen takes on the quality of a vision.

The ambition of the Romantic artist was to create a symbolic language independent of tradition. It was no longer enough to initiate a new tradition, which would in turn harden into an arbitrary system. What was needed was a natural symbolism, which would *remain eternally new.* This ambition may have been hopeless, its achievement a delusion; but to substitute a private esoteric code for the traditional iconographical one would have been absurdly self-defeating. What the artists and poets did was to attempt to disengage the latent meaning of the natural elements, the significance hidden in Nature herself.

When traditional iconography was rejected, then the symbols of Nature themselves had to be made to speak, and this they could only do when reflected through an individual consciousness. Nature was seen at once diffused with feeling and at a distance—the distance freed the senses from the distortions of a particular moment and made the significance of the work general and even universal in range. Wordsworth writes of the crag on which he waited anxiously, trying to sight the carriage that would take him home after the holidays. Ten days later his father died . . .

> And afterwards, the wind and sleety rain
> And all the business of the elements,
> The single sheep, and the one blasted tree,
> And the bleak music of that old stone wall,
> The noise of wood and water, and the mist
> Which on the line of each of those two Roads,
> Advanced in such indisputable shapes,
> All these were spectacles and sounds to which
> I often would repair and thence would drink,
> As at a fountain. . . .

All the traditional paraphernalia of Nature poetry have disappeared; the rhetoric is hidden. In their place are a stone wall, a single sheep, one tree, and the music of Nature.

Wordsworth gives each of these elements an extraordinary significance merely by naming them in a certain order. They are barely described; by juxtaposing them, Wordsworth allows the as-

sociations to build. The narrative of his anxiety to return home, followed by the death of his father, acts like a frame around a landscape; it enriches the meanings but is not indispensable. The meanings come directly from the order and gravity of the list. Nor do the elements of Nature have primarily an autobiographical significance for Wordsworth: he does not value them solely for their power to recall the past. On the contrary, that single moment in his life served to release the powers of speech in Nature. The ambition (and the achievement) of Friedrich and Constable are similar to Wordsworth's: the forms of Nature speak directly, their power released by their ordering within the work of art.

The fundamental principle of Romantic symbolism is that the meaning can never be entirely separated from its symbolic representation: the image can never be reduced to a word. Börsch-Supan treats Friedrich as an enemy whose code must be cracked so that we may discover his strategy. But there is no code, no idiolect, no totally private language to be deciphered and translated. Friedrich's art—like any art—resists translation: it can only be interpreted, and not even that without constantly returning to the specific images as they figure in each painting.

To read into Friedrich's paintings an esoteric code is to falsify not only their art but even their religious meaning. It makes the works appear to convey a systematic doctrine, whereas they clearly reject religion as dogma. It is significant, as William Vaughan remarks in his introduction to Börsch-Supan's catalogue, that churches never appear in Friedrich's work except in the distance, as unreal visions, or as ruins. The visible Church is dead, only the invisible Church, in the heart or revealed through Nature, is alive. This is part of Friedrich's Pietist heritage, a personal religion that refuses all outward forms, all doctrine. To put a landscape on an altar is an aggressive act, as destructive of the old forms as it is creative of a new sensibility.

His contemporaries, even when they disliked his works, sometimes seem to have understood Friedrich better than we do today. A simple painting of leafless bushes in the snow inspires Börsch-Supan to thoughts of death and resurrection. A reviewer of 1828 was more down-to-earth: "The greatest truth to Nature, but the

selection of such a limited appearance from the whole of Nature
can hold our attention as little as the aspect of the trifling detail in
Nature generally does." In his unsympathetic way, the reviewer
had grasped the profound realism that links Friedrich to Consta-
ble: there was, for him, no phenomenon in Nature too insignificant
for art. If this painting had a message that could be put into words,
it was just that.

2

When Friedrich appeared on the scene during the first years of
the nineteenth century, landscape played an important role in the
theory as well as the practice of European art. The catalogue of a
1974 retrospective of Friedrich in Hamburg contains a collection
of texts on the theory of art, especially German ones, from
around 1800; a similar anthology of French texts would be equally
impressive, but almost a quarter of a century was to pass before
Corot and Théodore Rousseau carried theory into practice.*
The new place of landscape in art derived, of course, from the cult
of Nature that had grown and remained fashionable since Jean-
Jacques Rousseau; the picturesque "English" landscape garden
was one of its earliest manifestations. More profoundly, however,
the development of landscape was one element in the general fer-
ment within the language of art, at a moment when everything was
called into question, not only in politics but also in all aspects of
culture. The Romantics believed that the simplest forms of Nature
could speak directly to us, could express sentiments and ideas
without the intervention of culture; they dreamed of creating
through landscape an art both personal and objective, an immedi-
ate, nonconventional, universally intelligible expression, a lan-
guage that would be not discursive but evocative.

* One might begin with the precepts of Girodet, and the important
"Lettre sur le dessin dans les paysages" ("Letter on landscape drawing") of
1795 by Chateaubriand, written by that famous verbal landscape painter
during his exile in England.

The impossibility of such a project not only is obvious to us today, as we have remarked above, but was undoubtedly felt by the authors of the program, by men such as Friedrich Schlegel or Novalis, who had meditated on the nature of language. The languages we speak are all too clearly founded on convention; therefore to the Romantics, as to Rousseau, the languages of everyday life are arbitrary and degenerate, fallen from the state of grace of the initial condition of humanity. In that primitive time, it was felt, there were no distinctions among the different languages or even between music, poetry, dance, and verbal expression; sign and meaning were not then related by arbitrary convention, but the sign was a natural and immediately understandable representation of sentiment and idea. This myth of original unity inspired the efforts for reform and renewal. It explains the privileged place given to music among the arts in Romantic theory (which later induced Walter Pater to say that all the arts "aspire to the condition of music"). Music seemed to express sentiments by acting directly on the senses. Figurative art, less satisfactory because less purely sensuous than music, had at least the advantage—through resemblance and imitation—of basing its language on a natural relationship between a symbol and what it signifies.

Traditional allegory and iconography, however, obviously require knowledge of conventions. A woman holding a pair of scales is Justice only to a person who knows the code. Classical mythology itself had become, to many Romantic artists, nothing but another system of such conventional transpositions. In the Romantic struggle to escape from these conventions, landscape played an important part. First of all, it seems to put us in direct contact with Nature. Moreover, the genre was paradoxically favored by the humble status in which it had been kept by academic theory since the sixteenth century; the humility of the genre facilitated a break with its deep-rooted conventions, symbolism, and tradition. The problem for the Romantic painters was to endow landscape with profundity, loftiness of sentiment, an expression not only of appearance but of the reality hidden behind things, of the mystery, the infinity of Nature, and even the drama of the self facing the universe.

In the late-eighteenth- and early-nineteenth-century attempts to free the symbol from convention in figure painting as well as in landscape, three main tactics can be distinguished. The first one consisted in elaborating a new, totally personal symbolism, an idiosyncratic mythology belonging entirely to the artist. William Blake is the most characteristic example of an artist who used this tactic; and it also explains, at least in part, the success of the poems of Ossian, that extraordinary Romantic hoax, in which Homeric poetry appeared to have been brought closer to Nature, freed from its cultural ties. (Celtic nationalism also played a part in the European vogue of these poems.) The forgery was perceived by those critics who noticed that the symbolic language was not unfamiliar, the conventions only too clearly adapted from Homer. The second method consisted, on the contrary, in the use of symbols, like the association of dark hues with sadness, which are so familiar that they are taken for granted and appear to escape from convention. Such symbols are so deeply rooted in ancient tradition, so pervasive in the entire culture, that their artificiality is no longer felt and they appear to be part of human nature. The third method was the exploitation of the latent possibilities of meaning in natural phenomena, the coming of dawn as a new beginning, for example. We have here a mode of expression so closely related to experience that we feel that the objects themselves are communicating with us, and that the symbolism is not in art but is the very language of Nature herself. This is the way that Friedrich in *The Great Reserve* exploits the reflection of the colors of the sky in the water, strengthening the meaning of a foreshortened perspective that curves the marshy foreground as well as the horizon. Philipp Otto Runge, in his complex, confused, and even contradictory program for a new art, applied all three methods. His ultimate aim was an ideal of pure expressionism through color, in other words, an entirely "musical" art.

Friedrich was often drawn to a kind of symbolic language so familiar through long use that it had become unconscious and all sense of its conventional nature had been eroded: the cross, the anchor, or the ship. He also employed symbols derived directly from the kind of experience that seems to precede language:

Caspar David Friedrich, The Cross on the Baltic Sea. *As early as 1830 this picture was cited (by O.W.C. von Roeder) as an example of Friedrich's allegorical landscapes.*

abrupt breaks in space, or the vertigo induced by being suspended over an abyss. The two kinds of symbolism often cannot be distinguished: when the artist, for instance, expresses transcendence through back-lighting—objects silhouetted against a glow that comes from beyond—or light coming from the depth of the picture so that it seems both in the picture and beyond it.

That Friedrich cultivated allegory cannot be doubted. The question is only how far we should push the decoding and what relation his allegorical expression has to other forms of expression.

In defense of a symbolic interpretation, his letter of 1815 to Louise Seidler has been cited: "The picture for your friend has already been sketched out, but there is no church in it, not a single tree or plant, not a blade of grass. On a bare and rocky seashore there stands, high up, the cross—for those who see it that way, a consolation, and for those who don't see it that way, just a cross."

No one needs to have it explained that, in this picture, the cross and the anchor are the signs of faith and hope, according to the most elementary Christian symbolism. What matters is the rest of what Friedrich writes: his insistence on what is not present in the picture, the artistic asceticism, the elimination of the picturesque, and even the possibility held out of choosing not to adopt the traditional symbolism. Friedrich values the Christian meaning above all, but the picture must also bring something to those who see in its principal motif not a consolation but only a cross. As Friedrich himself said, "Just as the reverent man prays without uttering words, and the Lord hears him, the sensitive painter paints, and the sensitive man understands and recognizes him, but even the more obtuse carry away something from his work."

These words of Friedrich invite us to examine more closely the manner in which he handles his motifs and impel us to consider them not as simple imitations of Nature but as subjects for meditation. The motifs themselves are very traditional. Each of them has a long history, as critics have easily shown; one can even find examples in German landscapes of the immediately preceding period, in the work of Adrian Zingg and Ferdinand von Kobell: archi-traditional motifs filled with significance but terribly threadbare. It was, in fact, by turning his back on the European tradition that Friedrich evolved his art, by cultivating a symbolic technique that seemed awkward to his contempories. (This awkwardness is analogous to the thinness of his paint; contemporaries, like Goethe, complained that his handling lacked sensuousness. It is obvious, both from Friedrich's statements and from the works themselves, that he cultivated this apparent poverty to give an impression of ascetic spirituality, to convince one that his paintings are pure idea, pure emotion.) The poet Clemens Brentano's criticism of *The Monk by the Seashore* helps us to comprehend the re-

action to this voluntary awkwardness: "If I had really wished to place a monk in my landscape, I would have shown him lying asleep or on his knees in prayer or in meditation, so as not to obstruct the view of the spectator." In other words, he would have integrated him into the landscape. Friedrich, on the contrary, stood him perpendicular to the earth in full view, straight up like a capital I, overlooking earth and sea, at the highest point of a dune, without any attempt to blend his forms with those of Nature. This figure has nothing in common with the mannequins one finds in landscapes from Claude Lorrain to Joseph Vernet. As tiny as he is, the monk, isolated and prominent, confronts the universe, and we confront it with him.

The manner in which Friedrich isolates each motif reminds one curiously of emblem books. He adhered to a tradition of using images in which the objects were detached, set in relief, shown clearly, juxtaposed didactically. Friedrich was undoubtedly influenced by popular books, by almanacks (for which a witty eighteenth-century illustrator like Chodowiecki produced so many prints), by illustrated fables, by a whole body of what might be called folklore, which certainly attracted him by its deep national roots. This is where one finds that particular visual rhetoric—announcing that the object signifies something beyond its simple appearance by contrasting it with what surrounds it—that almost hieroglyphic articulation of motifs, and finally that often aggressive compositional symmetry which leaves no doubt about the seriousness of intention.

The cross, the anchor, the rock, all these isolated signs, deprived of all picturesque encumbrance, of inventions—the "blades of grass" which are the usual connective tissue of landscape—speak, indeed, perhaps too clear a language in *The Cross on the Baltic Sea*. It is difficult to see in them simply a cross and an anchor rather than faith and hope. Those of Friedrich's pictures that "force one to dream" (in the words of David d'Angers) exhibit a disturbance of that neat order, a work in depth that converts the picture into more than the transcription of a concept.

In *The Ages of Man* the sumptuous harmony of the sunset, the silhouettes, the large figure with its fantastic contour, create an

Caspar David Friedrich, The Ages of Man. *This late work was painted around 1835.*

immediate atmosphere of strangeness. The five figures are not simply a traditional allegory of the ages of man. We are in the presence of a complex psychological interplay. What we have is a family with its emotional ties and tensions. The two children are obviously the center of interest; the man seems to draw the old man's attention to them—and ours, of course, to remind us that the child is the creative force, and that genuine naïveté is the most highly appreciated quality of Romanticism. On the sea are five ships: we immediately sense the relationship between the human figures and the ships, not only because the numbers correspond, but also because they cut similar silhouettes against the sea and sky. The traditional significance of the ship as a symbol of human destiny is emphasized and reinforced.

The analogy between the figures and the ships is so obvious that it demands to be followed up—but here things become more complicated and the allegorical discourse is disrupted. The old man evidently corresponds to the largest ship; the size and the resemblance of the shapes proclaim it; both have a character at once heroic and fantastic. However, while the old man is the farthest to the left and nearest to us in space, the large ship is in the center, so that the parallelism between figures and ships is not exact. On the other hand, there is a legible contrast between the two small boats each with two sails nearer to the coast, and the big sailing ships farther away. Must one relate the two smaller vessels to the children? It is tempting to do so. If we now consider the grouping of the figures, the impressive old man is set well apart from, almost opposed to, the group of four figures. Within this group not only are the adults distinguished from the children, but the women at the right are opposed to the men at the left; the parallelism of the silhouettes insists on the relation between the woman and the little girl. Thus one can place the two boats that are nearer the bank, more domestic, in relation to the feminine figures, while the large seafaring vessels can be thought of as the men. The complexity of the visual counterpoint introduces symbolic ambiguities, enriches the web of significance, and helps save the work from the schematicism that sometimes threatens Friedrich.

If Friedrich turned his back on a great part of the tradition of painting, if he imprisoned himself in an over-refined poverty, which he invested with a patriotic value, if he sometimes composed in an emblematic manner in contrast with the powerfully synthetic method of the other great landscape painters, he nevertheless did not neglect certain expressive values that lend his pictures substance and life. He was a master of light, of the evocative arabesque, of expression by color, and, above all, of the correspondence of forms—what is called visual metaphor, a sort of counterpoint that weaves a network of relations among the depicted objects and suggests the multiple readings of the representation.

The most important among the procedures that helped Friedrich to avoid an ostentatious simplicity and bareness, an overarti-

culated and allegorical language, is his naturalism, an exactness of representation that links him to the rest of European art. It is true that, in his aphorisms, he insisted on the importance of the interior, spiritual vision. The working out of the picture is, indeed, inward: an articulation of already prepared motifs, a mental composition, an expression of feeling. It is characteristic that Friedrich most often completed his conception in his head and then drew directly on the canvas. However, an aphorism counterbalances this: "Observe the form with precision, the smallest as well as the largest, and don't make a distinction between the small and the large but between the important and the petty." And, indeed, Friedrich's drawings show an assiduous study of Nature in its minutest details. He could count on his intimate knowledge of appearance and on an almost scientific understanding of natural effects; at the moment of painting he would then consult his stock of drawings and use entire motifs literally unchanged, preserving the freshness and emotion of direct observation.

One is reminded of a sentence by Constable: "For me, painting is only another word for feeling." If Constable and Friedrich may seem to be antipodal, they nevertheless shared a deep-rooted conviction, the fundamental postulate that sentiment and natural appearance are necessarily coherent. "Feeling can never be contrary to nature, it is always consistent with nature." This time it is Friedrich who speaks, but one might easily think that it is Constable, for whom the creative act was the very act of perception.

3

There are some works by Friedrich in which a verbal message or a private reference is implied. A pair of pictures may be mentioned here. In one, a man on crutches stands in a winter landscape with dead oaks and tree stumps; in the companion piece, the man has thrown away his crutches, the oaks are replaced by evergreens, and the shape of a visionary church in the distance clearly resembles an evergreen tree. The allegory is all too painfully

clear. But there are not many of Friedrich's pictures, and none at all after 1815, in which the symbolism operates so crassly, and there is no justification for trying to reduce the greater works to this level.

A criticism of art that claims to break a private code and to provide a dictionary of the meanings of the encoded elements embodies two misconceptions about art and language which are generally benign and sometimes even useful, but which are particularly harmful when dealing with the early nineteenth century. The first is that art is in all respects a language. The analogies of art and language are many and suggestive, they are indispensable to any serious view, but art lacks exactly that characteristic of language which enables one to compile a dictionary: translatability, or the possibility of substituting one sign or set of signs for another.

Translation in the arts creates an immediate sense of discomfort, a decided uneasiness. We are not sure what proper translation would be. Does an engraved illustration of a poem translate even part of it? Can one be substituted for the other, as we can substitute a definition for a word or a French expression for an English one, and still keep approximately the same meaning? Can Schumann be translated into Mozart? Can a picture by da Vinci be translated into one by Rubens (to take the famous example of Rubens's transformation of da Vinci's Anghieri cartoon)? Is one a proper substitute for the other?

The last question moves toward nonsense, as if it were not already clear that the place of substitution in art is indeed very dubious. But the possibility of substituting one set of signs for another is necessary to the functioning of language and fundamental to the concept of a dictionary. The idea of compiling a glossary of meanings for art seems to challenge that essential aspect of art which insists on the uniqueness of each use of a symbol.

The second misconception is about language: the conviction that meanings can be isolated outside of any situation or context. A dictionary is only a convenient fiction. "What royal decree," wrote Lichtenberg, "ordained that a word must have a fixed meaning?" Meanings fluctuate, although not absurdly or unpre-

dictably: they redefine themselves in new situations. The dynamics of this fluctuation may be studied and controlled, but we cannot maintain that a sign or word is always used with only one dictionary sense at a time. All the more reason to see that the signs in Friedrich cannot be given single, simple meanings in isolation: they take their meaning from a great variety of forces, few of them as direct and as easily definable as we might like to imagine.

This flexibility (or instability) of meaning is as essential to language as the possibility of substituting one word for another, which helps to stabilize meaning. Each use of a word may, if we choose, be considered as unique—related to all other previous and possible uses, but individual and irreplaceable, as untranslatable as a work of art. In this sense, the *possibility* of art is always present in language. No one was more conscious of this than the poets and artists of the early nineteenth century, for whom it became dogma. Everything for them was potentially language and therefore potentially art. "Anything can be a symbol," wrote Novalis, and he added that the relation of a symbol to its meaning could always be reversed: the meaning could become the symbol, the content could become symbolic form. The freedom of the symbolizing power of the imagination implied a radically new vision of language.

Above all, as we have observed, the symbolic language they wanted for art was to be a natural one—that is, not derived from the arbitrary conventions that were handed down by tradition. If the elements of Nature—sounds, shapes, forms—had an inherent meaning, as they believed, then the traditional accretion of ascribed meanings had to be abandoned as far as possible. The painters threw overboard much of the traditional iconography, with its rich complexity and its resources of meaning. The poets ignored, tried to ignore, or affected to ignore the whole traditional baggage of rhetoric that had been handed down over the centuries.

What they tried to destroy, in fact, were those aspects of the "language" of art that could be codified, that were susceptible to lexicography. Useful dictionaries of traditional religious iconography have been published; but if a dictionary of Romantic icon-

ography could be compiled—at least for the years 1800 to 1835—it would be chiefly a measure of the artists' failure. This early-nineteenth-century philosophy of art may appear today an aesthetic of crisis, a measure of desperation when traditional forms had broken down. We may doubt that forms have a meaning independent of culture, that language is immanent in Nature. But there is no question of the achievement: Wordsworth, Hölderlin, Constable, and Friedrich contrived to let the elements of Nature appear to speak directly and without intermediary; Schumann and Berlioz caused elements of abstract musical form to bear meanings that are analogous to verbal meanings if rarely coincidental with them.

All these artists were aware that they were radically changing the theory as well as the practice of their art. Each one expanded the limits of his art, triumphed over his medium by playing the conceptions of art and language against each other. For this reason, when dealing with their achievement, we must be doubly conscious of the limitations of both art and language: it was with these limitations that they worked. They counted on our sense of their art's going beyond what was possible, only to find it once more reintegrated in a purely pictorial or musical form. The interpretation of each work can never be imposed from without, even by means of a generalization about the artist's total style; it must begin again each time from within.

III

THE ROMANTIC VIGNETTE

AND

THOMAS BEWICK

1

Does each art have its proper sphere, some aspect of reality that it may reflect or imitate that is closed to the other arts? The eighteenth century thought so and attempted to define the nature and the limits of each of the arts, and to fix the opposition between art and reality that seemed indispensable to the autonomous existence of art in general.

In the first decades of the nineteenth century, the writers and painters—followed shortly by the musicians—broke through these limits. "Does not pure instrumental music appear to create its own text?" wrote Friedrich Schlegel in 1798, thinking of the extraordinary development of symphonic music in the late eighteenth century. The ability of music to create meaning and significance out of its own elements, independent of any attempt to mirror the world outside, became the model for the other arts.

In his novel *Franz Sternbald's Travels*, Ludwig Tieck predicted an abstract art of pure colors, with neither subject matter nor represented form. Novalis proposed tales and poems "without sense and without continuity . . . made up of associations like dreams . . . acting indirectly like music." Philipp Otto Runge wrote that "music must exist in a poem through the words, as music must also be present in a beautiful picture or building or in any ideas whatsoever which are expressed through lines." When Schiller spoke of the musical effect of poetry, he meant not the sound but the order and arrangement of the images and the modulation of the whole poem. A generation later, Schumann and Berlioz were to integrate specifically literary techniques into their music.

Not only the barriers between the arts but the autonomy of art itself was destroyed. This breakdown of the distinction between art and reality began playfully when, in one of Tieck's plays, the audience climbs onto the stage where the actors complain about

73

their parts.* Novalis, protesting the Romantic justification of Shakespeare as a pure artist, is more in earnest: "Art belongs to Nature and is, so to speak, self-reflecting, self-imitating, self-shaping Nature. [Shakespeare's works] are emblematic, ambiguous, simple, and inexhaustible, and nothing could be more nonsensical than to call them works of art in the limited mechanical sense of that word." In forms as different as Wordsworth's *Prelude* and Berlioz's *Symphonie Fantastique,* the work of art presents itself as autobiography, as fact, as part of Nature. Byron, with an international reputation as a Don Juan, wrote a poem called *Don Juan,* an open-ended work to which he continued to add as long as he lived. The characters in Brentano's novel *Godwi* speak about "the author of *Godwi"* and, at the end of the book, describe his death and write poems about him.

<div align="center">2</div>

The integration of the arts found its most natural expression and its greatest success in book illustration, the domain where literature and the visual arts interact without constraint and without pretension. The incorporation of images into a text, either to clarify the meaning or to make the book more attractive, goes back as far as antiquity. For the early nineteenth century, however, it was medieval manuscripts that represented the most successful association of text and image. "Vignette," the name given to the basic form of Romantic book illustration, was a term originally used to describe the little "vines" or tendrils, the ornamental flourishes, that crawl along the margins of Gothic codices. The freedom and fantasy, the complete integration of the visual and the verbal, which was supposed by the Romantics to be characteristic of me-

* There are Elizabethan precedents for these effects, but Tieck goes far beyond the works of Beaumont and Fletcher and Shakespeare that influenced him.

dieval bookmaking, became their ideal. This integration was re-
captured by the Romantic artists.

During the eighteenth century the embellishment of books of
quality was clearly divided into illustrations and ornaments. The il-
lustrations were usually copper engravings that looked like repro-
ductions of paintings. They were commonly separated from the
text by a framing line and by the plate mark; most often (and most
important), they were printed on separate pages. In addition to
these illustrations, there were ornaments, headpieces and tail-
pieces, often of an irregular shape and usually cut on woodblocks;
since they did not illustrate the text, they could be used again and
again in many different books. The seventeenth and eighteenth
centuries produced lavish books with beautiful copperplates; but
precisely because of their great elaboration, these pictures were
not well integrated into the book. It is characteristic that when
Firmin Didot produced his great edition of Virgil in 1798 with il-
lustrations by Girodet and Gérard, David's famous followers, he
printed 100 sets of the plates without the text, in addition to 250
copies of the book. But the vignettes of a Romantic book, like the
1838 edition of Bernardin de St. Pierre's *Paul et Virginie*, pub-
lished by Curmer, make no sense separate from the letterpress.

Romantic illustration, which was largely associated with the
new technique of wood engraving (we shall see later how this dif-
fers from woodcut), reached its height in the 1830s and 1840s. It
was only then that the implications of the new feeling for the unity
of text and illustration were fully realized. Before that, the experi-
ence of lithography had greatly enriched the graphic arts, but li-
thography, invented in 1799 and firmly established as an artistic
medium after 1816, did not lend itself readily to the illustration of
books. Lithographs must be printed on a different press from that
used for type, and furthermore, their rich velvety blacks and deli-
cate shades of gray do not go particularly well with pages of type,
making for a disparate effect. The 1828 edition of *Faust* with lith-
ographs by Delacroix is not a beautiful book, even though the il-
lustrations are superb—not only are the plates in this work
isolated on separate pages, but the design of the book is insensi-

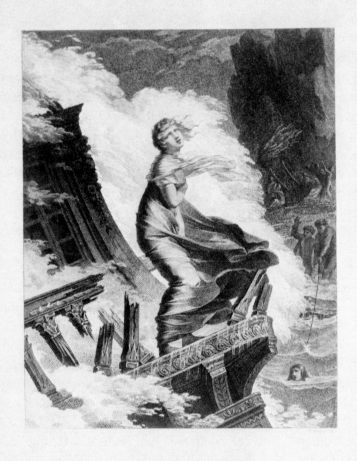

The Shipwreck, *engraved by B. Roger after a design by Pierre-Paul Prud'hon. An illustration for an edition of Bernardin de Saint Pierre's* Paul et Virginie *published in 1806. While the mood evoked by Prud'hon can already be called Romantic, the mode of presentation of the book, with clean copper engravings strictly separated from the text and elegant but severe typography, is still Neoclassical.*

entre l'île d'Ambre et la côte, et s'avança en ru-
gissant vers le vaisseau, qu'elle menaçait de ses
flancs noirs et de ses sommets écumants. A cette
terrible vue, le matelot s'élança seul à la mer ; et
Virginie, voyant la mort inévitable, posa une
main sur ses habits, l'autre sur son cœur, et, le-
vant en haut des yeux sereins, parut un ange qui
prend son vol vers les cieux.

...jour affreux ! hélas ! tout fut en-
glouti. La lame jeta bien avant
dans les terres une partie des spec-
tateurs, qu'un mouvement d'hu-
manité avait portés à s'avancer vers Virginie, ainsi
que le matelot qui l'avait voulu sauver à la nage
Cet homme, échappé à une mort presque certaine,
s'agenouilla sur le sable, en disant : « O mon Dieu !
vous m'avez sauvé la vie ; mais je l'aurais don-
née de bon cœur pour cette digne demoiselle
qui n'a jamais voulu se déshabiller comme moi. »
Domingue et moi, nous retirâmes de flots le mal-
heureux Paul sans connaissance rendant le sang
par la bouche et par les oreilles Le gouverneur
le fit mettre entre les mains des chirurgiens, et

The Shipwreck, illustrations designed by Tony Johannot and engraved on wood for an edition of Paul et Virginie published in 1838, one of the most opulent Romantic books. Illustration is now completely integrated with the text. The book, an octavo, was smaller than the 1806 edition, and a larger printing made it available to a wider audience.

tive to any kind of visual unity. There were, nevertheless, a few important and successful undertakings of lithographs in books, principally the great *Voyages pittoresques et romantiques dans l'ancienne France,* by Baron Isidore Taylor and Charles Nodier, a huge series of folios the first of which was published in 1821.

A lithograph is drawn on the surface of the stone, leaving no visible plate mark like that of a copper engraving, and the medium encourages subtle nuances of tone. Artists soon exploited these

Eugène Delacroix, Mephistopheles Hovering over the City. *This lithograph is the frontispiece of an 1828 French edition of Goethe's* Faust *illustrated by Delacroix. (The text was a mediocre translation by Albert Stapfer; a much better one by Gérard de Nerval appeared in the same year.) Delacroix's lithographs are an extreme Romantic statement. The book was not a success.*

aspects of lithography to create images that vanish at the edges
instead of having a definite contour: this is one of the essential
characteristics of the Romantic vignette. The effect was enhanced
by the omission of any suggestion of a frame, even that of a simple
line. Around 1820 lithographers perfected a system of centrifugal
composition, in which the most intense contrasts of light and
shade and the greatest descriptive precision are reserved for the
middle and weaken toward the edges until the image seems to fade
away.

Inspired by the initial experimental years of lithography, the
technique of wood-engraved Romantic illustration came to full
maturity in France in the 1830s. The 1835 edition of Lesage's *Gil
Blas,* illustrated by Jean-François Gigoux, is usually considered
the crucial work, and it is indeed a remarkable book for the un-
precedented profusion of its vignettes. Just as important, how-
ever, was the *Histoire du roi de Bohême et de ses sept châteaux* of
1830 by Charles Nodier, illustrated by Tony Johannot, where Ro-
mantic integration of words and images is already accomplished.
Traditionally, book ornaments had appeared at the beginning and
end of chapters; in the *Roi de Bohême* the vignettes come at un-
predictable places, often in the middle of a page of text. Further-
more, the picturesque variations of typography, with titles in
gothic, sometimes of rather fantastic fonts, increase the integra-
tion of the vignette in the book by giving a greater visual anima-
tion to the printed text itself.

Such experiments were not confined to France, nor was the
technique of wood engraving essential to their success. We find
a glorious English demonstration of this in the illustrations
by Turner for *Italy,* a collection of poems by Samuel Rogers
published in 1830; here intaglio engravings have been used,
but the copperplates were larger than the pages of the book, so
that the plate mark is invisible; this makes it possible for the
irregularly shaped images to fade into the page, just like the
ones engraved on wood. Illustration and text also appear on the
same page, and there is an exquisite sense of balance between
the two.

It was, however, around 1840 in France, where wood engrav-

Jean Ignace Isidore Gérard, called Grandville, The Steam-powered Concert. *An illustration from* Un Autre monde (*1844*). *Grandville's greatest work is a fantasy world that satirizes things as they are. Romantic ideas are evoked in fun. Here the steam orchestra, symbol of modern progress, is playing "The Ego and the Non-Ego, Symphony in C Major," a clear reference to German idealism.*

ing reigned supreme, that the production of illustrated books was most sustained and effective. Of a series of masterpieces published then, only a few can be mentioned. The *Paul et Virginie* published by Curmer in 1838 is usually and not unjustly considered the ultimate Romantic book. The main illustrator was Tony Johannot, but we also find such major artists as the landscape painters Paul Huet and Eugène Isabey, as well as the young Ernest Meissonier, who drew all the illustrations for "La Chaumière Indienne" at the end of the volume and was a famous book illustra-

tor before he became the most expensive painter per square inch of his time. *Les Français peints par eux-mêmes* is an immense, encyclopedic enterprise in nine volumes, produced from 1840 to 1842—a socio-picturesque description of France, where text and image blend in the very conception of the work, where each social type, each profession, is precisely and humorously described. A variety of authors, including Balzac, and most of the well-known illustrators of the time were enlisted for this great book. Among the artists, Paul Gavarni contributed the most, while Daumier had the lion's share of the last volume, *Le Prisme,* a premium distributed to subscribers at the end. *Les Français* is not only a beautiful book but also an important witness to the realistic element within Romanticism and hence to the continuity between the Romantic movement and Realism. On the other hand, *Un Autre Monde* (1844), by Grandville, a masterpiece of whim and wit, is a most striking example of the fantastic, created during the years when the Realist movement was taking shape.

If this new type of book illustration was so apt and definitive an expression of Romanticism, it was not only because the close association of text and image satisfied the desire to unite different forms of art. The vignette, by its general appearance, presents itself both as a global metaphor for the world and as a fragment. Dense at its center, tenuous on the periphery, it seems to disappear into the page: this makes it a naïve but powerful metaphor of the infinite, a symbol of the universe; at the same time, the vignette is fragmentary, sometimes even minute in scale, incomplete, mostly dependent upon the text for its meaning, with irregular and ill-defined edges, not unlike Schlegel's hedgehog. It is the perfect Romantic formula.

Apparently unassuming as an artistic form, the vignette launches a powerful attack on the classical definition of representation, a window on the world. The vignette is not a window because it has no limit, no frame. The image, defined from its center rather than its edges, emerges from the paper as an apparition or a fantasy. The uncertainty of contour often makes it impossible to distinguish the edge of the vignette from the paper: the whiteness of the paper, which represents the play of light within the image,

année qu'un seul tableau, un petit couteau et un simple ognon coupé
sur une table.

« En sculpture, nous mentionnerons *le Doigt de Dieu*, œuvre
gigantesque dont l'originalité dépasse les plus belles conceptions de
l'antiquité et de la renaissance. L'auteur de ce morceau colossal y
travaillait depuis vingt ans ; il l'a achevé ce matin même dans la
salle de l'exposition, en vertu d'une permission spéciale : faveur
inouïe, dans laquelle le doigt de Dieu se fait bien voir. »

Voilà pour la critique impartiale.

Hahblle se croyait encore sur la terre ; il s'aperçut de
son erreur lorsqu'il mit le pied dans un salon dont l'entrée

Grandville, The Finger of God, a colossal work. *In another illustration
from* Un Autre monde, *the Romantic fragment is caricatured. A robot
is sculpting a colossal thumb. As is often the case, what first appears as
a joke or caricature is later taken up in earnest; about half a century
later Rodin sculpted a* Hand of God, *and the fragmentary representation
of the human body became a major theme of modern sculpture.*

UNE
RÉVOLUTION VÉGÉTALE.

Aux armes Coquebœuf.
Nouvelle Marseillaise.

X. — Où l'on envisage les plantes sous le point de vue révolutionnaire
et potager.

Puff à Krackq.

« Ton sublime manuscrit m'est parvenu sans avarie, et
ta bouteille sans fêlure. Tu trouveras ci-joint le mémoire que
j'ai adressé à l'Académie sur tes découvertes, ainsi que le
récit exact de ce qui m'est arrivé depuis ton plongeon. Je
t'engage à lire attentivement ma dissertation sur les races
sous-marines, où je développe tes opinions sur l'existence
d'une race particulière qui a connu les traditions de l'anti-
quité, ou plutôt qui leur a donné naissance. Les Tritons, les
Néréides sont des échantillons d'espèces existantes et qui
ne sont que momentanément perdues; la constatation de
ce fait nous fera le plus grand honneur sous le rapport de
la science.

« J'achève en ce moment la liquidation de ma maison de
Déguisements Physiologiques, elle s'annonce sous les aus-

A page of Grandville's Un Autre monde. *The great variety of typefaces
in Romantic printing is shown here, with seven different fonts used,
including one with a strange three-dimensional effect.*

changes imperceptibly into the paper of the book, and realizes, in small, the Romantic blurring of art and reality.

The Romantic vignette was invented in the late eighteenth century by Thomas Bewick.

3

Indisputably, Bewick holds an important place in the history of book illustration. The literature about him is extensive, and his uneventful life is well documented, thanks largely to Bewick himself, who in old age took the precaution of writing an account of it. We also have his correspondence and other documents, the best known of which is a literary portrait by James Audubon, the author of *Birds of America,* who traveled to Newcastle to meet the author of *A History of British Birds.* But for reasons we shall try to explain, Bewick's accomplishment as an artist has been badly neglected.

There have been, however, powerful voices to proclaim it. In a lecture on the artist, John Ruskin boldly claimed, "I know no drawing so subtle as Bewick's since the fifteenth century, except Holbein's and Turner's." Wordsworth was still more eloquent:

> Oh, now that the boxwood and the graver were mine,
> Of the poet who lives on the banks of the Tyne,
> Who has plied his rude tools with more fortunate toil
> Than Reynolds e'er brought to his canvas and oil.*

Bewick was born in 1753 to a family of farmers and, at thirteen, was apprenticed to the engraver Ralph Beilby in Newcastle. The Beilbys were a well-known family of distinguished craftsmen,

* These are the opening lines of "The Two Thieves" in the manuscript of 1798. The version published in the 1805 edition of the *Lyrical Ballads*, "O now that the genius of Bewick were mine," is not only inferior but also tamer, in that Wordsworth avoids the reference to Reynolds. Of course, what Wordsworth meant was not that the genius of Bewick was superior to his own, but that a pictorial expression was more appropriate to his subject than words.

and Beilby glass is still avidly collected. Beilby's workshop did every sort of engraving: coats of arms on silver, engraving on glass, letterheads, and so forth. "I think," Bewick wrote, "he was the best master in the World, for learning boys, for he obliged them to put their hands to every variety of work." The Beilbys evidently considered themselves socially above the son of a farmer and tenant collier, as Bewick made clear when writing of his "attachment" to their daughter: "I felt for her & pined & fretted at so many barrs being in the way against any union of this kind— one of the greatest was the supposed contempt, in which I was held by the rest of the family, who I thought treated me with great hauteur, 'tho I had done every thing in my power to oblige them—I had like a stable boy waited upon their Horse & had cheerfully done every thing they wanted at my hands—."

Bewick tells us that the passion he had from childhood for drawing and for nature determined his life. Newcastle had a prosperous trade in children's books. When commissions came in for cutting woodblocks for such books, Beilby entrusted them to the young apprentice. "Some of the Fables cuts were thought of so well by my Master, that he in my name sent impressions of a few of them to be laid before the Society for the encouragement of Arts &c and I obtained a premium." At the end of his apprenticeship, he took a walking tour in Scotland, and then visited London for nine months. He did not like the "extreme Grandeur & extreme wretchedness" of the city and went back to Newcastle, where his former master took him on as partner. Bewick pursued his specialty as designer and engraver of book illustrations, although he certainly engaged in the other work of the firm.

In 1790 he completed his first major work, the *General History of Quadrupeds,* for which Beilby had written the text. This didactic volume of popular zoology was intended principally for young people, but it had an immediate and enormous success with a public far beyond that of children's books. Bewick worked briefly for William Bulmer of London, who was a printer and publisher of fine books—a business very different from the popular editions of Newcastle—but this venture into the higher sphere of bookmaking did not last.

In 1797 Bewick and Beilby published the first volume of the masterpiece *A History of British Birds*. Their association was soon after dissolved, owing largely, it would seem, to Bewick's obstinate and rather puzzling refusal to acknowledge Beilby's participation in compiling the text of *British Birds*. (Was this perhaps a way of getting even for "the proud man's contumely"?) Both text and illustrations of the second volume, on *Water Birds*, which appeared in 1804, are entirely Bewick's work.

The ambitious *Fables of Aesop* appeared in 1818. Although disappointing in its general appearance (it "was not so well printed," Bewick writes, "as I expected and wished"), this work contains some of his greatest vignettes. By this time Bewick was a famous man, but he remained in Newcastle for the rest of his life, except for two trips: one to Edinburgh in 1823, and another, in 1828, to London—fifty-two years after his first visit. He liked the city no better the second time. He died in Newcastle the same year.

Bewick has always been thought of as the perfecter of the new technique of wood engraving. In the traditional woodcut, as practiced for instance by Dürer, the board used by the engraver is a normal plank, usually from a fruit tree, with the grain of the wood running horizontal to the surface; the artist works with a little knife. Wood engraving is done on harder wood, the heart of boxwood, and this is cut so that the grain is perpendicular to the surface—whence the name "end wood"; the engraver works with a burin. Like a woodcut, the woodblock is printed from the surface, but it allows very fine work and, if printed carefully, will yield a vast number of impressions without significant loss of detail.

This technical development produced a revolution in the practice of book illustration. Most of the great books by the Romantics depend on it, and perhaps even more important, it made possible the publication of popular illustrated magazines such as the *Illustrated London News*. The new technique transformed visual information and thus helped to open what might be called the age of mass media.

While Bewick has long been considered the inventor of wood engraving, he himself made no such claim, and Jacob Kainen has

to have one of his eyes put out, knowing that of consequence his companion would be deprived of both.

This Fable is levelled at two of the most odious passions which degrade the mind of man. In the extremes of their unsocial views, envy places its happiness in the misery and the misfortunes of others, and pines and sickens at their joy; and avarice, unblest amidst its stores, is never satisfied unless it can get all to itself, although its insatiable cravings are at once unaccountable, miserable, and absurd.

Thomas Bewick, Dog Baying at the Moon. *The blank space between the two represents empty air, as a kind of visual pun.*

shown that, in fact, wood engraving was well established in England in the eighteenth century.* Further, it is clear from the *Memoir* that Bewick had no practical familiarity with the traditional woodcut. In discussing the work of Dürer, he is plainly trying to figure out how it was done, and he refers to "plank wood" as a curiosity. In his "Note on Bewick's Engraving," Iain Bain attaches much importance to Dr. Charles Hutton, a Newcastle mathematician who claimed to have introduced Bewick and Beilby to the technique of burin engraving on end wood.† It is hard to see what major role Hutton, who was not an engraver, could have played, beyond importing the necessary materials from London. In any case, the rudimentary technique of wood engraving was not the issue, but what Bewick did with it.

When Bewick was first introduced to wood engraving, it seems to have been a well-established practice, but it was used crudely for cheap illustrations; more expensive books used copper engraving. Bewick's technical innovation consisted in making the work on the blocks much finer and, more important, in obtaining clear impressions of this fine work.

Bewick's achievement, however, goes far beyond these matters of technique; he completely altered the way books were illustrated. The copper engravings previously used for the illustrations had to be printed on a roller press very different from that used for typography. This required considerable labor and was very costly. By perfecting wood engraving, which could be printed with the text, Bewick made his process available for sophisticated illustration. He also abolished the distinction between illustration and ornament. His tailpieces are not simply ornamental: they are little scenes or landscapes. Moreover, in the *Quadrupeds* and *British Birds,* the major illustrations of birds and animals are not on separate pages but appear at the top of a page of text, like a headpiece, and are not enclosed by a frame. Like the tailpiece, the main

* "Why Bewick Succeeded," Bulletin 218, *Contributions from the Museum of History and Technology* (Washington, D.C.: Smithsonian Institution, 1959).

† *A Memoir of Thomas Bewick: Written by Himself,* ed. Iain Bain (1976).

image can now develop according to its inner rhythm, and it van-
ishes into the white paper so that we cannot assign it a precise
limit. Bewick discarded the clearly limited pictorial field with such
natural ease that we are hardly conscious of his having done so.
This was nevertheless a revolutionary change. The immediate aim
was to create a more intimate association between images and ty-
pography, printing them together again, and to increase the
graphic unity of the book.

Bewick's invention of the Romantic vignette is at the frontier
between technique and artistic form.* But Bewick, as Wordsworth
said, was a poet. His great evocative power depended partly on the
strategy by which he increased the expressive power of the orna-
mental tailpieces, turning them into finely observed little scenes or
landscapes, without relating them directly to the text. The effect
was described in 1847 by Charlotte Brontë at the beginning of
Jane Eyre:

> I returned to my book—Bewick's *History of British Birds.* . . .
> The words in these introductory pages connected themselves with
> the succeeding vignettes, and gave significance to the rock stand-
> ing up alone in a sea of billow and spray; to the broken boat
> stranded on a desolate coast; to the cold and ghastly moon glanc-
> ing through the bars of cloud at a wreck just sinking.
>
> I cannot tell what sentiment haunted the quite solitary church-
> yard with its inscribed headstone; its gate, its two trees, its low
> horizon, girdled by a broken wall, and its newly-risen crescent, at-
> testing the hour of eventide.
>
> The two ships becalmed on a torpid sea, I believed to be marine
> phantoms.
>
> The fiend pinning down the thief's pack behind him, I passed
> over quickly: it was an object of terror.
>
> So was the black, horned thing seated aloof on a rock, surveying
> a distant crowd surrounding a gallows.

* As is normally the case with such brilliant innovations, there were prec-
edents. The most remarkable appeared in eighteenth-century Venice—char-
acteristically in a place where the Baroque was most tenacious. Bewick's
innovation must have been made possible in part by a lingering provincial
survival of Baroque or Rococo design.

that name was only propagated by the feed which
paffed the digeftive organs of this bird, whence
arofe the proverb " *Turdus malum fibi cacat ;*" it
likewife feeds on caterpillars and various kinds of
infects, with which it alfo feeds its young.

This bird is found in various parts of Europe,
and is faid to be migratory in fome places, but con-
tinues in England the whole year, and frequently
has two broods.

Thomas Bewick, Two Horses in the Rain. *Bewick creates in miniature
the blurred view of objects seen through rain and even a shivering
sense of cold and wetness.*

Each picture told a story; mysterious often to my undeveloped understanding and imperfect feelings; yet ever profoundly interesting.

Although there is no explicit connection between the endpieces and the text, we feel a hidden one. An intimate feeling for nature unites Bewick's familiar scenes, his glimpses of life, his visions, with the accompanying descriptions.

Bewick is not at his most original and profound in those pieces that attracted Jane Eyre and made her dream of moonlit cemeteries and Gothic ruins, stock images from the pre-Romantic warehouse. Rather, he is most astonishing in the exact picture he gives of rural life, which is also vividly described in the *Memoir*— the sense that he conveys of the effects of weather, of the succeeding seasons, of country people, who move at ease in their natural setting and seldom strike us as being posed. Winter here is not the picturesque and scenic winter that one may find in Boucher or in Bewick's contemporary Fragonard, but a truly cold day with the poor struggling against the cold. A vignette of two horses, immobile and resigned in the rain, is one of the most moving images of Romantic art, at once extremely real and as haunting as an apparition. One must look to Géricault for anything comparable.*

Nevertheless, to compare Bewick with Géricault—or with Reynolds and Turner—makes the art historian uneasy. Somehow the comparison seems scandalous. The theory of genres and of their hierarchy is so ingrained in our thinking about art that it still determines our attitudes. In the abundant literature on Bewick, there are monographs only by collectors, bibliographers, technicians, biographers. (Sydney Roscoe has devoted a sizable volume, and a very good one, solely to the bibliography of Bewick's three major works.) Bewick is discussed in treatises and histories of

* We are thinking in particular of Géricault's *Flemish Horses* in the Museum at Dijon. While there is also a vignette lithograph of the same subject by Géricault, the moody atmosphere of the painting is closer in feeling to Bewick's work.

book illustration and is dealt with briefly in books on prints, but he is absent from the history of art.

Clearly this neglect has to do with Bewick's position as an assertively provincial craftsman on the fringes of the world of art. In the *Memoir,* he says he is proud of being an autodidact, without formal artistic training. "I never was a pupil to any drawing master and had not even a lesson from Wm Beilby or his brother Thomas." Yet Bewick talks about art, gives advice freely, and shows no particular modesty in his judgment.

Toward the end of his life, during his visit to Edinburgh in 1823, he was persuaded to make a lithograph. He chose to represent "a Horse in the long or full trot,"* as the result of a discussion with a painter named Stowe about the correct representation of a horse's motion, a subject of considerable artistic debate in the nineteenth century that was only settled by Eadweard Muybridge's photographic investigation. (Degas and Thomas Eakins were still interested in it.) Without putting himself in the same category as "the very ingenious painter" Stowe, Bewick did not shrink from the debate: "This led to a close conversation, or rather lecture on the subject, in which I convinced him thoroughly of his being quite wrong, and indeed of the absurdity of his drawings, in this respect."

While socially he remained in his sphere of craftsmanship, Bewick felt that his understanding of Nature and his ability to represent it made him an artist in the fullest sense of the word. There is little doubt, however, that the passionate admiration of certain writers—Wordsworth in particular—reflects not only their regard for his work but also their sense of the disparity between his accomplishment and his artistic culture; his status was not that of an artist but of an inspired artisan, an artistic *bon sauvage.* The *bon sauvage* is a disturbing figure because one can never be sure to what extent he realizes the subversive implications of his "naïve" intelligence.

* The incident is narrated in a letter of Bewick to John Dovaston. See *Bewick to Dovaston, Letters 1824–1828,* ed. Gordon Williams (1968), p. 31.

4

The success of the vignette form was not confined to the domain of the printed book. The Romantic artist was largely eclectic and used old forms, which he altered according to his needs, often simply giving a new meaning to an old vehicle, as with Friedrich's transmutation of a landscape into an altarpiece. The vignette is perhaps the only completely new formal invention in the visual arts of the time, one completely appropriate to Romanticism: this explains its vast diffusion beyond the limits of illustration.

We have already mentioned the role that lithography played in developing the ideas implicit in Bewick's invention and in paving the way for full-fledged Romantic illustration. However, lithography is an important mode of expression in itself. It, too, was a completely new invention, and an attractive one. Because the technical aspects could be entrusted to a professional printer, it presented no obstacle to the artist's freedom and control, as etching or engraving does. He could draw on the stone more or less the way he would on paper. The stone could be printed in sizable editions of about a thousand impressions without serious loss of quality, and the price could be set rather low. Lithography became genuinely popular. For example, Nicolas Charlet's, and later Auguste Raffet's, nostalgic and increasingly sentimental images of the Napoleonic epic had an immense audience: these lithographs, many of them grouped in albums, are the visual equivalent of the *Chansons* of Pierre Jean de Béranger, the populist middlebrow poet of the Restoration years whose poems, almost unreadable today, were embellished by every major illustrator of the period, including Delacroix.

All French artists of the time tried lithography, attracted by its ease and popularity. Lithographs formed an important part of Géricault's output, and they were among the few works of his to reach the public during his lifetime. His most famous lithographs are those he executed before his English trip of 1820: *The Boxers* and military subjects, like *The Return from Russia.* All these are regular, rectangular pictures, clearly framed by a limit. While in

Théodore Géricault, Horses of Savoy. *This lithograph was part of an album of twelve studies representing various horses. Each is not only scrupulously depicted, but also placed in a setting that evokes the mood of its original habitat, here the mountains of Savoy.*

England, however, he became interested in the vignette and drew a number of subjects using this new formula. On his return to France, he published many vignette lithographs, such as the set called *Studies of Horses, from Nature,* in which he explored the tonal possibilities of the technique with amazing virtuosity. These sheets may lack some of the power of the early ones, but they have a finesse and subtlety that are largely underrated today.

Following Géricault's lead, Delacroix was immediately at home with the vignette formula, and he produced brilliant examples, among them *The Wild Horse,* of 1828. His portrait of Baron Schwitters of 1826 adapted the vignette form to a type of Romantic lithographic portrait that had an immense success; it became a speciality of Achille Devéria in particular, who drew all the glori-

ous figures of French Romanticism on stone, making with these images his most lasting contribution to art.

The type of strongly centered composition with an indefinite periphery characteristic of the vignette was often adopted for Romantic paintings. It was partly a return to a Baroque method of composition, but in Romanticism it tended to be more emphatically exploited, with greater opposition between the accentuated center and the relative indeterminacy of the edges. Turner's famous spiral whirlwinds are the ultimate form, but Delacroix's *Greece on the Ruins of Missolonghi* and *Medea* are also striking examples. His *Death of Sardanapalus* disturbed conservative crit-

Eugène Delacroix, The Death of Sardanapalus. *The painting was exhibited at the Salon of 1827–28 but arrived very late (mid-January 1828). Almost universally attacked by the critics, it was the most controversial of Delacroix's major paintings. The original inspiration was Byron's drama* Sardanapalus *(1821), but the painting does not illustrate Byron's text. Delacroix himself may have composed the text printed in the Salon catalogue within quotation marks.*

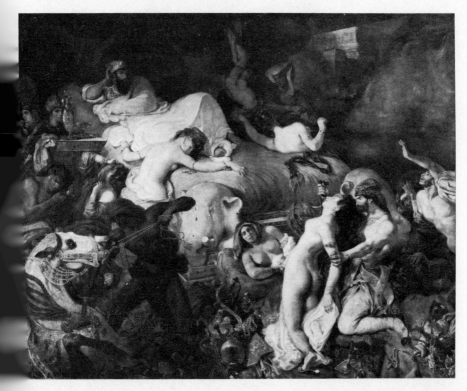

ics in 1828 partly because of the impression that everything in the picture is sliding; this peculiarity derives from the fact that, as in an enormous vignette, everything in it whirls around a center instead of being built up into the traditional pyramid. Similarly, David d'Angers, in one of his most original works, the bust of Paganini, managed to turn even a three-dimensional sculpture into a vignette, where the features of the inspired musician emerge out of a chaotic turmoil of hair. In retrospect, we can understand much of the art of the period better when we perceive the vignette that is hidden within.

Pierre Jean David d'Angers, Paganini. *A bronze exhibited at the Salon of 1834.*

IV

THE REPRODUCTIVE IMAGE

AND

PHOTOGRAPHY

1

"This idea of a faithful reproduction has attracted great artists at all times. Have I not seen Girodet apply himself to drawing a large number of his compositions on lithographic stones and follow the progress of this new technique with a lively interest? Lithography fascinated him, he said, just because it allowed him to reproduce his own work without the help of an interpreter and with his own hands. Similarly, I saw my relative Hersent [a Neoclassical painter and lithographer] at the end of his career apply himself with fervor to the newborn photography, because he saw nature reproduced by herself without the help of an interpreter."

The foregoing footnote appears unexpectedly in an 1872 monograph on the sixteenth-century painter Jean Cousin, written by Ambroise Firmin Didot, a scholar and a member of the great family of printers and publishers. It suggests many things: the importance of the new techniques of reproduction for Romantic aesthetics, the double claims of direct self-expression and the multiplication of images for popular diffusion, the equivalence of the exact transcription of natural appearance and the exact transcription of the artist's style and personality, and, finally, the way that photography developed as an integral part of the graphic arts.

Photography appeared to realize one of the Romantic dreams: the immediate transmutation of reality into art without the intervention of an interpreter, a code, or a tradition. No artistic medium was so controversial during the nineteenth century. It was an object either of wonder or of contempt—often of both at once. Many artists and critics affected to despise the new invention until, as André Jammes has remarked, they decided they wanted photographs of their mothers. In an introduction to a selection of Nadar's photographs (Paris, 1982), Jammes, one of the greatest authorities on nineteenth-century photography, quotes Baudelaire's letter to his mother of December 1865, written after the poet's famous onslaught on photography in the *Salon of 1859*. He

wrote that he wished to have her picture taken and defined what he considered a good portrait: "The face must be at least one or two inches large. Paris is almost the only place where one knows how to do what I would like, that is, an exact portrait but one that has the softness [*le flou*] of a drawing." As Jammes remarks, this evidently refers to Nadar's portraits. Nadar, who was Baudelaire's friend, himself defined the task of the portrait photographer:

> Photography is a marvelous discovery, a science that occupies the most elevated intelligences, an art that sharpens the most sagacious minds—and the application of which is within the reach of any imbecile. . . . Photographic theory can be learned in an hour; the first notions of practice, in a day.
>
> I shall tell you what cannot be learned: the feeling for light—the artistic appreciation of the effects produced by different and combined sources of light [*"les jours divers et combinés"*]—the application of one or another of these effects according to the nature of the physiognomy that you must reproduce as an artist.
>
> What can be learned even less is the moral understanding of your subject—the instant tact that puts you in communication with the model . . . and which allows you to give, not an indifferent plastic reproduction, banal and fortuitous, within the reach of the merest laboratory assistant, but the most familiar and favorable resemblance, the intimate resemblance.*

For Nadar, evidently, the portrait photograph differed from a painted or lithographic portrait only in its medium. The artistic problems were the same: the use of light to compose, to uncover physiognomic structure and create texture, the revelation of quintessential character by pose and gesture. Photography was, for Nadar, a graphic medium like any other: it had its own technique and its own methods, but it was a form of art as much as etching or painting. The ease of its use was almost irrelevant to him. He had begun as a draftsman and was known for his caricatures before he moved to photography.

Historians of art generally discuss photography in terms of painting and of the influence of one medium on the other: they try

* Quoted in the preface to André Jammes, *Nadar* (1982).

to show that photographers made photographs that looked like paintings, or that painters made paintings that looked like photographs. This, however, obscures what was happening even when it most seems to be true—as in the case of Nadar, whose photographs do, indeed, resemble paintings or, more often, lithographs. The similarity of many of Nadar's works to portraits by Ingres and, above all, by Devéria is striking—and only to be expected, as they were all working in the same genre although in different media. The portrait had its traditions, its conventions, and its code of meaning: all of these had been expanded in the nineteenth century, but the genre was a relatively stable one. Nadar, in short, was not imitating paintings but making portraits.

As for the undeniable influence of photography on painting, the significance of this has been considerably undermined by the realization that artists had been making paintings that looked like photographs for more than a half-century before the invention of photography. This insight of the late Heinrich Schwartz was developed in a valuable and stimulating exhibition organized by Peter Galassi. He explored one thesis: that the photographic vision, the informality and directness of approach that we admire in photography, had been already prepared in painting from the late eighteenth century on, particularly in painted studies or sketches of landscape.* In Galassi's view, the freedom and directness of photography, in order to be communicated, depended on certain modes of presentation, certain methods of cropping and points of view, that were already developed earlier in a particular kind of painting and taken over by photography.

We sometimes hear that the perspectives and lighting effects we associate with photography were simply the result of the technical invention of the camera in the 1830s and 1840s and made their way into painting only later, with Degas and the Impressionists. But few students of the nineteenth century will find Galassi's point either surprising or difficult to accept. These ideas have been current for many years, but no one has stated them so clearly

* Peter Galassi, *Before Photography: Painting and the Invention of Photography* (1981).

Pierre-Henri de Valenciennes, Study of the Sky at the Quirinal.
Although his completely idealized landscapes are once again appreciated after a long eclipse, Valenciennes's reputation is more firmly established today on his quick sketches, or pochades, *which have great freshness and spontaneity. These* pochades *were studied and copied by young landscape painters in the early nineteenth century, were later completely forgotten, and have been rediscovered only in our time.*

or demonstrated them with such cogency. They are illustrated by Galassi with some early photographs and with works by many painters, including famous masters such as Jean-Baptiste-Camille Corot, John Constable, Thomas Girtin, and Caspar David Friedrich. The catalogue also includes many enchanting views by lesser figures. The painted sketches of François-Marius Granet, especially striking for their boldness and sharpness of vision, are much too little known, while the views sketched in and around Rome by Pierre-Henri de Valenciennes in the 1780s are already widely acknowledged as landmarks in the history of art.

The paintings are representative of an important tradition, and many other artists or examples could have been added or substi-

tuted. Some of the early landscape studies of William Mulready before 1810 would have served as well as those of John Sell Cotman or John Linnell. Nature studies by Théodore Caruelle d'Aligny have what Galassi calls the "abrupt, frozen, refractory quality" of Ferdinand Georg Waldmüller's wonderful landscapes, which makes them seem photographic.

Galassi also shows that the origins of the modern tradition in painting are more complex than many have thought. One of the most striking pictures in *Before Photography* is an Italian view by Léon Cogniet (1794–1880), a conservative painter best known for his large historical pictures. This is an early and private oil sketch, but it is very smoothly painted, not treated in a sketchy

Pierre-Henri de Valenciennes, Landscape with Biblia Changing into a Fountain. *This painting, which Valenciennes may have exhibited at the Salon of 1793, is characteristic of his finished historical landscapes.*

Léon Cogniet, At Lake Nemi, near Rome. *This was one of the landscape studies painted in Italy, where Cogniet went on a Prix de Rome in 1817, and stayed until 1824.*

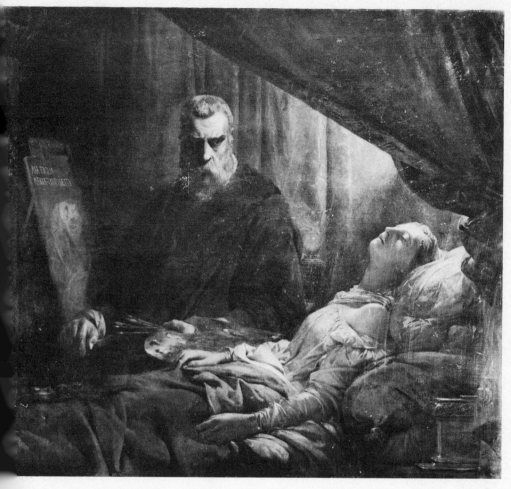

Léon Cogniet, Tintoretto Painting His Dead Daughter. *The painting had a great success at the Salon of 1843.*

texture. What brings photography to mind here is the change of values that takes place as a result of distance and the attenuation of hue. The picture is also cropped like a snapshot: in the right foreground in sharp focus is a small branch with leaves—hanging, we presume, from a tree, the rest of which is cut off by the frame; the background (a river and the opposite bank) is delicately blurred, as if out of focus. This study, poetic in its mood and its finesse, not only calls to mind photographs in which a tree branch or building near the lens sharply intrudes into a picture of a more

distant scene, but serves as a reminder that even cautious and conventional painters like Cogniet were not entirely outside the major developments of art and what was original in the vision of their time.

The little picture is fascinating, but it does not make Cogniet's later work more significant, or his public *grandes machines* more interesting. The present fashion for academic nineteenth-century style has not yet reached Léon Cogniet's serious productions. The real discoveries in nineteenth-century painting are to be made in other fields than the revival of faded reputations, above all in the interaction of social and technological change with the major artistic movements of the time.

Galassi places the continuity between painting and photography within the history of perspective and, more generally, within the changing conception of vision as it relates to the making of pictures. The theory of one-point perspective, as published by Leon Battista Alberti in 1435, is that of a window on the outside world, or in more technical terms that of the visual pyramid interrupted by a plane of projection which is the surface of the picture. But, for Italian artists of the Renaissance, perspective was as much a device for constructing images, a method of composition both on the plane and in an imaginary three-dimensional space, as it was a way of catching the appearance of the outside world. Galassi sees a progressive development from the image-constructing of the Quattrocento to the view-catching of photography and of painters like Degas, which was a way of reducing the three-dimensional world to a two-dimensional pattern. "Gradually," he writes, "over a period of centuries, Uccello's procedure of logical construction gave way to Degas's strategy of selective description."

There is a weakness in this historical view; it disregards the empirical type of representation developed in Flanders by Jan van Eyck and others early in the fifteenth century, a technique already geared to the catching of appearance. It should be added that the use of perspective to construct pictures never lost its claim on painting during the nineteenth century, as witness Jacques-Louis David and Georges Seurat (to name painters just before and just after the invention of photography). But this reservation does not

invalidate Galassi's main argument, that photography belongs to the history of pictorial representation.

In the remarkable pages he wrote on photography in *Painting and Society* (1952), the French art historian Pierre Francastel insisted that the camera was an apparatus to produce pictures according to pictorial perspective. Photographs that did not conform were usually discarded, as when vertical parallels—the piers of a cathedral for instance—seem to converge. Today we have lenses that "correct" such "distortions." Francastel's point only reinforces the claim that photography belongs firmly to the history of pictorial representation. After all, the two main inventors of photography, Daguerre and Talbot, were both painters.

And yet there is something moving and exciting, something almost magical, about the beginnings of photography. Whatever the continuity between photography and the pictorial tradition, however much we may feel that the invention of photography was inevitable and perhaps even overdue, the invention marked a break, a watershed in the history of representation. This is due not so much to anything intrinsic to photography, or to its apparent objectivity (which, however, should not be underestimated, as criminologists and horse-race enthusiasts know), or to its more exact rendition of appearance. On the contrary, early photography was often unclear or ambiguous, and neglected a great deal of visual information, such as color, that painting conveyed much better. But, although some early critics of photography felt that it lied because it did not fit with their visual habits and their established pictorial codes, in the end photography, "the pencil of nature," as Talbot put it, carried conviction.

That photography not only does not, but cannot, lie is a matter of belief, an article of faith. It is not that a photograph has more resemblance than a handmade picture (many have much less, and what could be more *like* something else in appearance than a successfully painted *trompe-l'oeil?*), but that our belief guarantees its authenticity; to put it simply, we tend to adhere unquestioningly to the conviction that the photographic image is of something that was actually in front of the camera, in a necessary and deducible relation to it; we tend to trust the camera more than our own eyes.

From this, the photograph has acquired a symbolic value, and its fine grain and evenness of detail have come to imply objectivity; photographic vision has become a primary metaphor for objective truth.

It would be foolish to claim that this phenomenon is unrelated to the way a photograph is made, to the mechanical apparatus and chemical processes that largely replace the decisions and judgments of the picture maker. These characteristics of photography had great importance, both as potential and as limitation. But they could be overcome, as was shown very early by Julia Cameron, the celebrated English photographer: for better or worse, she turned photography into "Art" so successfully that her pictures seem the product of fantasy just as much as any painting of the time. The decisive break between painting and photography, in the end, is a mental and psychological one—not simply the result of a technical invention, but what was made of it. Although many of the finest painters, including Degas and Eakins, experimented with photography, the world of art, for the most part, rejected and banished it to the world of science. This ensured both its integrity and its power. If the history of art were now really to absorb photography instead of relegating it to a marginal status, that would entail a thoroughgoing revision of the discipline—and a renunciation of the idea that art is an autonomous activity with a consistent history of its own.

This is why Nadar is such a fascinating but, in the end, irrelevant figure. He is so clearly and consciously an artist, and his portraits are so evidently art in the most banal sense, that he can be integrated easily enough into the most conventional art history. This was already obvious at the time. There is a well-known caricature by Daumier that shows Nadar working his camera over Paris in an aerial balloon; the caption reads, "Nadar elevating photography to the level of art." This amiable and ironic work records Nadar's exciting experiments in aerostatics and aerial photography. But the caption refers to something else, to his artistic claims. The two men both worked in minor artistic media, but Daumier, who was almost secretly a great painter, practiced his job as a cartoonist with no pretension, and his importance is all

the greater for it. Nadar's photographs perfectly sustain their claim to be accepted as high art, even great art—and are thereby condemned to be no more than art. His portraits had, of course, a documentary interest as a record of the great men of his time, but this is equally true of the medallions of David d'Angers and the lithographs of Achille Devéria.

Other photographers (the American Timothy O'Sullivan, for example) were much less art-conscious. They were the legitimate successors of the eighteenth-century topographic draftsmen and engravers, who were rarely considered artists in the full sense of the word but whose work was recognized—very early in the nineteenth century by Goethe, for example—as one of the chief sources of modern landscape painting. It is true that one can select the most "beautiful" works of these photographers and discuss and admire them as one would drawings or paintings, but this is a distortion and a reduction of their significance: it cuts these works off from their scientific and social functions.* After its origin as a new graphic medium, photography spilled over almost at once into science because of its incomparable ability to document, and into commerce and industry, especially as a way of producing the souvenirs demanded by the railroads' expansion of tourism. Today photography reaches into all activities of life—but then, so does art, and the failure to integrate photography into art and into the history of art was a refusal of artists and historians to abandon the distinction between high and applied art, to recognize that their own field had no real autonomy, only one that was professionally imposed.

Galassi has not done justice to the shock waves that photography produced in the history of representation. However, by stressing the very real line of continuity between painting and photography, he makes it possible for us to understand how photography and the effect of reality it produces came about within a large movement of ideas in the nineteenth century. The objective photographic vision depended paradoxically on means that stressed the

* See Rosalind Krauss, "Photography's Discursive Spaces," *Art Journal*, Winter 1982, pp. 311–19.

subjective elements of perception. The unfamiliar angle of vision, the seemingly random cropping, which developed before photography and were carried on by it, can be understood as ways of stressing the necessary presence of the distinctive perceiving subject, the peculiarly individual point of view. That such a development took place throughout the Romantic period, when the subjective perception of the outside world was at the center of thought, is understandable; and insofar as the camera eye—or camera-I—institutionalizes and enforces this authority of the highly personal "point of view," it is indeed a fulfillment of the Romantic movement. The invention of photography was wonderfully timely.

V

THE *JUSTE MILIEU*
AND
THOMAS COUTURE

1

As someone once said, it is not history that repeats itself but historians that repeat each other. When it comes to the history of nineteenth-century painting, however, it might be better if they repeated each other more often, or at least more judiciously: one of the difficulties about recent writing on the subject is that some of the most interesting books published early in the twentieth century are either forgotten or only superficially read today.

An odd example of this is John Rewald's diatribe against Louis Dimier in his introduction to the catalogue of the Pissarro exhibition shown in London, Paris, and Boston in 1980/81. According to Rewald:

> Shortly before the outbreak of the First World War, Louis Dimier, a French critic whose reactionary attitude entitles him to a special niche in the literature of art, published a learned volume, *Histoire de la peinture française au XIXe siècle (1793–1903)*. He chose 1903 as his cut-off date because that was the year in which Léon Gérôme had died and with that artist there "disappeared the successor of David and Ingres, heir to the authority established by them." As the impartial historian he pretended to be, Dimier dutifully recorded that Gérôme had been the only one who brilliantly resisted Impressionism,* "designating Manet's paintings as *cochonneries*" . . .
>
> Those who think that Dimier honestly believed in the historic role played by Gérôme, should perhaps consider that what is at stake here is not Dimier's sincerity, but the stand he took. At the time Dimier deemed it relevant to slander Impressionism (with Monet, Renoir, and Degas still alive), to completely overlook Pissarro, and to glorify Gérôme, the cause of the latter was already irremediably lost; new generations had appeared, on whom Gérôme's "authority" did not have the slightest hold.

* Rewald's "brilliantly resisted" misconstrues Dimier's *"résisté avec éclat,"* which means resisted with a lot of publicity and noise.

113

It is hard to imagine a more gross misunderstanding of Dimier's acutely intelligent and brilliantly perverse volume. Dimier disliked and disapproved of Impressionism, but he loathed the so-called academic painting of the nineteenth century even more. His most savage wit was reserved for Jules Bastien-Lepage and Gérôme. Rewald has not perceived the bitter sarcasm of Dimier's characterization: "the successor of David and Ingres, heir to the authority established by them." David and Ingres are, in fact, the villains of Dimier's book.

As Dimier saw it, when Jacques-Louis David abolished the Academy during the Revolution, he destroyed with it the greatest source of strength in the education and administration of the fine arts in France. During the eighteenth century, the Royal Academy had welcomed almost every artist of some distinction, protected their professional welfare, and ensured the continuity of an artistic tradition through a carefully organized system of instruction. Teaching was a duty assigned by rotation to the senior members. When the Academy was reconstituted after the Revolution as a branch of the Institut de France, it was no longer a large corporative body devoted to teaching and to the maintenance of professional standards. It had become nothing but a small clique with official support. After having been persecuted by this new power in his youth, Ingres, a depraved genius, managed to make himself the head of the clique, and achieved the ruin of what was left of tradition by his Romantic individualistic doctrine. This, in sum, is Dimier's version of the history of the Academy in the nineteenth century.

Born in 1865, Dimier was still a man of the nineteenth century, and grew up with a keen sense of the role played by contemporary institutions, a sense that has been lost and is today being won only with difficulty. (Much recent scholarship on the way the Academy and the Salons functioned is, in fact, a reconstruction of what Dimier took for granted and barely mentioned because it was so obvious to him.) A radical right-winger, he saw the nineteenth century as the unfortunate result of the Revolution, with a few uncertain signs of recovery.

In spite of Dimier's reactionary politics (he was one of the four

men who founded the contemptible Action Française), he hated whatever was doctrinaire in art. His allegiance went largely to Géricault and to Delacroix, above all to the latter's attempt to repossess the great inheritance of Baroque decorative mural painting; he greatly admired Manet (even during his Impressionist period) and Degas, wrote at length and with enthusiasm about Fantin-Latour, and had an odd weakness for Albert Besnard. He was outraged by Monet, ignored Pissarro, and was interested by Gauguin's theories, although repelled by his neoprimitivism. As for Gérôme, while Dimier found a few of the early pictures mildly attractive, he was largely crushing about the rest—indeed, devastating about *The Death of Caesar* (the empty Senate with bloody footsteps leading away from the dead body bundled up in its white toga—"Laundry Day," Dimier remarked, was the characterization of Gérôme's contemporaries), and he quoted with evident relish Baudelaire's gibe at the neo-Greek style of which Gérôme was the greatest representative: "antique brats playing with antique hoops and antique dolls."

Basically Dimier thought that the nineteenth century was a terrible mistake, but he was no precursor of the present modish taste for the various conservative styles of the period. We do not need to accept Dimier's judgments, but his lively book is still valuable. He gives a provocative analysis of the interplay between the development of style and the organization of artistic education; he takes account of the official influence on artistic ideals; above all, paradoxically because of his detestation of Ingres, he comes close to a modern evaluation of this extraordinarily original genius (and Dimier did not fail to recognize either the genius or the originality).

The neglect of Léon Rosenthal's great book of 1914, *Du Romantisme au Réalisme*, is more serious. This is still the finest work on nineteenth-century French painting. It has been unobtainable for years, and both a reprint and a translation are badly needed. Rosenthal knew the whole field, from the most outrageous avant-garde to the most dyed-in-the-wool academic, and his treatment is thorough, witty, and penetrating. Those who have recently attempted to revive the faded glories of the century have usually listed Rosenthal's work in their bibliographies, but it cannot be

said that they have come to terms with his ideas or faced his argu-
ments. It is easy enough to see why, as Rosenthal's treatment of
most of the candidates for resurrection is crushing, and so closely
argued as to seem definitive.

Most of the painters from 1820 to 1860 who stood outside the
great avant-garde tradition and who are now the intensive object
of rehabilitation and study are grouped by Rosenthal under the
rubric of *"le juste milieu"*—the middle-of-the road. The term was
first employed by a minor critic of 1831, who used it to recom-
mend the painters who steered a careful path between the mori-
bund Classicism of the school of David and the wild-eyed
Romanticism of the more audacious younger artists. As such, it
did not represent a real compromise, as the school of David was in
ruins by the 1830s—in such a disastrous state, indeed, that Ingres
(who had studied with David, but who was an even more contro-
versial figure than Delacroix) was able to take over the Classical
school and pass himself off as the heir of David.

Juste milieu, however, has political overtones: Louis-Philippe
himself had announced his intention "to stay in a *juste-milieu*
equally distant from the excess of popular power, and from the
abuse of royal power." This expressed the acknowledged middle-
class political position between 1830 and 1848, a dubious and
fragile compromise between radical monarchism and left-wing re-
publican doctrine.

Between 1831 and Rosenthal's book of 1914, *juste milieu* does
not often appear as a stylistic term, but the concept existed in an
important way. The critic Gustave Planche defined three currents
of contemporary art in his review of the Salon of 1833: "renova-
tion" (Ingres and his school); "innovation" (Delacroix and the
Romantics); and "conciliation," another term for *juste milieu.*
Planche mounted a relentless attack on what he considered to be
the tepid character of this school. Following him, Baudelaire re-
served his greatest virulence for what he called *"les tièdes"*—the
lukewarm, the half-hearted.

Neither the term "conciliation" nor the term "middle-of-the-
road" is well chosen, since these painters did not steer a middle
path between the Romantics and David or even between the radi-

cal Delacroix and the traditional Ingres. As Louis Dimier argued, it was Delacroix who renewed the earlier traditions of the grand manner, and Ingres who remained much more consistently the radical. Nevertheless, *juste milieu* is a useful term, since the work of this group is a singularly apt representation of the ideals of the July Monarchy, which tried to achieve a middle-class democratic popularity, stability, and general affluence without conceding any radical reforms. After all, the explicit slogan of Guizot, Louis-Philippe's prime minister, was "Get Rich" (*"Enrichissez-vous"*—that is, get rich enough to qualify for the vote, open only to men of considerable property).

By "middle-of-the-road" Rosenthal indicated those painters who were enormous favorites with the public in the 1830s and 1840s, but who had largely been discredited by 1900. The principal artists were Paul Delaroche, Horace Vernet, and Léon Cogniet, and there were many minor figures. The primary artistic goal for all these painters was instant accessibility. Rosenthal writes:

> They did not constitute a coherent group; they had no leaders, nor any recognizable principles. . . . It is in an arbitrary and, admittedly, artificial fashion that we have grouped them. However, they do have in common the character of rejecting anything that was absolute or excessive, anything that might have been considered audacious or even decisive. . . . If we examine a picture signed by a painter of the *juste milieu,* whatever its dimensions and whatever its subject, we are struck at first by its immediate intelligibility. (P. 205)

This accessibility absolves the spectator from the need for a previous artistic culture or initiation such as that demanded by the work of Delacroix or Ingres (although the work of the *juste milieu* often required a certain elementary historical and literary background). As Rosenthal says:

> Under the pencil of Léon Cogniet, Delaroche, or Vernet, the forms will be conventional, whether rounded or dryly angular [*ronde ou sèche*]; they will be lame with a less experienced painter, but the

contour will always be emphasized. Lines define all the masses, decisive modeling indicates all the volumes; lines and modeling guide the eye without demanding from it any collaboration. . . . Color finishes the definition of the figures and the objects by giving them those aspects under which they are generally known. . . . These principles banish anything fuzzy, all imprecision, they forbid the interpretation of forms, the study of the exchange of colors, of reflection. . . . (Pp. 205–206)

Even more important is Rosenthal's second criterion, closely related to the first:

The images must present a subject.

This necessity, this primacy of the subject, is the most certain sign of the *juste milieu*'s inferiority. Painting for them is only a medium; the interest of the picture does not depend on its aesthetic merit, but on the scene represented: the painter must be a clever dramatist, a good costume designer, an adroit stage director. . . . The success is assured if he knows how to find the anecdotal side of the grandest event; at least, he must not forget to lighten the weight of a serious drama by some clever by-play. . . . (Pp. 207–208)

It has been said* that Rosenthal's idea of Delaroche, Vernet, and the other painters of the *juste milieu* is anachronistic, an early-twentieth-century view colored by the myth of the supremacy of the avant-garde. On the contrary, the criticism of contemporaries was often very similar. Here, as reported by Théodore Silvestre, is the wonderful characterization of Delaroche by his great contemporary Delacroix:

"I can't hear his name without thinking of the following story, which happened in Russia to my uncle Riesener:

"An opulent and important person had asked him to come to his home and paint his wife's portrait. The work being well advanced,

* See, for example, the letter by Albert Boime to *The New York Review of Books*, October 21, 1982, p. 49.

our boyar, rather pleased, went to fetch a cage and said to
the painter: 'Very nice, very nice; but if on my wife's hand you
would set this canary that she is so fond of, it would be per-
fect. . . .'

" 'Possibly,' said Riesener, laughing to himself.

" 'Also,' added the husband, 'if in Madame's other hand you
would put this lump of sugar in order to excite the bird, wouldn't
the portrait be even more expressive? But it would also be necesary
to make it clear that the canary prefers his mistress to the lump of
sugar.'

"Well," concluded Delacroix, "that boyar is the exact likeness
of Paul Delaroche in search of thought and expression."

Rosenthal's analysis of *Edward's Children,* generally known in
English as *The Little Princes in the Tower,* Delaroche's most fa-
mous picture, is a brilliant elucidation of the use of anecdote to
ensure the supremacy of subject over the visual:

Here are two children sitting on a bed in a dark room. A ray of
light appears under the door near which a little dog stands on the
alert. This is either an insignificant spectacle or a real enigma.
Everything changes when we are told that they are the children of
Edward [the First of England]. With the help of history and of
Casimir Delavigne (whose drama of 1833 is a little later than De-
laroche's picture), we lament the deplorable fates of the young
princes, wax indignant at Gloucester and his hired assassins about
to descend on an innocent prey. Thus our emotions must be
aroused, our sympathies engaged, not only by the beauty and
charm of the two characters we see on the canvas, but also by their
tragic story, by the ignominy of their executioners, by a drama and
by facts none of which are portrayed and which are only suggested
to us. . . .

The impressions that [Delaroche] attempted to produce are, for
the most part, independent from the way the picture is painted. It
is enough if the composition can trigger our imagination. It is even
preferable that the eye not be detained too much in the contem-
plation of the canvas: this would weaken the emotional effect. . . .
Nothing is more insipid, more vacuous than the handling of *Ed-
ward's Children.* (Pp. 213–14)

Hippolyte (known as Paul) Delaroche, The Little Princes in the Tower of London. *The scene represents the children of Edward IV just before they were assassinated by order of their uncle Richard III, who usurped the throne. The picture, commissioned by the state and exhibited at the Salon of 1831 and then placed in the Luxembourg Museum, remained the painter's most popular work.*

We might say, in summary, that the common denominator of the art of the *juste milieu* (especially that of Delaroche and Vernet, both of whom were extremely powerful in the Academy) is the complete penetrability of the painting: the eye goes right through the painted canvas to the scene or object represented. Its appeal is comparable to that of the panoramas and dioramas that were so popular at the time; the effects and the audience were often the

same for both. The painting of Delaroche and Vernet was not a mean between advanced traditional art, or between Romantic and Classic, but between high art and popular culture: like most middle-brow work of the nineteenth century it betrayed both sides. At its most successful, it has the undeniable and eternal attraction of an epic movie like *Gone With the Wind.* Delaroche's pretension was much more obtrusive than Vernet's; Vernet remains consequently more interesting. In his book on Thomas Couture, Albert Boime has splendidly compared Vernet to Norman Rockwell.

2

Does Thomas Couture (1815–79) really belong in this company? In *Thomas Couture and the Eclectic Vision* (1980), Albert Boime argues at length that he does. Rosenthal did not think so, and some, at least, of the contemporary enemies of the *juste milieu* were indulgent to Couture, who arrived late on the scene. The poet Théophile Gautier, perhaps the most influential art critic of the mid-century, despised the *juste milieu;* in 1836 in his famous manifesto of art for art's sake, the preface to *Mademoiselle de Maupin,* he complained facetiously that some critics were so ignorant that they "took Piraeus for a man and Paul Delaroche for a painter." Gautier, however, encouraged Couture from the beginning and was unreservedly enthusiastic about his vast, and most famous, painting, *Romans of the Decadence.*

Thomas Couture never completely disappeared, in spite of a serious eclipse. He was always remembered as Manet's teacher, and *Romans of the Decadence,* which had caused a sensation at the Salon of 1847, was never taken down, as far as we know, from the walls of the Louvre. Twenty years ago, however, he was just another *"pompier,"* a dimly perceived glory of the past. The last few years have seen a consistent effort to build at least a small pedestal for him. Albert Boime has led the campaign, and his book brings it to a close. *Thomas Couture and the Eclectic Vision* is an ambi-

tious work; the author has set out more or less to redo the nineteenth century, to put it in a new perspective.

Unfortunately, it is not always clear what Boime has to say. Sometimes it seems as if he wants simply to tell us everything he knows about the century, and he knows a very great deal indeed. But there is also something fundamentally odd about the book. Boime credits Couture with an immense importance both as a representative of his time and as a crucial link in the development of modern art (we are even asked to accept him as Jackson Pollock's artistic great-grandfather); on the other hand, Boime does not claim that Couture is a great painter—or, for that matter, a great, or even a very nice, man.

What does come out clearly—besides Couture's paranoia, egocentrism, willingness to compromise, and vulgarity—is a sort of middlebrow flair in the handling of subject matter. The subjects of Couture's pictures have echoes in all directions: up into high art and down into popular culture, to the right with the Academy, to the left with the avant-garde, back into the past and forward into the future, not to mention their references to contemporary events. Boime has explored this fascinating aspect of Couture extensively: the proliferating connections that he traces everywhere are woven by him into an almost impenetrable tissue.

He attempts to unify all these connections with two concepts, which he more or less equates: the *juste milieu* and eclecticism, the philosophy of Victor Cousin. The authority of Cousin in the 1830s and 1840s was indeed tremendous; today he appears, like Couture, only as a dimly perceptible light from the past.

Boime's version of eclecticism accommodates everything. Almost anybody in nineteenth-century France can be shown to have some connection with Victor Cousin; either they read him (most people did) or they knew a friend of his (his mistress was Louise Colet, and her other lovers seem to have included, at least in passing, most of the important literary figures of the time). Furthermore, since Cousin cooked up a stew of all the ideas current in the early nineteenth century, any later statement can be traced to something he touched upon. Boime even manages to claim Baudelaire as an eclectic by taking Baudelaire's ironic statements at

face value, especially the famous comic dedication of his *Salon of 1846* to the bourgeois. But Baudelaire unhesitatingly condemned eclecticism and detested anything that smacked of the middlebrow (even if he occasionally failed to recognize it); this fastidiousness should not be taken away from him.

Boime's treatment of the critic Gustave Planche, who was indeed a friend and fervent admirer of Cousin, is also unconvincing. Boime finds Planche's attack on the painters of the *juste milieu* "curious." This inconveniently curious behavior does not faze Boime, however, and he assures us that "without realizing it, Planche himself became the spokesman for the *juste milieu* position even while downgrading its concrete appearance." He offers the following summary of Planche's position: "He required that art have clear principles, and he proposed this formula: 'Invention within the circle of nature and tradition.' " This is a creed that any artist or critic of whatever persuasion would have adhered to— Ingres, Delacroix, or even Courbet. The trouble with Boime's middle-of-the-road is that after he has finished expanding its importance, there is nothing left on either side of it. It would be more useful to stay within the narrower limits of Rosenthal's version of the *juste milieu*.

In the 1840s the artistic situation seemed stagnant; the *juste milieu* (in Rosenthal's sense) had merged with the few wretched holdovers from the school of David to constitute a stale academicism. Ingres was now triumphant, but, partly because of his own assertive attempts to impose himself as a classicist, he was felt to represent the past rather than the future. In spite of his prestige, he was always relatively isolated within the Academy. In 1840, the reaction of his most gifted pupil, Théodore Chassériau (who defected to Delacroix), was characteristic. He wrote from Rome to his brother that Ingres "will remain as a memory and a reproduction of certain stages of past art without having created anything for the future." Ingres offers the unusual case of an artist who went in his mid-forties directly and immediately from being a detested avant-gardist into an old-fashioned reactionary. On the other hand, Romanticism was running out of steam, and Delacroix showed his strong classicizing tendencies in his *grande machine* of

1840, *The Justice of Trajan.* Alexandre Decamps, a Romantic whom Couture greatly admired, was one of the few painters whose mastery was universally acclaimed, but this was partly because his ambitions were modest and he never attempted anything on a grand scale.

In this situation, Couture appeared as an impressive painter and innovator. He was decidedly an antiacademic independent. Although he had studied with Delaroche, he broke definitively with his master. As early as 1846 (that is, before *Romans of the Decadence* brought Couture the greatest fame he was ever to enjoy), Baudelaire already spoke of the "school of Couture" in reference to Diaz and others, and even before that, around 1844, the young Courbet seems to have been struck with his technical procedures.

What was so attractive to artists was Couture's distinctive and striking method of execution, which produces strong pictorial effects and attracts attention to the painted surface. In this sense, Couture decidedly differed from the *juste milieu*. The technique was fully developed by the mid-1840s, when Couture embarked on his great work, and he soon systematized it into mannerism.

The methods he perfected were expeditious and easy to learn. His draftsmanship was summary, with nothing of the exacting observation of Ingres or the complexities of Delacroix's "colorist" way of drawing "from within," as Baudelaire put it. He adapted a number of well-rehearsed formulas with the minimum of distortion to produce an effective approximation of appearance. This is clear above all in Couture's portraits, where the initial generalized form still remains obvious under the smaller details which produce the likeness. His procedure is exactly the opposite of Ingres's arduous progress from a searching observation of the model to a new and appropriate abstracted form; but Couture's method was as efficient as it was superficial. The thick, continuous black contour of the drawings was retained in the paintings, and gave them an appearance of stylistic vigor.

His application of color was both superficial and adroit. Boime has given an excellent account of Couture's system. He prepared his canvases with reddish-brown ground, which remains apparent

in the finished painting. On top of this he applied unmodulated local hues, while a generous heightening in chalky white gave an impression of brilliance. The different hues are kept apart by the brownish base, which avoids clashes. It also produces a general impression of coloristic richness without forcing the artist to confront the interaction of colors, a problem that was so stimulating and rewarding for Delacroix.

3

While Boime assesses Couture's pictorial accomplishment soberly, he makes immense claims for Couture's historical importance. He wants us to believe that "the entire Impressionist circle was like a planet receiving its light from Couture's sun." According to Boime, in fact, Couture determined the direction of the entire modern movement through his pupils, especially Manet and Puvis de Chavannes.

Manet did indeed spend six years in Couture's studio; if he had not respected his master, he would surely have left. From Couture, Manet learned a technique, a discipline, and a routine. Some of it stayed with him all his life, and some of it he had to get rid of. There are early works by Manet that are very close to Couture's manner, but there are none after the 1850s, even if he continued periodically to use devices learned from Couture: a way of stressing a dark contour, perhaps some general compositional formulas, even certain themes that interested his master.

Is this enough to justify Boime's claims that "Manet constituted only one link in a chain forged between Couture and the young artists trying to reconcile the realist premises of their art with the more vital forms of academic painting" (a provocative but unconvincing description of the young Monet's or Pissarro's ambitions)? Even if Manet continued to employ devices established by Couture, one cannot disregard the fact that he used them to such different purposes. Unlike Couture's, Manet's use of stressed outline

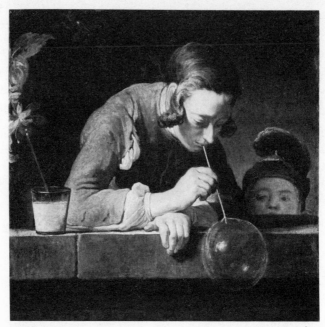

ABOVE, *Jean Baptiste Siméon Chardin*, Blowing Bubbles.
BELOW, *Thomas Couture*, Blowing Bubbles.

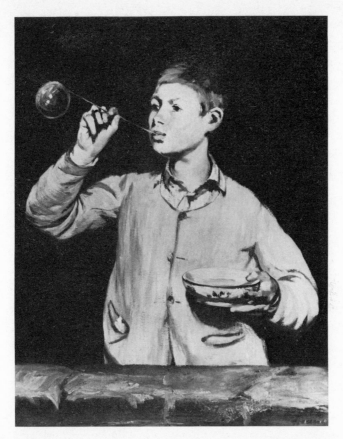

Edouard Manet, Soap Bubbles. *The model was the artist's son Léon Leenhoff.*

was usually suggestive—it was only elliptically descriptive—and it confirmed the flatness of the surface in a way that Couture's never did.

Manet's power to abstract from reality has nothing in common with Couture's idealized world. When he painted a boy blowing bubbles, he clearly turned his back on Couture's sentimental version of the same theme and engaged in dialogue with Chardin's treatment. Boime is perhaps right to say that the antagonism of Manet and Couture has been exaggerated, although the story of Couture's indignation, when he returned to his class one day and found that Manet had made the nude model put his clothes back on and pose naturally, is a revealing one. Couture's fundamental method of preparing the canvas with dark ground in order to

make a transition between light and dark was mostly abandoned by Manet, and this meant an irreparable break with much of Couture's method.

Although Puvis de Chavannes studied with Couture for only a few months, he had a real reverence for his master and was profoundly marked by Couture's artistic ideas and ambitions. Boime reproduces many early works of Puvis that abundantly prove the point. The later works of Puvis, however, the works that are deeply original, are very different. Boime is right to remark that, far from being smooth, the surface texture of these later works is assertive, and their chalky quality may owe something to Couture; but in Couture's work, the graininess of paint and the assertive brushwork are only distributed here and there to give accent and brilliance, while Puvis uses them throughout to produce a general wall-like effect and a destruction of illusion. This is what painters like Gauguin admired so much.

About Gauguin's important painting of 1897, *Where do we come from? Who are we? Where are we going?*, Boime writes:

> A close examination of the surface of this picture shows a distinct resemblance to the work of Puvis. While the coarse burlap texture exaggerates Puvis's effect, its interaction with the layers of opaque impasto and thick outlines bordering the forms relates it intimately to his style and handling. Thus the character of its execution descends in a straight line from Couture.

Boime assumes that if A influenced B, and B influenced C, then C has been influenced by A. The weakness of such reasoning is clear. Even if both used dark outlines and grainy paint, Gauguin has little to do with Couture. It would seem as if Boime was even more a victim of the myth of the avant-garde than previous historians. The only way he can enhance the prestige of Couture, it appears, is to find him a place in the genealogy of the modern tradition. If he were genuinely interested in the influence of Couture, he would discuss painters like Auguste Glaize, whose *Cupids on the Auction Block* in the museum at Béziers shows a clear dependence on Couture (admittedly, it is a little hard to see this picture, for it has been hung directly behind a large model of a

three-masted schooner). Boime prefers to set Couture in a more tenuous and unpersuasive relation to Gauguin and Jackson Pollock. We cannot establish the importance of Couture on such a basis, and it seems unlikely that our way of appreciating the art of the nineteenth century will be altered radically enough to leave a major place for his work. Nevertheless, his opposition to the Academy gave the initial moral support needed by such artists as Puvis and Manet, and *Romans of the Decadence,* in spite of its bombast, remains an extraordinary accomplishment.

VI

REALISM
AND THE
AVANT-GARDE

1

The avant-garde is a historical construction rather like the French Revolution. The more one studies the Revolution, the less one is sure exactly which events belong to it, who engaged in it, and for what motives: the events seem not to hang together with the continuity one had imagined, the people are difficult to classify, their motives disparate, purely personal, often mysterious. A report of a talk given by one of the most distinguished authorities on the Revolution, Richard Cobb, shows the state of the question:

> We had Richard Cobb on July 24 arguing that the French Revolution should never have happened, possibly never did happen, and in any case had no effect one way or the other on most people's lives. Revolutionary rhetoric, he said provocatively, is *always* meant to deceive—to conceal the "obscene truths" that constitute the revolution. His respectful audience—a mixed lot of tourists and academics—refused to be provoked, which led him, with some embarrassment, to qualify everything he had said, admitting to mischievous intent.*

We cannot, clearly, rid history of the French Revolution (although we are no longer sure what it was), if only because people believed that it happened, and this continuing belief represented an ideal of change, an image of hope and terror, for centuries afterward.

The avant-garde embodies a similar ideal of historical change, an acknowledgment that the nature of art was radically altered from 1800 to 1950, and that this alteration, sometimes called the "modern tradition," was achieved by a small group of artists and opposed, for the most part, by the government, the museums, the Academy, and important sections of the press.

* The report is by Judith Chernaik, a scholar of English Romantic literature, in the *Times Literary Supplement*, August 7, 1981, p. 919.

In painting, the radical change was the abandonment of the conception of space that had been dominant since the Renaissance—an infinite, continuous, homogeneous space prior to, and independent of, perception. The new spaces of avant-garde painting were often more subjective, or distorted by perception, deliberately flat as in Manet's work, deformed by expressive violence in Edvard Munch. Space could be constituted by color as in Matisse, or fragmented and reordered as in Cubism. The avant-garde also gradually destroyed the hierarchy of genres, by which different kinds of painting had been classified for three centuries. The distinction between the sublime (history and religious painting) and the familiar (landscape, still life, scenes of daily life) was effectively abolished. Most important of all, the avant-garde realized the program of the Romantic movement, as far as such a project was realizable, and made painting an independent art with a comprehensible language of its own that depended hardly at all on literary or historical explanation. Painting was no longer an illustrative art; it served only rarely to embody a moral or to present a historical narrative.

It is now widely recognized that the traditional version of how these changes came about needs some revision. The myth of the avant-garde artist is too good to be true: the creative spirit savagely attacked by critics, mocked by the public, and struggling to assert his original conceptions in the teeth of a moribund academic tradition, who lives and works unsung and unhonored, and sells for derisory sums the pictures that make a fortune for dealers after his death. The Avant-garde Painter is only too useful for explaining the history of art: the arduous but certain and continuous victory of the future over the past. Seen in this light, the avant-garde is identified as the force of history itself—without it the art of centuries would either remain static or, at best, vegetate slowly, the mutations visible only from a long perspective. The misunderstood and the rejected suddenly and violently displace the established and official: the history of art becomes like old-fashioned military history with campaigns, great generals, and glorious victories. Best of all, the underdog always wins.

We now realize that most of the avant-garde artists attacked by

the critics had powerful defenders as well, even early in their careers; many of them not only enjoyed private incomes but sold their pictures at prices that made them fairly comfortable. Some, like Courbet, Delacroix, and Puvis de Chavannes, even saw a few of their pictures well placed in museums alongside the master-pieces of the finest academic hacks. It was, in fact, the more con-servative painters who occasionally had trouble making a living and the avant-garde who sometimes sold easily; much of the "modern tradition" is based on landscape, always popular in the nineteenth century, while the official style emphasized the life-size painting of religious and historical scenes—and what collector would have wanted to hang on his wall a representation three yards wide of the decapitation of Saint Denis?

Who belonged to the avant-garde—or, rather, to the suc-cessive waves of avant-garde movements from the Romanticism of Delacroix to the Abstract Expressionism of Pollock and de Koon-ing—is a question to which the answers have recently become a little fuzzy around the edges. But with all the inadequacy of the avant-garde as an all-embracing explanation of change (and it has other faults too numerous to go into here), it remains indispens-able to history; in fact, it helped to create history. The avant-garde is not simply a construction imposed *post facto* on an earlier real-ity; it was already constructed and embedded in that reality. It was believed in by artists and the public and helped to form the devel-opment of art, for better or worse. The avant-garde artist is a cen-tral Romantic hero, and the public of the 1820s and the 1870s expected of him the same excesses and much the same scandals as did the public of the 1920s. In fact, the impossibility of rigidly de-fining the avant-garde is just what makes it useful: it is a mobile concept, which can be continually reshaped as we learn more about the period it covers. Recent attempts to get rid of it are as mischievous as Cobb's witty deconstruction of the French Revolu-tion.

The mischief is made largely by scholars, dealers, and museum curators who have no taste for the modern tradition or for the way successive avant-gardes have transformed painting beyond recog-nition for more than a century and a half. There is, of course, a

Charles Cuisin, View of Troyes from the Place du Préau at Evening.
*Landscape painting exhibited at the Salon in the mid-nineteenth
century was more varied than one would expect. This nocturnal study
by an almost unknown painter bears little resemblance to any
contemporary work.*

great deal of art in the nineteenth century that lies outside the
modern tradition, and some of it has attractions for almost anyone
today; but most of this art contributed only in the most insignifi-
cant way to major changes in style. The history of art is not made
up of everything that artists have done—it is hard even to imagine
such a history.

It is possible to dispense with the black-and-white classifica-
tions of official and avant-garde when one deals with the few ob-
scure figures whose work had some individual character, a
painter, for example, like Charles Cuisin (1815–59), who seems
to have worked mostly in Troyes and to have stood outside the

contemporary politics of art. His few known landscapes were painted in the 1840s and suggest an acquaintance with German painting (Friedrich's, in particular) exceptional but not unique in France. (Friedrich's style was, in fact, completely outmoded in Germany by the 1840s.) The *View of Troyes* has an original note that has little to do with the major developments of landscape in the Barbizon school and even less with the classicizing style of Paul Flandrin or Caruelle d'Aligny. The cultivated naïveté, the intricate play of orthogonals, the poetry of silhouetting and reflection, the precisionist aesthetics of the detail, as in the blades of grass—all have a haunting quality that is distinctly personal, even if one assumes an influence from Germany. Cuisin exhibited such works at the Salon, and critics took no notice of them. In fact, the recent revival of interest in Friedrich may have made us aware of qualities in Cuisin that would have escaped the attention of his contemporaries.* The study of modest figures like Cuisin seems to us more rewarding and more enlightening for nineteenth-century studies than the attempt to reinflate the official style. Cuisin escapes the monotonous dialectical movement in which the revolutionary of this generation becomes the classic of the next. None of the major actors, the artists in the public eye, however, evaded the fate of playing the role assigned to them by the ideology of the avant-garde.†

In addition, the avant-garde has so influenced and shaped contemporary aesthetics—we all take for granted the public's desire to be shocked, the artist's search for originality—that most of the revival of official art takes the form of a provocative taste for kitsch. Most lovers of art with a sense of the modern think their legs are being pulled when, as a serious alternative to the work of Delacroix and Cézanne, they are offered the journalistic battle

* The aesthetics of Léon Bonvin, who worked almost entirely in watercolor and without any public recognition, are, however, similar to those of Cuisin.

† We should like to thank M. Jean de Sainte-Marie, Director of the Museums of Troyes, for making available to us the information about the pictures of Cuisin in the Museum of Fine Arts.

pictures of Horace Vernet or the once-famous portrayals of the executions of the English aristocracy which were the specialty of Paul Delaroche. Salvador Dali's championship of Meissonier as the greatest painter of the nineteenth century still seems (in spite of Meissonier's evident skill) like one of Dali's publicity-seeking pranks, along with his jumping through a department store window; and Dali's evident sincerity, explicable by the Surrealist movement's interest in kitsch and nineteenth-century nostalgia, has not been able to return Meissonier to his former status as a major figure.

The historians who deplore modernism (and their name is, if not legion, at least platoon or squadron) have lately tried another strategy. They now claim that the simplistic division of nineteenth-century art into "avant-garde" and "official" is untenable, that the avant-garde itself was incoherent and inconsistent, and that the so-called modern tradition has no continuity.

Some recent exhibitions have been devoted to this revisionist thesis. The most important were "The Post-Impressionists" in London in 1979 and "The Realist Tradition," shown in Cleveland, Brooklyn, St. Louis, and Glasgow in 1981. The incoherence of both exhibitions was obviously considered a positive value, and the organizers had a touching faith that progress in historiography was bound to take place if one could just forget what previous historians had written. The revisionists hoped to create healthy and fruitful confusion—for Post-Impressionism, by putting in almost every kind of painting done between 1885 and 1910; for Realism, by including any manner of portraying contemporary life from 1830 to 1900. In both shows, every appearance of selection was avoided. Nineteenth-century painting, it was implied, had a chaotic richness, teeming with life and variety, until art historians came along and imposed their rigid Manichaean categories of "avant-garde" versus "official" art.

The attack on the modern tradition should have succeeded, if anywhere, with the reconsideration of nineteenth-century Realism. Here, surely, was a movement that attempted to tie painting firmly to history and to life, and that had apparently little interest in the modern tradition's development of art as an autonomous

language, independent of all other forms of expression. The signal failure of "The Realist Tradition" is perhaps more surprising than any of the other recent manifestations of antimodernist taste.

A Realist picture in this exhibition, organized by Gabriel Weisberg, was any work that dealt with contemporary life, generally of a humble kind and preferably with humanitarian concerns. Other than this criterion of subject matter, there seemed at first sight to be very little reason why some pictures were included and others not. The year 1830 was a poor choice for an opening date. One might ask why such an exhibition did not start with Géricault: his stark, direct representations of contemporary life would surely qualify as Realist works. Jacques-Louis David himself, in fact, had a powerful sense of contemporary reality, and was it not he who insisted on working from the model, in reaction to his predecessors? On the other hand, why did "The Realist Tradition" include Octave Tassaert, a Romantic painter whose charming and sentimental *Corner of His Studio* (1845), reproduced on the dust jacket of the catalogue, would be considered by most people as much less "Realist" than Delacroix's wonderfully unaffected painting of the same subject dating from some fifteen years earlier? Why was James Tissot absent? At least he thought of himself as a Realist.

The real problem of the show was a confusion between "realistic" and "Realist." Realistic portrayal has existed in art for thousands of years, but nineteenth-century Realism was a very much more narrow affair; at least, so it was to the nineteenth-century itself. The realistic rendition of a saint's vestments had nothing to do with it, nor did effects of *trompe l'oeil*. Weisberg and his team seemed to prefer realistic rendition of Realist subject matter, but this was understood very loosely. In an essay on the drawings included in the catalogue, Petra ten-Doesschate Chu dismissed Daumier, the astounding recorder of nineteenth-century Paris, as not a Realist draftsman because he did not draw directly from his models. It is not clear why it was not Realist to draw from memory, particularly if one had a memory like Daumier's. Fortunately for the visitor to the show, the organizers were inconsistent

ABOVE LEFT, *Eugène Delacroix,* Studio Corner: the Stove. RIGHT, *Octave Tassaert,* A Corner of His Studio. *Exhibited at the Salon of 1849.*

enough to let Daumier in as a painter, no doubt on the grounds that it is all right for a Realist to paint, if not to draw, from memory.

These are only a few examples to show what at first seemed to be mere confusion. What emerged clearly from the exhibition was its attempt to minimize the stature of artists like Courbet, Millet, Manet, and the other great figures generally considered as part of the avant-garde, and to transfer some of their prestige to the brothers François and Léon Bonvin, Isidore Pils, Théodule Ribot, and others who have little in common save their relative obscurity. How else justify an exhibition called "The Realist Tradition" where there were only two paintings by Courbet (an insignificant portrait and a lovely but minor landscape) and a dozen by Bonvin, an exhibition where Ribot was given more attention than Manet? Ribot, who specialized in painting cooks, was an imitator of the seventeenth-century Spanish artist José Ribera; his works, monotonous in the long run, make an effective use of sharp contrasts

of light and dark. Bonvin was a Realist, indeed, but a timid, if agreeable, painter. Nothing of his ever had the weight or the influence of the works of Courbet.

The entries in the catalogue make it amply evident that the confusion was deliberate. Here, for example, is the end of the entry on a mildly attractive *Still Life with Asparagus,* an intimate little painting by the very official and generally tiresome Philippe Rousseau: "Dedicated to A. Arago, director of the Beaux-Arts, the painting documents Rousseau's official ties as well as his ability to paint in a free manner suggestive of the still lifes of Bonvin or Edouard Manet." One must applaud the way Weisberg slips in the very dubious suggestion that a still life by Philippe Rousseau looks like one by Manet, and hints that a painter with "official ties" could produce the same kind of work as the most advanced of his contemporaries. The exhibition was devised to ensure this

Théodule Augustin Ribot, The Cook Accountant.

leveling, to make Bonvin seem as good as Courbet, and Manet no better than Bastien-Lepage (a painter whom Pissarro particularly detested because he flirted with modern art while remaining profoundly alien to it).

In his introduction to the elaborate and useful catalogue, Sherman Lee, the director of the Cleveland Museum, is candid about the general intention. "Why," he asks, "this exhibition? Why this growing curiosity about 'anti-modern' aspects of the century of Impressionism and Post-Impressionism?" No doubt the quotation marks around "anti-modern" are prophylactic, put there to reassure the uneasy. Nevertheless, the exhibition was indeed an assault on the view of the modern tradition that has Impressionism as its center. It urged us to renounce the distinction between the Realism of the avant-garde (from Courbet and Degas to Seurat) and all other manners of portraying contemporary life in the nineteenth century.

The relative consistency and the coherence of the avant-garde tradition becomes apparent, however, if we ask how the representation of contemporary life was conceived in mid-nineteenth-century art. We shall find, then, that painters as different as Courbet, Manet, Pissarro, Seurat, and Degas shared the technical innovations of the most interesting Realist writers of their time, and that this sets them off sharply from almost all the other painters shown in this exhibition.

Many artists and writers made doctrinaire statements about Realism, from Champfleury and Courbet to Zola; but the most articulate and profound expression of avant-garde Realist theory, its problems, goals, and working methods, is to be found in the correspondence of Flaubert, above all in the letters he wrote to Louise Colet at the time he was working on *Madame Bovary*. This is not to say that the psychological wellsprings of Flaubert's doctrine were the same as those that inspired the ideas of the Realist painters; they did not share the loathing for contemporary life we find in Flaubert's letters. But it may well be that Flaubert's peculiar antipathies enabled him to expound the doctrine of Realism with such definitive clarity. We must not be misled by labels, how-

ever: "I have written my book against Realism," he told his pub-
lisher.

<div align="center">2</div>

Out of a hatred of his own time, Flaubert paradoxically created
a means of representing modern life that allowed it, with a mini-
mum of distortion, both its own dignity and its integrity. Flau-
bert's hatred was almost pathological. He wrote to his friend Louis
Bouillet on September 30, 1855:

> Against the stupidity of my era, I feel floods of hatred which choke
> me. Shit rises in my mouth as in strangled hernias. But I want to
> keep it, to solidify it, harden it. I want to make a paste out of it with
> which I shall daub the nineteenth century, the way Indian pagodas
> were gilded with cow manure; and who knows? perhaps it will
> last?*

The youthful failure of Flaubert's attempt at imaginative writ-
ing in the high Romantic style, the rejection by his friends of the
first version of *The Temptation of Saint Anthony*, made him turn
to the portrayal of contemporary life. He began *Madame Bovary*
almost as a penance, ostensibly for therapeutic reasons, to cure
himself of writing badly by inspiration, to force himself to write
calculatedly well. For this, he needed a subject of no evident im-
portance and of no interest to him—the suicide of a small-town
physician's wife. At least one side of his nature hated the atmo-
sphere and the characters of his book. No doubt some of the ha-
tred was self-hatred, but the mechanisms of defense he evolved,
the radical changes he made in the relation of a novel to the reality
it professes to describe, were useful to later writers more at ease
with themselves or with the society in which they lived.

Flaubert was explicit about the way *Madame Bovary* was a cure
for his own Romantic excesses. He predicted, however, that the

* In all our references we have followed Jean Bruneau's dating of Flau-
bert's letters, in his new Pléiade edition of the correspondence.

cure itself would end by giving him an extreme and permanent disgust for writing about ordinary life. He added:

> This is why it is so hard for me to write this book. I have to make great efforts to imagine my characters and then to make them talk, as I find them profoundly repulsive. But when I write something from my *guts,* it goes fast. However, there lies the danger. When one writes something of *oneself,* the sentence can be good in *spurts* (and lyrical minds achieve their effects easily and by following their natural inclinations), but *the total composition* fails, repetitions abound, redundancies, platitudes, banal phrases. On the contrary, when one writes something *imagined,* since everything must flow from the conception, and the smallest comma depends upon the general plan, the attention bifurcates. One must keep the horizon in sight and at the same time look at one's feet. (August 26, 1853)

Flaubert here emphasizes a paradox. To write from one's guts produces the lyrical introspective work: to *imagine* something is to describe the reality of one's time. Imagination here, far from being the free movement of fantasy, is the power to visualize the real world, and for Flaubert to exercise this power required immense effort: it forced him to disregard his own inner life and concentrate on an outer reality that repelled him. This kind of alienation is not peculiar to Flaubert: it has a complex and fascinating history in the nineteenth century.

If the success and even the greatness of the conception of his novel derived, as Flaubert saw it, from his antipathy to the subject, this attitude was even more important for the smaller details and for the technique of representation itself. Here the most revealing document is Flaubert's description of the problems of writing a crucial scene in *Madame Bovary,* when his heroine, troubled by her adultery, goes to see the priest.

> At last I begin to see my way in my damned dialogue with the vicar. But frankly there are moments when I almost want to throw up, *physically,* the whole thing is so vile. I want to render the following situation. My little woman, Emma Bovary, in a fit of religion goes

to church. At the door, she finds the vicar, who, in a dialogue
(without any specific subject), proves to be so stupid, dull, inept,
gross, that she goes away disgusted and unpious. And my vicar is a
very good man, even excellent. But he only thinks of the physical
(the suffering of the poor, the lack of bread or firewood) and has
no idea of moral failings, of vague mystical aspirations—He is very
chaste, carries out all his obligations—It has to be 6 or 7 pages at
most, and without *one comment or any analysis* (all in direct dia-
logue). (April 13, 1853)

This was the scene that Baudelaire was to single out in his re-
view of the book. Its extraordinary effect depends, as Flaubert
realized, on the absence of comment or analysis—on the apparent
withdrawal of the author from the work.

This claim to objectivity made by the dispassionate style, by the
absence not only of moral comment but even of any attempt to
generalize the events of the novel, by the unwillingness to charac-
terize the most sordid and repulsive events as atypical, excep-
tional, or indeed anything except run-of-the-mill—the pretense
made by Flaubert's style that the brute facts are speaking for
themselves—this was the principal basis for the scandal caused by
Madame Bovary. Flaubert's revulsion is conveyed above all by his
refusal to express it directly, a refusal which signifies his contempt
for the society and culture portrayed in the book. What was most
personal and most profound in Flaubert, therefore, was that which
went without saying.

How conscious Flaubert was of the originality of this procedure
comes out in a letter written five months later:

How hard dialogue is, when one wishes above all for it to have
character! To paint by dialogue without its losing in vividness, pre-
cision and distinction, and still remaining banal, that is monstrous,
and I know of no one who has done it in a book. (September 30,
1853)

"Still remaining banal": that is the condition which preserves the
integrity and the truth of Flaubert's imaginative re-creation of
contemporary life. It is as if the reality represented by *Madame*

Bovary was to remain unaffected, even untouched, by the "vividness, precision and distinction," which were the ideals of Flaubert's art.

In another letter, Flaubert is even more explicit on this radical opposition between style and content:

> What I find so difficult are ordinary situations and trivial dialogue. To write the *mediocre* beautifully,* and at the same time to have it retain its aspect, its shape, its very words, that is truly diabolical, and I am faced now with the perspective of these delights for at least thirty pages. One has to pay dearly for style. (September 12, 1853)

The style must remain uncontaminated by the mediocrity of the characters and situations, uncorrupted by triviality. At the same time, the characters and situations are hermetically sealed from the aestheticism of the style. Flaubert wants to maintain a double purity. (It should also be clear that, in Flaubert's hands, the grace and distinction of the style constitute a brutal, although oblique, comment on the trivality of the culture portrayed.)

For the mediocre to retain its mediocrity meant an abandonment of all those grand rhetorical gestures that writers had used to ennoble and idealize their material from classical times until the mid-nineteenth century. These gestures were still as essential to novelists of contemporary life like Dickens, Balzac, and George Sand as they had been to Cicero. Although in England women like Jane Austen and Maria Edgeworth placed less reliance on elaborate rhetorical forms, their dialogue retained an elegance that generally divided it from the banality of ordinary speech. In accepting the most deadening mediocrity of speech as material for a work of art—one in which the triviality of the material was not concealed or vanished, but set into relief—Flaubert was taking an

* *"Ecrire bien"* has a strong meaning for Flaubert, which "to write well" would not convey, and *"écrire bien le médiocre"* is a peculiar turn of phrase. "To write the *mediocre* beautifully" is the best we can do, but it is not very satisfactory.

extraordinary step, as he himself understood. Idealizing rhetorical figures of speech appear in *Madame Bovary* only as parody—most strikingly and movingly in the parody of the text for extreme unction at the death of Emma, but generally with a malicious absurdity in the mouth of the pharmacist.

There is an ennobling rhetoric of events as well as of speech, and this, too, is avoided by Flaubert. None of his characters could shake his fist defiantly at Paris, as Balzac's Rastignac does. None of them is capable of a great act; in his work truly unselfish gestures are made only by those who do not fully understand what they are doing.

3

This ascetic liberation from rhetoric has its parallels in the work of the great Realist painters from Courbet, Manet, and Degas to the Impressionists. Rhetorical figures of speech, conceived pictorially, are the idealizing formulas for pathos, the whole repertory of poses and gestures that the Renaissance artists derived from classical statuary and reliefs, and invented in new forms. Modulated formulas for grouping figures, especially pyramidal compositions, were used for the same idealizing purposes. David's grand history paintings, such as *The Oath of the Horatii,* gave formidable authority to this pictorial rhetoric.

For the most part, when these Classical formulas turn up in Realist painting, they appear as quotation or as parody (most notably in Manet). In general, however, the traditional idealizing pose is absent; the force of the painting often depends on a sense of this absence. There is also an attempt, particularly striking in a few of Courbet's paintings, to develop a new set of expressive gestures largely independent of the Classical repertory—the strangely slumped figure on the left of *The Wheat Sifters,* for example. These sometimes succeeded in puzzling his contemporaries, like Delacroix. The great achievement of the Realist school in paint-

Jacques-Louis David, The Oath of the Horatii. *The picture, commissioned by the king of France, was painted in 1784 in Rome, where it was exhibited, and then shown at the Salon of 1785 and again at the Salon of 1791. Immediately recognized as an epoch-making work, it established David's supremacy in history painting. Even when he was exiled, the painting was put in the Luxembourg Museum at its opening in 1818.*

ing, however, was the acceptance of trivial, banal material and the refusal to ennoble it, idealize it, or even make it picturesque.

Flaubert's Realism derives from his Romantic inheritance and is at the same time a partial renunciation of it. Realism had been an essential element of the Romantic tradition of the early nineteenth century. In such paintings as Géricault's *The Raft of the "Medusa,"* based on an account of an actual shipwreck, the inten-

tion was to deal adequately and nobly with contemporary life, to transform it into art. But Romantic alienation was not Flaubert's method. "To make the familiar strange and the strange familiar" had been Novalis's definition of Romantic art. Flaubert's way demanded that the familiar remain familiar, and that the picturesque and exotic effects of the earlier Romantic artists be abandoned. What place was left then for art? Only the technique and the virtuosity of the means of representation.

If contemporary life was to be represented with its banality, ugliness, and mediocrity undistorted, unromanticized, then the aesthetic interest had to be shifted from the objects represented to

Gustave Courbet, The Wheat Sifters. *The painting, shown in 1855 in Courbet's private pavilion next to the World's Fair exhibition, belongs to a group of pictures about life and work in the country. The light palette is unusual for the painter.*

the means of representation. This is the justification of the indissoluble tie of mid-nineteenth-century Realism to art for art's sake; and although it is sometimes seen as an odd contradiction in Realism, it is, in fact, the condition of its existence.

The claim—not always justified—to represent reality with all of its ordinary matter-of-fact truth carried with it, as a kind of corollary, a belief in the aesthetic indifference of subject matter. In Flaubert's words:

> Therefore let us try and see things as they are, and not try to be cleverer than God. Once upon a time it was thought that only sugar cane could produce sugar. Nowadays it is extracted from almost everything; the same with poetry. Extract it from anything at all, for there are deposits in everything and everywhere: there is not an atom of matter that does not contain thought; and let us get accustomed to considering the world as a work of art, of which we must reproduce the processes in our works. (March 27, 1853)

This statement suggests the Romantic origins of the aesthetics of pure art as much as it does the Romantic sources of Flaubert's Realism. But if the subject of a work is aesthetically indifferent, then the aesthetic significance comes to rest entirely on the style, which must attain an abstract beauty of its own absolutely independent of the subject.

For identical reasons, the Realist movement in painting from Courbet to the Impressionists appears as an initial move toward abstract art. Richard Brettel has written in *Art Journal* (Fall/Winter 1980):

> I can remember being terrified when I was a graduate student that someone would ask me to define Impressionism on my oral exam. The answer to the question could take a number of directions. Impressionism has been considered by some to be an extension of realism, the artistic equivalent of naturalism—and there is ample evidence to support those claims. Other scholars view the movement as a decisive break from realism in the direction of an autonomous modern art. As such, Impressionism plays two roles in the narrative of modern art, roles that are not exclusive but have rarely been considered together.

But the "two roles," an extension of Realism and an autonomous modern art, are only one; and as we suggest, there was no break between Realism and Impressionism, much less a "decisive" one. The autonomy of art is already both implicit and explicit in Realism: it is the guarantee of the truth of what is being represented.

In order to heighten the effect of reality, painters throughout history have traditionally altered the balance between the perception of the picture as a design on a flat surface and as a suggestion of three-dimensional space; the tension between the two is central to European painting since the Middle Ages. The resistance of the picture surface could be decreased by making the paint smooth and inconspicuous, augmenting the three-dimensional effect and the vividness of the things represented, sometimes by brightening the palette in order to obtain striking effects of light. This was still the strategy of "official" painters like Meissonier and, a little later, Gérôme, who both insisted on the painting as an open window or an illusion. Since a painting is quite clearly not a real window, this insistence makes it simply an illusion. The eye goes right through the surface of a Meissonier painting into a world of fantasy. Such pictures are both realistic and unreal;* they have nothing to do with Realism. We are first aware of the scene; the means of representation take second place.

Courbet's procedure is precisely the opposite. By the time he painted his mature work, especially *A Burial at Ornans,* he insisted on the painted surface as no one had ever done before. Only the late Rembrandt had come close to it, but never on this scale. The thick impasto is extremely apparent; the paint is often laid down with a palette knife rather than a brush, so that it becomes a tangible, built-up crust that arrests the eye. Not for a moment are we allowed to believe that we dream, that we have in front of us a vivid but unreal world—an effect that Delacroix could still brilliantly exploit in *The Death of Sardanapalus.* On the contrary, with Courbet, we are forced to remember that we are in front of a

* When such devices are pushed to an extreme, as in some Pre-Raphaelite works, especially those of the early years of the Brotherhood, around 1850, the effect is one of hallucination.

Gustave Courbet, A Burial at Ornans. *The picture, painted in 1850 in Courbet's native town of Ornans, where local people posed for him, was exhibited at Ornans, Besançon, Dijon, and finally in Paris at the Salon of 1850–51 with two other major works,* The Stone Breakers *and* The Peasants of Flagey. A Burial *upset the critics most, caused a real scandal, and gave the artist enormous publicity. From then on Courbet was always seen as a major force in French painting, even if most critics were hostile.*

solid work of art, a painted object, a representation. Imagination has become the power of visualizing the real world, while fantasy is banished. The insistence is entirely on representation, on painting as a transcription of the experience of things.*

Not that the things represented are of no interest or importance, but they preserve what might be called the ordinary indif-

* In an article on Turner (*Times Literary Supplement,* July 10, 1981, p. 783), Lawrence Gowing writes: "It is enough to notice that, in the presence of oil paint solidly troweled in the likeness of rock and snow or brushed obliquely and wetly down with the storm, we are moved to *belief.* The intrinsic reality of the paint is so unmistakable that we have to credit the actuality and the human consequence of what is happening—in the studio and on the mountain." The strategies of Goya—extreme, but isolated, and having no repercussions for a long time—have been analyzed by Fred Licht in *Goya: The Origins of the Modern Temper in Art* (1979).

ference of their being. The burial that Courbet represents is strongly individualized and characterized because only the particular event has real existence; but it is not a special burial. To make it beautiful would make it special: it is the picture that is beautiful, not the burial, and the picture in no way embellishes the burial.

The painting is executed with all the originality and virtuosity that Courbet was capable of. And his gift was spectacular: Delacroix recognized it even in *The Bathers,* a painting he detested. The extraordinary *facture,* or working of the paint, in which both the material of the paint and the painter's physical action are powerfully displayed, carries most of the aesthetic value of the work.

This new relation between the motif and the execution, this new emphasis on the material of paint itself, was later dramatized by Manet, often described misleadingly as the first "pure painter," and it is indissociable from what was considered by nineteenth-century viewers as a brutal realism or naturalism (the distinction is by no means always clear). The attention to paint goes hand in hand with what seemed at first sight to be an ostentatious indifference to what is represented. The public was shocked because Manet painted a face in exactly the same way as he painted a hat. We are today so captivated by the aesthetic qualities of the painted surface that we often find it hard to pay much attention to what was painted. The public of the 1860s, on the contrary, more attentive to what was painted, was upset by an apparently insufferable objectivity.

The Impressionists, whose admiration for Manet was never in any doubt, carried even further the aesthetic autonomy of the means of representation. In some of their most original works they gave a new and startling independence to the brushwork. With Manet the large and visible sketchlike brush strokes follow the shape of the objects represented; in some Impressionist works, however, the brushwork, smaller but highly visible, is evenly distributed on the canvas without regard to the forms, and it constitutes a palpable texture so unrelated to these forms that the public found the representation difficult to decipher. At the same time there is no doubt about the Realist intention of the Impressionists and their will to be true to visual sensation, to represent things

Gustave Courbet, The Bathers. *At the Salon of 1853, the critics were unanimous in finding this work revolting, but it was bought by Alfred Bruyas, a collector from Montpellier, who had an independent mind. He became Courbet's friend and indefatigably loyal supporter.*

strictly as they are seen without regard for what we know about them, even without regard for their solidity and structure. In the Realist tradition, the independent aesthetic aims of the Impressionist technique (whose originality was uncontested even if sometimes condemned) were proof that what was represented had been left untouched, uncontaminated by art.

<div align="center">4</div>

One evening at a dinner party, it is said, a lady turned to Degas and asked him aggressively, "Monsieur Degas, why do you make the women in your paintings so ugly?" and he replied, "Because women are generally ugly, Madame." The story may be apocryphal,* but it illuminates an essential facet of French avant-garde Realism. Degas's pictures are beautiful, but the beauty of the picture in no way embellishes what is portrayed: the dancers in Degas's famous ballet pictures are made neither more nor less attractive by the painting. Flaubert's prose, distinguished and beautiful in itself, does not disturb the banality of the contemporary life he represented. Pictures and novels lay a double claim, first to absolute truth undistracted by aesthetic preconceptions, and then to abstract beauty, uninfluenced by the world that is represented.

At the same time, in avant-garde Realism there is an extreme insistence on the means of representation; the rhythm of the prose or the patterns of brush strokes are always obtrusively in evidence. We are always acutely conscious of the surface of the picture, the texture of the prose. Neither novel nor picture effaces itself modestly before the scene represented. A work of avant-garde Realism proclaims itself first as a solid, material art object, and only then allows us access to the contemporary world it portrays. This priority makes the beauty of the book or the picture appear to be irrelevant to what is being represented. Stylistic

* It was used in a lecture by a famous art historian, who could not subsequently recall where he had found it: no one has been able to enlighten us, although we have followed up several false leads.

forms that idealize had consequently to be avoided at all costs. Flaubert's practice and the theories he formulated in his letters to Louise Colet while writing *Madame Bovary* once again offer a model for critics. The way he was able to avoid idealization and yet achieve an extraordinary distinction in style has its parallels in most of the greatest Realist work of the nineteenth century.

Flaubert's stylistic criteria are essentially negative—at least, the best way to approach his aesthetic is through what he rejected. Because he wished to achieve "a prose that was really prose," the techniques of verse were anathema to him: he carefully combed through his first drafts to remove all effects of rhyme, assonance, and alliteration. Certain rhythms of verse had to be avoided as well, above all the rhythm of the ennobling twelve-syllable Alexandrine line.* The rhythm of his prose has an extraordinary asymmetrical grace: to achieve this he used to bellow his sentences out with great violence, which led his neighbors to believe that he was a lawyer practicing his harangues.

When *Madame Bovary* was coming out in serial form in the *Revue de Paris,* the editors were concerned because a newspaper named by Flaubert, *Le Journal de Rouen,* was a real paper; to avoid trouble, they suggested calling it *Le Progressif de Rouen.* Flaubert worried about this for days: "It will spoil the rhythm of my poor sentences," he lamented comically. Finally he compromised on *Le Fanal de Rouen; fanal* (beacon) was a common name for newspapers and it had the same rhythm as *Journal.*

It would be a mistake, however, to reduce Flaubert's style to questions of rhythm and sound, any more than the style of Courbet and Manet can be discussed solely in terms of color and line. Perhaps the most extraordinary innovation of Flaubert relates to the action: we may call it the suppressed metaphor. When Dr. Charles Bovary comes to treat Emma's father, he is offered a li-

* Since French verse is basically syllabic, and any number of syllables may constitute a verse, it is evident that some verse rhythms will occur constantly in Flaubert's prose. What he suppressed were two successive groups of six syllables (or even three plus three), as the Alexandrine with a central caesura is the basic classical French form and implies an idealized tradition even more than the iambic pentameter in English.

queur by the young girl, who takes a glass herself with very little in it—she finishes it off by sticking her tongue into the tiny glass and licking the bottom. When he leaves the house, Charles first realizes that Emma is nubile and considers marriage. The sexual metaphor becomes a part of the causal structure of the novel.

This shows that the determinism of Flaubert's novel is less a scientific theory than an aesthetic system. All the forces of Flaubert's style are called up to represent Emma's suicide as inevitable. "We were sitting on the school-benches" are the opening words of the book, and for three pages the narration is in the first-person plural. It is "we" who describe the hat little Charles Bovary wore on his first day in school, a hat so grotesque that "we" laughed riotously, and the little boy was punished by the teacher for his shyness. This form of narration never returns even once during the rest of the book, which continues with the objective third-person form. It is "we" who will cause Emma's death: the traumatic sense of ridicule inflicted by the weight of social opinion on the little boy who will marry her will make him forever incapable of the courage to change the mediocrity and boredom of the life he gives her. Emma, in turn, tries to live out the aspirations she has learned from cheap fiction, the only culture she knows (apart from one performance of *Lucia di Lammermoor*). She ends by corrupting everything she touches.

The determinism allows the facts to speak for themselves without comment: the inevitability is an aesthetic quality. It is not merely a substitute for beauty, but is to be considered absolutely beautiful in itself. This is the key to a style that is abstractly beautiful and that can exist only as a perfect representation of events, and is beautiful only insofar as it succeeds in making what happens seem inexorable.

5

To Flaubert, art is both representational and at the same time in itself pure and abstractly beautiful. This identity of representation and pure art (in a specifically modern sense) is made

explicit by Flaubert in a letter to Louise Colet encouraging her po-
etic ambitions:

> When writing free yourself more and more from what is not pure
> Art. Always have the model in sight, and nothing further. You
> know enough to go far: take my word for it. Have faith. Have faith.
> I want (and I shall succeed) to see you get fired with enthusiasm
> for a caesura, a period, a run-on line—in short, for the form in it-
> self, disregarding the subject, just as you used to get fired with
> sentiment, with heart, with passion. Art is a representation, we
> must think only of representing. (September 1, 1852)

Pure form and representation, for Flaubert, are not opposed
but identical. Along with heart, passion, and sentiment, the impor-
tance of "subject" is minimized: it is only, so to speak, the occa-
sion for the form. This aesthetic made possible the greatest
triumph of *Madame Bovary,* the agricultural fair, where one hears
superimposed the lowing of the cattle, the sentimental sighs of
Emma's seducer, and the banal oratory of the mayor. Passages
like this were to become the model and inspiration for Joyce and
many other novelists. As Flaubert wrote proudly of this chapter:
"If ever the effects of a symphony are to be transferred to a book,
it will be here" (October 12, 1853). He remarked, "To try and
give prose the rhythm of verse (while leaving it prose and very
much prose) and to write daily life just as one writes history or
epic (without denaturing the subject) is perhaps an absurdity. This
is what I sometimes ask myself. But it is also perhaps a great and
very original project" (March 27, 1853). This is a revealing pas-
sage, as it shows Flaubert's consciousness of the novelty of his
project, and the intimate relation of the attempt to describe daily
life to the development of a new prose style.

Flaubert's interest in style, passionate to the point of morbidity,
may seem—even when the equivalence of style and representa-
tion is granted—a betrayal of the original Realist ideal. A con-
tempt for poetry and for pure stylistic effect was often expressed
by Champfleury and other Realists in the 1850s—for example, in
Le Réalisme by Champfleury, published in 1857, the same year as
Madame Bovary. The novelist and art critic Edmond Duranty,

editor of a magazine also called *Le Réalisme,* which was the chief organ of the movement in 1856 and 1857, was far from pleased with *Madame Bovary;* he cannot have been happy to see an interloper stealing the honors, but his contempt for Flaubert's stylistic extravagance was certainly heartfelt. His own novels (the first of which dates from 1860 and was heavily influenced by *Madame Bovary*) have something of Flaubert's dryness and all of his interest in the banality of ordinary speech, but they have none of the stylistic indulgence that Flaubert carried to the point of mannerism.

Nevertheless, it was Flaubert's version of Realism that prevailed. His view of style as musical form, combined with his emphasis on representation, was carried even further by the brothers Goncourt and by Zola. The style of the Goncourts, publicized by them as the *style artiste,* is, if anything, more obtrusive than Flaubert's; they did not look for the *mot juste,* the exact word, but for the excessive, or provocative, word, and their ideal was to make the reader physically experience, through the style, the emotions of the characters. Zola himself realized how much of his success came from his ability to create symphonic effects of language with his dazzling descriptions of department stores, central markets, and slaughterhouses. "Musical realism," as this style has been called, tried to make a clear separation between the artist's aesthetic sense and his social interests, but the separation made it possible to convey the social philosophy of the Realist novelists and painters without seeming didactic: the philosophy appeared to be implied by the facts represented.

It is amusing to note that Duranty, who showed so little sympathy for what he considered Flaubert's stylistic high jinks, wrote—besides his Realist novels—marionette plays, just as Champfleury wrote pantomimes. They were both interested in popular types of art, but a tendency to extreme forms of stylization seems to have been innate to the members of the Realist group, and it balanced their concern for the naked, unadorned truth. Duranty was forced to realize these two sides of his nature in different outlets, while Flaubert found a way to combine them and, in so doing, to assure the permanence of his method.

The relation between Realistic style in literature and painting is brilliantly indicated by Albert Boime in one of the finest passages of his book *Thomas Couture and the Eclectic Vision* (1980):

> In Courbet the tension between style and that which it purported to describe pointed to a fundamental paradox of realism. For realism, far from harmonizing style and subject in a way that makes one forget the presence of a style, accentuated the gap between mundane reality and the artistic attempt to transcend it in the very act of describing it. Instead of defeating art, as some had feared, the practitioners of realism contributed powerfully to a cult of art. The examples of Champfleury, Courbet, the Goncourts and Flaubert are revealing. It was hard for them to describe banality in beautiful formal language, and their attempt to do so relates directly to their mannered stylistic approaches. Precisely to the extent that the artist wanted to deal with the commonplace, style tended to develop into an all-important value. (Pp. 438–39)

Boime wishes, however, to see Couture's work as a synthesis of all the important elements of the nineteenth century. He continues: "Courbet called for the unity of everyday life with the highest artistic concerns while Couture insisted on elevating unpoetic reality with a poetic vision compatible with the grand manner. Were these goals mutually exclusive?" The only answer to Boime's question is, unfortunately, yes: Couture's and Courbet's goals were indeed mutually exclusive. Couture continued the old idealizing rhetorical tradition, and Courbet's aim was its destruction. Above all, Courbet's Realism, in spite of its occasional use of allegory, is a dramatic progress in what has been called "the disappearance of the subject."

This can seem a puzzling idea; "subject" in nineteenth-century art criticism has an idiosyncratic sense, and cannot be identified either with "content" or "material." Once again, for clarification, we may turn to Flaubert:

> What seems beautiful to me, what I would like to do, is a book about nothing, a book without any exterior tie, which would hold together on its own by the inner force of its style, just as the earth

stays up without support, a book which would have almost no sub-
ject, or at least where the subject would be almost invisible, if that
is possible. The most beautiful works are those with the least mate-
rial; the closer the expression is to the thought, the more the word
sticks to it and disappears, the more beautiful it is. (January 16,
1852)

Madame Bovary was to be a partial realization of "a book about
nothing"—partial, because Flaubert's conception altered slightly
as he wrote, and even more because "a novel without a subject" is
an ideal unrealizable in all its purity. "*Almost* no subject, or at
least where the subject would be almost invisible" is Flaubert's
prudent qualification. "Subject" is, therefore, not the action or
the scene represented: it is what the action or scene is about.
"Subject" is that which prolongs the thoughts of the spectator be-
yond the representation: the narrative significance, the moral, the
meaning. That is why Flaubert's technique, as he described it,
abandoned the use of analysis or commentary: he avoided even
the appearance of "subject."

A still life with fruit has no subject, but if the fruit spills in pro-
fusion from something shaped like a horn, then the allegorical
subject of the Horn of Plenty begins to emerge. A landscape in
which the artist confines himself to a rendering of the visual scene
has no subject, but a landscape with a small child being suckled by
a goat has the subject of The Childhood of Jupiter, no matter how
tiny the figures. Degas remarked about one of his pictures of a
Woman in a Bathtub, "A hundred years ago we would have called
that *Suzanne au Bain.*" (And, of course, he would have had to
add at least a minimal suggestion of two peering elders.)

How many of the seventeenth- and eighteenth-century land-
scapes, still lifes, and genre scenes of lower- and middle-class
interiors are paintings without subjects and how many have extra-
pictorial meanings, allegorical, historical, moral, anecdotal, or
otherwise, is still a matter of debate. How many of those paintings
that clearly have subjects were executed for the sake of the repre-
sentation alone, and with very little interest in the subject on the
part of the artist or his public, is an even more difficult question.

There are, for example, residues of traditional allegorical sub-
jects in the paintings of Chardin, as recent work has shown, but
these residues are not very important for an understanding of his
work.

The ideal of art without a subject, the belief that painting must
sustain itself through its own intrinsic devices, is explicitly
broached first, as far as we know, by Romantic theorists like Tieck
at the tail end of the eighteenth century, following the French

Eugène Delacroix, Women of Algiers in Their Apartment. *During his
trip to North Africa in 1832, Delacroix paid a short visit to Algiers
and had a chance to observe the women in their private quarters. The
painting, executed two years later, was exhibited at the Salon of
1834, where Louis-Philippe bought it for the Luxembourg.*

Revolution. The way had been prepared for this ideal, but it remained a controversial issue. Much of the history of nineteenth-century painting can be written in terms of it, as it touches on the other important issues, like the hierarchy of genres (history painting, after all, is based on subject), and the controversy over the relation of a sketch to a finished painting (as many sketches reflect purely visual qualities more directly and more immediately than large-scale finished works).

When Constable's landscapes, which made such an impression on the advanced French painters, were exhibited at the Paris Salon of 1824, the critics complained that they had no subject. By the 1830s, it would no longer be a reproach for the most intelligent critics: to create a picture without a subject was beginning to be understood as a test of supreme artistry. The Romantic critic Gustave Planche in his *Salon of 1834* praised Delacroix's *Women of Algiers* specifically for this reason:

> This painting, in my opinion, is the most brilliant triumph that M. Delacroix has ever achieved. To interest by the art of painting itself reduced to its own resources, without the aid of a subject that can be interpreted in a thousand ways and too often distracts the eye of superficial viewers who, occupied only with their own thoughts, value a painting according to their dreams and conjectures, this is a difficult undertaking, and M. Delacroix has succeeded in it. . . . [In Delacroix's *Liberty Leading the People* of 1831] imagination conspicuously aided the brush. In *Women of Algiers*, there is nothing of this sort; it is painting and nothing more.*

With the Realist painters, the disappearance of subject became crucial: it guaranteed the truth of the picture, and the objectivity of the representation. "Subject" is always a manipulation of reality, an arrangement of the material that precedes the act of representing, just as the classical poses (on which history painting

* The translation is from Elizabeth G. Holt's *Triumph of Art for the Public* (1979), one of her invaluable and stimulating anthologies of writings on art.

generally depended to convey the subject) demanded an arrange-
ment of the human form that preceded even the conception of the
picture. The important change made by Realism to the Romantic
tradition was—at least ostensibly—an acceptance of life as it was:
the goal was to transcribe reality without previous alteration. With
a few important exceptions, not only does the disappearance of
subject characterize the work of avant-garde Realism, but even in
allegorical works like Courbet's *The Artist's Studio* there is evi-
dent a weakening of subject by comparison with earlier allegorical
painting.

6

The three enemies of Realist painting were the sentimental, the
picturesque, and the anecdotal. Into one of these three pitfalls
most of the painters displayed in "The Realist Tradition" tumble
almost constantly. Among the artists of avant-garde Realism, how-
ever, only Millet and Renoir at their weakest drop into the senti-
mental; and only Manet, most often ironically, and perhaps
Renoir, indulge in the picturesque. The anecdotal, in which "sub-
ject" attempts to reassert its rights, what Pissarro called *la ro-
mance*, appears in avant-garde Realism with exceptional rarity.
Not even Daumier, for whom subject appears to retain its impor-
tance, employed the anecdotal technique very often.

The anecdotal is the projection in time of the single moment
seized by the picture, leading away from the immediate visual
sensation into both past and future: the visual is therefore only the
initial impulse, and the goal lies outside the work itself. The anec-
dotal technique originated in Flanders and Holland, but it reached
its most elaborate form in Victorian genre painting, like that of
William Mulready and William Holman Hunt. Into a scene of daily
life, the painter drops little details that appear, at first glance, to
be irrelevant to the main action. They are clues to the past and fu-
ture, which allow one to reconstruct how the scene came about,
and to predict how it will continue. In this way, the painting be-

comes a point of departure for the spectator's fantasy, absorbing him in an imaginary world.

The insignificance and triviality of the clues are essential to the anecdotal technique. François Bonvin's *Young Savoyard,* for example, represents the boy counting his few pennies. He has an apple, a piece of bread, and an extra pair of shoes; these props are carefully placed to help us imagine, even create, the boy's life. (The catalogue entry remarks about the shoes that they are "ill-fitting, but a luxury nonetheless.") The anecdotal picture not only emphasizes the subject, but—by forcing one to speculate and even invent part of the subject—draws the mind away from the picture itself into reverie and reflection. It evades the effect of immediate real presence preferred by the Realist painter.

There is nothing anecdotal about Courbet's *Burial at Ornans:* we do not know who is being buried and we would not be one hairsbreadth closer to understanding the picture if that question could be answered. The spectator is entirely occupied by the aggressive presence of the personages—paralleled, mediated, and guaranteed by the aggressive presence of the paint. A genre scene is raised, by this aggression and by the life size of the figures, to the dignity of a history painting. The infinitely repeatable scene of a village funeral is given the singularity of an important historical event. This is what shocked Courbet's critics, and justly so. Even the most trivial aspects of a burial are monumentalized here without sentimentality. The "disappearance of subject" in Realist art did not prevent the artist from making controversial statements about society, religion, and death.

Along with the anecdotal, Courbet rejected the dramatic. He was not the only painter around 1850 to attempt to make a monumental work out of the material of daily life. Another example among several is Jean-Pierre Alexandre Antigna's *The Fire,* an important canvas in the Salon of 1850/51, which was shown in "The Realist Tradition": a family of poor workers is surprised by a fire in their humble garret. Antigna's procedure is essentially the same as Géricault's in *The Raft of the "Medusa."* He chooses a dramatic moment, an extreme situation, arranges his figures into a traditional pyramidal composition, and varies the poses according

Jean-Pierre Alexandre Antigna, The Fire. *The obvious qualities of this important painting, shown at the Salon of 1850–51, where Courbet showed the* Burial, *were appreciated in spite of complaints by conservative critics, and it was purchased by the government for the Luxembourg. Unfortunately, Antigna was unable to maintain himself at this level and his work for the most part sank into morose sentimentality.*

to precepts both formal and expressive that go back to Jacques-Louis David and the Classical tradition. The circumstances may be ordinary, but the situation is idealized by rhetoric and the actors magnified by drama.*

* In a series of fascinating articles, as well as in his book *Absorption and Theatricality: Painting and Beholder in the Age of Diderot* (1980), Michael Fried has explored the question of theatricality in French painting from David to Manet, but the focus is too narrow, and the development is better understood as part of the larger relation of painting to rhetoric.

Courbet, on the other hand, acts as if this classical tradition did not exist. The figures of the *Burial* are lined up, and give the initial impression of an absence of composition. Size seems to be enough to convey importance. Courbet can do without the classical formulas of composition because he has other tricks up his sleeve: popular imagery, the example of the recently discovered brothers Le Nain, and his own extraordinarily subtle sense of rhythm. He affirms the importance of ordinary life without raising it out of the ordinary, without insisting on the subject. (Of course, like Flaubert in *Madame Bovary,* he cheats a little bit. The skull in the foreground is one example: one does not normally see a human skull displayed during a burial, but this emblem of death is a concession to the traditional "subject.")

The picturesque, like the anecdotal, focuses directly on "subject": it emphasizes aspects of life that are exotic, quaint, outlandish. As the word itself implies, the picturesque claims that some aspects of reality make better pictures than others, or at least that ordinary life must be transformed, heightened, romantically transfigured in order to be made worthy of art. The picturesque dresses life; it, too, manipulates reality before the act of painting begins. It overlaps with the sentimental, which bathes the scene painted with conventional, second-hand feeling. The *Corner of His Studio* of Tassaert shows both tendencies with great charm: the painter, huddling up for warmth as he peels potatoes on the floor of his studio, is so young, so charming, so poor. This may be a realistic painting (after all, some young painters were handsome, and many were poor and often cold), but it is not Realist, for Realism—in spite of its pretensions to accept all of life—was as rigorous in its exclusions as academic Classicism.*

Sentimentality is hard to define, since the falseness of its emotion depends so much on the perception of the spectator. The critical history of Jean François Millet is a spectacular demonstration of this: pictures like the *Gleaners,* which originally seemed to be brutal and deeply stirring presentations of reality, were later con-

* For the most important study of Realist imagery see Linda Nochlin's *Realism* (1972).

Jean-François Millet, The Angelus. *Originally executed for the American painter Thomas G. Appleton, who did not acquire it, this 1857 painting was sold for a thousand francs and then changed hands a number of times. Its spectacular rise in price through these transactions is testimony to Millet's rocketing popularity. The picture eventually sold in 1889 for 580,650 francs to the American Art Association in the midst of great publicity, the French having failed to secure it for the Louvre. The painting was exhibited in several American cities, and was then sold once again in 1890 for 800,000 francs to Alfred Chauchard, director of a department store, who eventually bequeathed it to the Louvre.*

sidered sentimental and conventional. The still-infamous *Angelus* is hard to redeem from this charge. It is impossible to avoid the exterior associations not only evoked by the picture, but actually built into it: the painting itself stands in awe of the dignity of the peasant couple's lives, displays their merits and their sufferings, shows compassion for their piety. (Dimier, who hated this painting, claimed that it was exhibited in America under the title *They Have Buried Their Child.*) Yet Millet never sought out and exploited sentimentality the way a painter like Bastien-Lepage did in *The London Bootblack,* seen in the "Realist Tradition" exhibit. Where so much cosmetic is applied to the misery, the spectator

Jules Bastien-Lepage, The London Bootblack. *The picture was painted in London in 1882 in the studio of Dorothy Stanley, who described the artist's method with great precision.*

immediately understands that not only the picture but the scene itself is nothing but a picturesque image. Bastien-Lepage's engaging apple-cheeked cockney boy, so picturesquely attired, makes Murillo's charming beggar children look positively grubby by comparison.

7

In its pretense of objectivity, its apparent refusal to take a moral stand, avant-garde Realism often puzzled contemporary critics. Manet's *Olympia* sometimes seems as puzzling today as it was to Manet's contemporaries. The woman confronts our gaze,

making us uncomfortably aware of her presence, or rather of our intrusion. The scenario is easily decipherable, and yet leaves ample space for ambiguity and uncertainty. A black servant brings in a large bouquet of flowers sent by someone, possibly by us. Olympia is nude but she wears slippers and a black ribbon round her neck. These props, which are foreign to the traditional nude, make her look naked, undressed. Worst of all, in the eyes of Manet's contemporaries, she deliberately covers her genitals with her hand, making the impression of nakedness and intrusion unavoidable. In the traditional nude (Titian's *Venus of Urbino*, for instance) the woman's hand often looks as if it had strayed accidentally but gracefully so as to hide her private parts, while Olympia clearly holds her hand there with a decisive gesture. At her feet, a black cat, this most Baudelairian of animals, prowls as if to make the sexual intent of the scene even more explicit.

There has been much speculation about the scandal created by the picture when it was shown at the Salon of 1865 (two years after it was painted; Manet seems to have hesitated to exhibit it). There were many reasons why it would shock—first of all, Manet's way of painting, in flat tones, with contrasted large areas subtly modulated but with very little modeling. This handling, which seems so exquisitely delicate today, appeared crude and ugly to most people at the time, even to Courbet. As representation, it seemed false because it was so different from the "correct" way of representing the human body, and at the same time it seemed crudely realistic, too much like real skin, real flesh.

What baffled contemporary critics (and still seems to baffle modern ones) is less what Manet did than what he refused to do. Manet did not sentimentalize this slim, successful prostitute—this is clearly what we are faced with—the way Alexandre Dumas had turned Marguerite Gauthier (of *La Dame aux camélias*, later to become the libretto of *La Traviata*) into a sympathetic victim of prejudice: Olympia is neither embarrassed nor dissatisfied with her profession. Nor does Manet idealize or sanitize his model by art, removing her from contemporary life into an atmosphere of unreality distant in time or space, where moral values would no longer prevail and where the beautiful replaces the good. She is

Edouard Manet, Olympia. *The model was Victorine Meurend. Shown at the Salon of 1865 two years after its execution, this painting was one of the most brutal confrontations of the century between an artist and an uncomprehending public. At first the critics were almost unanimously, and ferociously, hostile, but Emile Zola took on Manet's defense and judged* Olympia *his most accomplished and characteristic work.*

not an exotic, picturesque figure, some sultana imagined by Delacroix or Devéria; she is almost the absolute opposite of the odalisques in Ingres's ultimate sexual fantasy, the famous *Turkish Bath,* painted by the aged master at the same time as Manet's work. *Olympia* is no dream.

Most disturbing for a nineteenth-century audience, we suspect, must have been Manet's detached attitude to his Olympia—his refusal to moralize, to pass judgment—all the more so because the prostitute was very much a favorite nineteenth-century subject, and one that, precisely because it opened the door to all kinds of fantasies, demanded a clearly defined moral attitude—humane pity, indignation, or whatever. Simple acceptance, the Realist atti-

tude, was hard to swallow. In *Romans of the Decadence*, Couture
had placed a courtesan at the center of his *grande machine:* ener-
vated and enervating, corrupted and corrupting, this languid
beauty is the very symbol and principle of moral decline. Couture
made certain that his lesson would be clear and unavoidable, in
spite of (or even because of) the erotic appeal of the nude, by
having moral philosophers frown disapprovingly on the central
group, where his courtesan reigns.

We may apply directly to Manet's *Olympia* what Baudelaire
wrote in his review of Flaubert's *Madame Bovary:* "Let us then be
vulgar in our choice of subject, since the choice of too grand a
subject is an impertinence for a nineteenth-century reader. And
also let us make quite sure we do not let ourselves go and speak
our mind. We shall be like ice when we tell of passions and adven-
tures that enflame ordinary people; we shall be, in the terms of the
[Realist] school, objective and impersonal." This passage gives us
some idea of the direction taken by Manet in the early 1860s. He
had adopted a style that enabled him to confront the contempo-
rary moral issues without, apparently, taking a moral stand. It
was, indeed, a style that revealed the hypocrisies covered by the
artistic conventions of the female nude that he deliberately aban-
doned.

Yet one feature distinguishes Manet's procedure from that of
other exponents of Realism; it is the explicit, even blatant, refer-
ence to previous art—here to Titian's *Venus of Urbino* and
through it to the whole tradition of the female nude. The idea that
Manet borrowed compositions because he lacked imagination, an
explanation that prevailed for a long time, now seems absurd. Nor
can we say that the memory of the old masterpiece is evoked
either to ennoble Olympia or to satirize her; there is no trace of
either idealization or satire in the picture. It has been suggested by
Linda Nochlin that Manet's intent was to make fun of Titian's
painting,* but if he was being explicitly satirical (in Nochlin's

* In "The Invention of the Avant-Garde," *Art News Annual* XXXIV
(1968), p. 16, quoted by Reff, *Manet: Olympia* (1977).

Thomas Couture, Romans of the Decadence. *The conception of the work goes back to 1844–45; in 1845 Couture started the painting and in 1846 the state purchased it in advance of its completion. It was the* clou *of the Salon of 1847, where it had an almost complete triumph.*

terms, if the picture was a big "joke" on Titian), then surely contemporary critics would have had less difficulty understanding the work. But no one ever seems to have found it funny, and such a joke would have been out of character, given Manet's great respect for artistic tradition.

It seems likely that Manet was commenting on the old masterpiece, or measuring himself against it. Theodore Reff has pointed out in his brilliant monograph on *Olympia* (1977) that there was considerable discussion in the nineteenth century as to whether Titian's famous picture represented the classical goddess or a real Venetian courtesan. It may well be that *Olympia* refers to this debate and even takes a stand: in that case, Manet would be saying that Titian's Venus was indeed a courtesan presented realistically

in terms of sixteenth-century style and sixteenth-century life, and that his Olympia was the modern equivalent of Titian's courtesan.

By painting the Venus of Urbino of his day, Manet retrospectively affirmed the modernity of Titian's work and restored the relevance it once had before it became an almost sacred object. Titian's *grande horizontale* is as Venetian in her voluptuous roundness as Manet's is Parisian and mid-nineteenth-century in her nervous, cramped beauty. Manet's work is parody, not as satire, but in the serious meaning of "parody" as a varied repetition. Manet is ironic only in one sense: he compares himself to Titian but withholds the terms of the comparison, the rules of the game.

8

How the disappearance of subject worked for nineteenth-century Realism can be seen if we compare two pictures close together in time, both related to the fall of the brief revolutionary government of the Commune in Paris of 1871, and both using the technique of allegory, where subject cannot be completely eliminated. "The Realist Tradition" showed Meissonier's *The Ruins of the Tuileries* (1871). In the foreground is portrayed, in minute realistic detail, the ruins of the Tuileries palace, which had witnessed the pomp and circumstance of the Second Empire. At the center of the painting, framed by a gap in the ruins, we see, sharply contrasted against the blue sky, the distant silhouette of the top of the Arch of Triumph of the Carrousel with its bronze group of the Triumph of Peace. To avoid any doubt about his intention or his fidelity to the Empire that made his fortune, Meissonier placed a Latin inscription on the front of the picture, which tells us that "the glory of our forebears survives the flames."

The meaning of the work depends on conventional and classical devices: centrality and frontality confer nobility and importance, distance in space stands for distance in time; the whole *concetto* (or conceit, in the old Baroque sense) depends on our extrapictorial knowledge of the things represented. Without these fea-

Jean Louis Ernest Meissonier, The Ruins of the Tuileries. *The Latin
inscription reads:* GLORIA MAIORUM PER FLAMMAS USQUE SUPERSTES
MAIUS MDCCCLXXI.

tures, Meissonier's canvas would be simply a documentary and picturesque view, like the painting of the same motif (also in the "Realist" exhibition) by Isidore Pils. Meissonier's striking image has to be deciphered, like the traditional emblematic conceits of seventeenth-century poets.

There is also a painting by Courbet dated 1871; it, too, has a Latin inscription: *71 G. Courbet in vinculis faciebat* ("71 G. Courbet made this in prison"). The picture, one of Courbet's late masterpieces, is of a large hooked trout fighting for life. The work eludes classification according to traditional genres: it is not a still life, although that is the only kind of painting in which one would expect a trout (and Courbet painted several such still lifes). Although seen against a natural background of water and earth, the fish almost fills the canvas. It is, at the very least, life-size, the kind of heroic catch that anglers brag about. Dramatically presented, carefully and brilliantly executed, the picture can be viewed close up only with some discomfort. The projection of human feelings and situations into the animal realm has a venerable tradition, but Courbet manages to give an impression of complete immediacy.

The intention of allegory is asserted by the Latin inscription—and, in fact, by the date as well, since most experts believe the picture was not painted in 1871, when Courbet was imprisoned for his activities during the Commune, but later, in 1872 or 1873, in Ornans, before he fled to Switzerland. Not that Courbet was above boasting that he could paint such a picture in his prison cell, but it was equally like him to compare himself to such a grandly beautiful trout—a self-portrait, in fact, rather than a still life. The Latin inscription is both a declaration of an elevated meaning and an ironic reference to such high-toned inscriptions in other paintings. This discussion, however, is largely irrelevant, as the feeling of being a hooked fish is conveyed so directly by the painting itself.

For this reason, one might almost say that Nochlin was right to conclude in her book *Realism* (pp. 73–74) that this is just a painting of a fish. The "subject" tends to disappear: the picture is what it seems to be. That is also true of *The Artist's Studio,* which

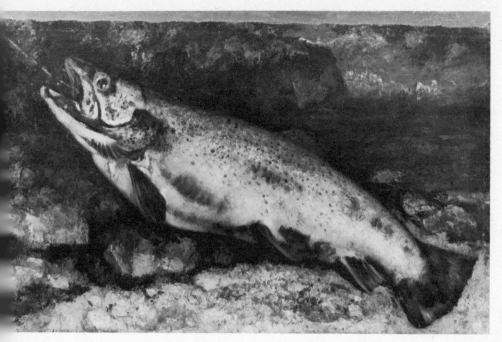

Gustave Courbet, The Trout. *Though inscribed at bottom left,* 71
G. Courbet. In vinculis faciebat, *the picture is generally thought to
have been painted in Ornans in 1872 or 1873. The allusion to
Courbet's imprisonment after the Commune is all the more significant.*

Courbet himself called "A Real Allegory." In Realist allegory, visual reality is accepted, and the significance is not at one remove from it. Meissonier's *Ruins of the Tuileries* is the graphic transcription of an idea; Courbet's *Trout,* the visual embodiment of an experience.

The disappearance of subject in Realist painting clearly did not mean a lack of concern for what was painted, but a refusal to falsify it, a renunciation not only of the idealizing rhetorical gestures and classical compositional grouping, but also of conventional sentiment or exoticism. It meant an acceptance of visual reality, of that which was given immediately to the eye—and a faith that this reality could be transcribed without falsification into art and still speak for itself. Few of the works in the "Realist" exhibition display this faith (with the exception of François Bonhommé's ex-

traordinary stark pictures of factory interiors and mining land-scapes, which, in contrast with most Realist art, were painted as a celebration of capitalist industry). One can learn more about Real-ism in nineteenth-century art from Flaubert's correspondence than from "The Realist Tradition."

Efforts to rehabilitate the minor Realists and the more "offi-cial" figures of nineteenth-century art are motivated, at least to some extent, by a reasonable and scholarly desire to avoid seeing the past century entirely through modern eyes. The supremacy of Courbet, Manet, and the Impressionists—the "modern tradi-tion" in short—is at least partially due to their importance for twentieth-century painting. They are our ancestors, or so we like to think. A more objective approach would surely acknowl-edge the contacts between the avant-garde artist and those who were able to obtain government patronage.

Only Pissarro was totally intractable and uncompromising, but Manet never quite gave up the hope of official recognition, and Degas, who spurned it, had many friends outside the avant-garde—especially among fashionable painters like De Nittis and Gervex, who made avant-garde innovations palatable. It is true that the original Impressionist exhibition of 1874 in Nadar's stu-dio must have looked very different from our present idea of Im-pressionism; many of the artists who participated in this show might not today be considered as belonging to the "modern tradi-tion." The ambiguous status of Thomas Couture in the 1840s and 1850s and of Puvis de Chavannes after that is an indication of the complexities of the artistic situation.

Paradoxically, however, in trying so hard to avoid imposing a twentieth-century viewpoint on nineteenth-century art, historians may end up by obscuring some of the most essential and dynamic elements of mid-century Realism. The "disappearance of sub-ject," for example, is not a twentieth-century notion read anachro-nistically into earlier work. Degas, looking at Renaissance pictures of historical and religious themes, remarked, "We have let all those idiots take these beautiful subjects away from us." The "dis-appearance of subject" was won with difficulty, and not, as we see, without nostalgia for the past. But the line that Degas drew be-

tween those who abandoned "subjects" and the "idiots" who continued to paint them was firmly drawn, and it separates the modern tradition from the academic work that neoconservative historians hope to resurrect.

Seen by nineteenth-century eyes, in fact, Realism was above all an avant-garde movement. Wagner's *Lohengrin* and *Tannhäuser* are hardly representations of contemporary life, and yet they were oddly labeled "Realist" at the time; that arch-reactionary music critic François Joseph Fétis even called Wagner "the Courbet of music." Because of its avant-garde character Wagner's work was assimilated to Realism and championed by the Realists; they were the ones who organized a clique to applaud *Tannhäuser* when the members of the Jockey Club conspired to hoot it down.

One final quotation from Flaubert sums up, perhaps better than anything else, the extraordinary achievement of the mid-century avant-garde. In a letter of January 23, 1854, to Louise Colet he rails against French culture and complains that for two centuries life and art have been impoverished, sterilized, and constricted in France; he adds:

> But I believe there is something above all this, to wit: the ironic acceptance of existence and its plastic and complete recasting through art.

This needs no further comment, except that the quality of irony of many of the avant-garde Realists—of Daumier, Courbet, Manet, Degas, and Seurat—sets them off by a gulf from other painters of contemporary life. This irony has received neither the recognition nor the study it deserves.

VII

THE RECOVERY
OF THE PAST
AND THE
MODERN TRADITION

1

In the French university system, what is called "modern" art begins with the Renaissance, with the rediscovery and revaluation of classical Roman art and Greek and Roman culture, and the attempt to transform all contemporary art to meet the standards derived from a study of the Ancients. How far classical culture was really unknown and unappreciated during the so-called Middle Ages, whether the artists of the Renaissance really produced their works according to classical canons, to what extent the Renaissance was an exercise in promotion and publicity—these are complex questions which we shall beg cheerfully and without regret. The classical norms remained theoretically in force with some uneasiness until the end of the eighteenth century, when they met with massive opposition, but the model of the Renaissance—the rediscovery of a forgotten style and its canonization as an ideal for contemporary art—set a pattern for revolutionary movements in art. Later artists who wished to upset the status quo often looked for ancestors, for a legitimation through genealogy.

The history of nineteenth-century art is bound up with a series of reassessments of forgotten or despised styles and artists; what is unprecedented is the number and variety of the rediscoveries. Most of the new movements in art that make up the standard history of the nineteenth century are bound up with a new appreciation of a neglected part of the past. Both art and scholarship were deeply historicist in the nineteenth century. The styles of the past were a means for the modern artist to find his own individuality: the paradox that this embodies was a nagging source of worry to many critics of art and architecture at the time.

The early nineteenth century's worship of the Gothic helped to create some of the most characteristic Romantic forms: the *"style troubadour"* (practiced by painters as opposed as Delacroix and Ingres), the Gothic novel, and melodrama are only the most obvious productions of the mania for things Gothic. The despised Ro-

coco was revived by the brothers Goncourt, and admired and imitated by such painters as Tassaert and Roqueplan both as a novelty and as a way of attacking Davidian Classicism; the Rococo influence extended even to Millet. The Realist generation of Courbet and Champfleury discovered that the French, like the Dutch, had had a Realist school in the seventeenth century, with the brothers Le Nain. Later artists, scholars, and dealers went farther afield: Manet admired the recently popular Japanese prints not only as exotic curiosities but as models of art; by the end of the century Gauguin imitated the folk art of Brittany, the reliefs of South Asia, and even the carvings of primitive peoples. (These latter had already interested Romantic artists like Préault, who pointed out their importance to Baudelaire.)

It would be a mistake to assume that all these newly appreciated styles and newly discovered artists were completely misunderstood or unknown before they were brought into prominence. Many of these discoveries can be seen as largely a popularization of what had been understood all along by a few connoisseurs, but this way of putting it hides the nature of the revaluations, which often illuminate fundamental shifts in taste, aesthetic outlook, and even political interest.

The emergence of the taste for the Gothic may serve briefly as an example. The great Gothic cathedrals never completely lacked admirers, even at the height of the Renaissance reaction against Medieval style. During the seventeenth century, too, when Classicism was deeply entrenched, some of the most important architects—Wren in England, and Borromini and Guarini in Italy—continued to study and adapt Gothic forms; in France, churches in Gothic style were still sometimes built for ideological reasons by monastic orders, and above all by the Jesuits. (Founded in 1540, the Jesuit order was a relatively new one that needed to live down its youth: the use of an outmoded style was a striking way of asserting its adherence to tradition. Etienne Martellange was the most important Jesuit architect in France during the seventeenth century, and the best example of his Gothic style is at La Flèche.) The comparison of a Gothic cathedral to the trees of a forest, generally supposed to be an invention of the

Romantics, with their interest in "organic" form, was made by a seventeenth-century Jesuit poet, Pierre Le Moyne, who contrasted the degenerate modern architecture of the cities of his time with the great medieval buildings.* Not that the comparison of architecture to trees was a novelty even in the seventeenth century: it dates back to Vitruvius and was eventually put to hard work by eighteenth-century Neoclassical theory—and practice, too, with the insistence on stumpy classical columns, which appear to grow directly out of the ground. But Gothic architecture lends itself with particular aptness to the simile, and this was perceived and exploited in the fifteenth century by the architects themselves, who designed moldings to look like wood (dead wood with dry twigs at Sens), and even created columns that sprout roots at their bases.

The interest in, and sympathy for, the Gothic that continued uninterrupted from the sixteenth to the end of the eighteenth century was of a different nature from the later Romantic mania. Medieval literature was collected by eccentric antiquarians, and publication of medieval works occurred in the early eighteenth century. The architect Nicholas Hawksmoor produced an up-to-date version of Gothic in 1718 for All Souls College at Oxford (and it looks already very like nineteenth-century Gothic), Jacques-Ange Gabriel worked on a Gothic façade for Orléans Cathedral, and Germain Soufflot studied and used the structural aspects of the old style. A new note, however, was struck in 1770 with Goethe's essay on Strassburg Cathedral: this was a truculent manifesto of a new, nationally inspired school of art; and Gothic architecture became, like Shakespeare, a weapon for the destruction of Classical art. The climax was reached by the middle of the nineteenth century, when Pugin claimed that the Gothic was the only style in which one should be allowed to build: Gothic architecture was *modern* architecture.

Clemens Brentano is a witness to the fundamental modernity of the Romantic view of the Gothic: he said in a letter to Philipp Otto

* Joseph Ryckwert, in *Adam's House in Paradise* (2nd edition, 1982), gives several interesting examples, preceding the Romantic movement, of the comparison of Gothic architecture to trees.

Runge that a poem by Hölderlin, a painting by Matthias Grünewald, and the work of Runge himself were the three greatest artistic experiences of his life. To a Romantic poet, Grünewald was Gothic, as Dürer was, or Johann Sebastian Bach, who made Romantic critics think not of Baroque churches but of lofty medieval cathedrals. Romantic historicism could sometimes, with scholars like Joseph Ritson and Fustel de Coulanges, achieve an almost pedantic sense of the stylistic consistency of a culture, but it was generally hit-or-miss when issues of contemporary art were at stake. That is why the Medieval revival lived comfortably side by side with interest in a Renaissance poet like Ronsard, who was seen by Sainte-Beuve as a precursor of the Romantic poet for his vitality, for his freedom, and, above all, for his enormous ambition, his aspiration to the sublime. Flaubert was to say that Ronsard was the greatest of all French poets, a model to be held up to contemporary writers, a claim that the more wily Sainte-Beuve never quite ventured.

Scholarship and artistic invention did not run in tandem in the nineteenth century, but at their most effective they supplemented and reinforced each other. This is what allows us to plot some of the changes in contemporary style by the changes in the direction of scholarship. The revival of Ronsard gave way by the 1840s to an interest in seventeenth-century poets, not only Racine but Baroque poets like Théophile de Viau and François Maynard, who were particularly attractive to Baudelaire. Although Théophile had been condemned by the dominant classical taste of the late seventeenth century, his work showed a strong classical influence; and the interest of Baudelaire's generation is significant in the light of the developing classicism of the mid-nineteenth century. Baudelaire's own prosody and rhythm are closer to Racine's than to Victor Hugo's. Similarly in the visual arts, the restoration during the reign of Louis-Philippe of the work of Francesco Primaticcio and Rosso at Fontainebleau is reflected in contemporary painting by a direct influence on Delacroix and his attempt to recreate a modern version of the great decorative projects of the Renaissance.

Objective justice is always the ostensible goal for these revivals,

the rectification of past misunderstandings, the discovery of mis-
understood genius. Most of the promoters have something else up
their sleeves, and we should be wary of some nineteenth-century
criticism of the past for this reason. When Champfleury brought
the brothers Le Nain out of obscurity during the 1840s, he wrote
that admittedly they had serious faults, including a lack of compo-
sition. T. J. Clark has pointed out* that their "faults" were exactly
what Courbet chose to imitate. Did Champfleury, very close dur-
ing those years to Courbet, really think that the structure of the
Le Nain pictures was faulty, or was his apparent admission a kind
of lightning conductor—an attempt to placate contemporary
taste? It was surely good tactics to confess from the start that the
pictures were not composed according to the best academic stan-
dards, and then go on to those aspects of the works that would be
more immediately acceptable. And it always requires an effort to
free oneself from the good taste of one's own time; Champfleury's
initial reactions to his discovery, like most other people's, must
have been mixed. A critic's sensibility, like an artist's, is generally
in movement, particularly in a time of rapid stylistic change. For
the nineteenth century, we cannot take contemporary witnesses at
their face value, or believe that they express, even for themselves,
a definitive judgment.

2

The hidden motives in these developments of taste may often
have been less artistic than social or political—in any case, all
these revival movements made for odd bedfellows. But sometimes
a purely political interest may have allowed an almost equally pure
aesthetic sensibility free play. We see something of this confusion
in the intense search in nineteenth-century France to discover a
sixteenth-century French Renaissance style. That search mani-
fested itself in a widespread use of the Loire Château architectural
style and ornament, the imitation of so-called Henri II furniture,

* In *Image of the People* (1973), p. 16.

the avid collection of the painted enamels produced at Limoges, and the above-mentioned restoration of the painted decorations at Fontainebleau.

In the middle of the century, Léon de Laborde, nobleman, art historian, right-wing politician, explorer, amateur photographer, curator at the Louvre—a great original, in short—introduced a new trend by making an intense study of the beginnings of French painting. Nationalism and royalism were the moving forces of his work. He entitled his book *The Renaissance of the Arts at the French Court* (1850–55), and the first chapter was devoted to the decisive and continuing role of king and court in artistic production and in the formation of taste from the Middle Ages to the present. He argued that the great sculpture of the thirteenth century was already a reflection of courtly elegance. However, his major concern was the distinctiveness and continuity of French art. He wrote: "There was, in my opinion, *and I want to rediscover it,* a national art which I believe I can trace from the Greek colonies and the Roman domination until our own day" (our italics). He could not have stated more eloquently the ideological basis for the rediscovery of an art whose very existence was questionable.

Laborde was largely an archivist, and he found more written evidence than actual works of art. The immediate result of his research was the publication of the mass of documents that form the basis for our knowledge of the School of Fontainebleau, that is, of the Italian Mannerists who worked for Francis I and his successors—above all, Rosso and Primaticcio.

Ironically, Laborde showed no particular preference for this kind of art. He was ill-at-ease with it, partly because his nationalism and his royalism were in conflict. The prominence of Italian artists rendered the art of Fontainebleau suspicious; on the other hand, his faith in king and court gave it status and importance. What Laborde really liked was Clouet and, above all, Jean Fouquet and fifteenth-century painting. As he says: "To try to attribute the Renaissance in France to the impulse given by five or six artists that Francis I had installed at Fontainebleau—that amounts to confusing the false Renaissance with the real one, our Italian Renaissance of 1550 with the French Renaissance of

1450; or rather, as has generally been done since the sixteenth century, and is too readily accepted today, it is to disregard the value of French art, its originality, its continuity."

In other words, he was looking for French "Primitives." He did not call them that, and he did not find many of them, but he started a movement which, after a slow and patient effort, eventually found its fulfillment with Henri Bouchot's famous exhibition of 1904, *Les Primitifs français*, where works by Fouquet and indeed most of the other fifteenth-century French paintings now known to us were exhibited. The enthusiastic nationalism that possessed Bouchot was boundless: his work was a form of French imperialist annexation. He even claimed, "In the fourteenth and fifteenth centuries, the Van Eycks, although born in Maeseyck, although considered as Flemish and speaking some local Germano-Flemish dialect, were nonetheless French, substitute Parisians, the product of our land." Bouchot's chauvinism reduced Flemish painting from Van Eyck to van der Goes to nothing more than a provincial variety of the great French school.

What is striking in this movement is not only its willful reconstruction of a national fifteenth-century style of French painting, but, as a corollary, the condemnation of the later Renaissance, of what we now call Mannerism. Francis Haskell has noted that the remarkably inclusive collecting of the 1840s and 1850s was also strictly aesthetic, very little biased by political or religious prejudices.* Laborde belonged to that generation: a complex and colorful figure, he was himself a distinguished collector—not everyone owned a head from the Parthenon. His nationalist views of a "French" Renaissance may have implied a censure of the later, sixteenth-century Italianizing style but he never made this explicit. He did not—at least not consciously or openly—disapprove of the later Renaissance. Not so his followers. Like Ruskin, whose ethical-artistic creed made him forbid his workers to look at the art of the Carracci brothers, the supporters of the French Primitives had to condemn Primaticcio and Rosso; Bouchot was vehement on this subject.

* *Rediscoveries in Art* (1976), p. 73.

It was during the reign of Louis-Philippe that Primaticcio's decorations at Fontainebleau had been fervently restored: the purpose of the restoration was largely political. The palace of Francis I at Fontainebleau was, even more than Versailles, a symbol of the continuity of the French dynasty, but the sixteenth-century frescoes were, in fact, admired for their artistic merit—and also seriously disfigured by the restorers. By 1900, however, it had become something of a provocation for Louis Dimier to publish a large scholarly monograph on Primaticcio. The exhibition of French Primitives of 1904 had a section of sixteenth-century pictures, and Bouchot expressed his full contempt for an art that in his eyes was antithetical to the French national genius: "Rooms will be reserved for the sixteenth century, where one will find the French works of the Clouets and of Corneille de Lyon, compositions still Gothic and national, soon to be submerged by the sad movement of the Renaissance, by works made for the use of princes afflicted with exotic snobbisms. The influence of Italy in its decadence, of Cellini, Primaticcio, Rosso, brilliant acrobats, bold jugglers, had penetrated our country. Then do we find these frail, false, lifeless, thoughtless forms that the School of Fontainebleau imposed everywhere." When, in an acrimonious exchange, Dimier protested some of the serious scholarly weaknesses of the exhibition, Bouchot peremptorily said that a man who had written a large book on Primaticcio could not possibly be taken seriously in a discussion of aesthetic matters. Between Laborde and Bouchot a shift had occurred. The older man had preferred what he considered the early French Renaissance of the fifteenth century to its later development; for Bouchot there is a break between the "Gothic" Primitives of the fifteenth century and the Renaissance, which he condemned, at least in France, as a foreign intrusion.

Although in 1850 Laborde published the documents that constitute, as he himself put it, "the solid foundation of a new and true history of the school of Fontainebleau," this history was not written until fifty years later, when Dimier published his monograph on Primaticcio in 1900—and the significance of this art remained unappreciated for another two decades. Dimier, in spite of his extreme right-wing politics, was fiercely opposed to national-

ism in intellectual matters. His work was intended to prove that the very concept of "French" art was vacuous, and that the real painting of France in the sixteenth century was created by Italians, Rosso and Primaticcio, and by Jean Clouet, a Fleming (as Dimier mischievously emphasized in order to embarrass those scholars who wished to see Clouet as purely French). His scholarship was dazzling, but it did very little to restore Primaticcio's fame.

Only from the 1920s, with the "rediscovery" of Mannerism, did the School of Fontainebleau come to be more generally appreciated. This revival of Mannerism, as is well known, was directly related to the art of German Expressionism, to the extent that our present view of Mannerism has been heavily colored and even partly distorted by the Expressionist aesthetic. From 1921 until the Wildenstein exhibition of 1939 almost all the major discussions of the School of Fontainebleau came from Germany. In France during the first decades of this century, it was Bouchot's taste for the Primitives that prevailed. This was a survival of the Romantic taste for the Gothic, but it was effectively reinforced by the modernist Primitivism of the 1890s. Bouchot's generation enjoyed a certain bareness and awkwardness of style, as well as the decorative values of two-dimensional arabesques. It was the artists who gave the signal for these changes of taste: Emile Bernard imitated popular woodcuts, and the importance for Gauguin of the folk-style Calvaries of Brittany has already been mentioned above. We must remember that this transformation of sensibility was active in contemporary art in order to understand the forces that prepared the immense success of the exhibition of 1904.

Of course, the change of taste in France did not occur in isolation, and it is connected with all the other national and religious vindications of Primitives, first those of the Germans and then of the Belgians. (The Belgian "nation" was itself in question and demanded ideological buttressing all the more.) The late Renaissance was also violently condemned on moral and religious grounds by Ruskin and other Gothic enthusiasts.

Yet the enterprise of Laborde and his followers is impressive, both for its success in recovering a whole field of collecting almost

entirely on the basis of sheer national faith, and for the efficacy of the anathema cast on the art considered as the enemy, the School of Fontainebleau. Its rediscovery in our own century was made all the more effective. In the history of the neglect and rehabilitation of the School of Fontainebleau, it is impossible completely to disentangle the roles played by nationalism, politics, and contemporary movements in art.

3

The incentives of nineteenth-century rediscoveries and revivals were multiple, complex, and sometimes contradictory. It is now received wisdom that the tendencies of contemporary art played a dominant role in these revivals, and that truly effective recoveries from the past are directly connected to the concerns of living artists. The finest account of these nineteenth-century revivals is Francis Haskell's *Rediscoveries in Art* (1976), a work that is fascinating to read and will remain indispensable for a long time to come. Haskell does justice to the complexity of the problems with exceptional tact: a child of British empiricism, he is suspicious of received wisdom, and he likes nothing better than to stand a commonplace on its head. In one of the most provocative chapters, he qualifies the notion that modern art is responsible for the major rediscoveries of older styles by showing how the Pre-Raphaelite movement in some ways hampered rather than promoted the appreciation of the Italian Primitives. A whole section of the public and many critics were repelled by the modern movement of Millais, Hunt, and Rossetti in England and extended their antipathy to the earlier art such advanced artists admired. While this may indeed have delayed the general acceptance of early Italian painting, it nevertheless only binds the new art more closely together with the recovery of the old, making one more dependent on the other.

In his treatment of Théophile Thoré, Haskell returns indirectly to the same theme in a manner more dangerous for the traditional

thesis. He writes, "Thoré's Vermeer, and even his Hals, were created in opposition to the most 'advanced' trends in the art of his own time." If this is true, then the relation of modern art and the appreciation of older styles is not what we have thought. This challenging statement deserves careful scrutiny all the more because, according to Haskell himself, Thoré "is the archetypal hero of this book."

Thoré was principally a critic of modern art, one of the greatest of the nineteenth century. He was engaged in the Romantic movement and admired painters like Delacroix and Théodore Rousseau, the leader of the Barbizon school. A socialist in politics, he believed in modernity for its own sake, and as years went by, he extended his support to Courbet and Realism. He even kept up with the modern movement; at the end of his life, in the late 1860s, he gave favorable notices to Monet and Renoir astonishingly early in their careers. He hated on principle what seemed to look back and prevent change, and he aggressively attacked the imitation of antiquity or the Renaissance; allegory, which he barely tolerated in old painting, he detested in modern. He was consequently unfair to Ingres and totally blind to the merits of Gustave Moreau.

According to Haskell, Thoré's support of Realism—of Courbet, Millet, and Manet—was considerably less than enthusiastic and wholehearted; even his great friend Théodore Rousseau disappointed him with his later work. In Haskell's view, Thoré turned to early painting—the Dutch seventeenth century in particular—as a reaction against the modern school. What he missed in the moderns was a deep humanity, which he found, as Haskell suggests, in the psychological interest of the figures, faces, and scenes of Dutch painting.

Haskell here brings out an aspect of Thoré's thought that has been neglected. Certainly Thoré's idea of Vermeer is by no means that of the pure painter that Proust has bequeathed to the twentieth century—an artist, so to speak, entirely free from the contingency of his time. For Thoré, Vermeer was a follower of Rembrandt; he was convinced that Vermeer must actually have worked in Rembrandt's studio; and he was keenly aware of a hu-

manistic side to Vermeer, the types he represented, their physiognomic qualities, and the human interest of the scenes. He was even aware of the allegorical implications of Vermeer's pictures, an aspect of the artist that is being "rediscovered" today. But of course, with his distaste for allegory, he did not exaggerate its importance as some do now in their pride of having something new to say. "Fortunately," Thoré wrote, "in Vermeer, one discovers these little allegorical subtleties only after one has understood everything through the expression of the characters. . . ."

If Thoré's Vermeer was not the disembodied, highly abstract painter he has often become for some twentieth-century critics, it does not mean that Thoré was unaware of something peculiar to Vermeer, those qualities that make him accessible to a modern sensibility. We cannot agree with Haskell when he writes: "Thoré did *once* come very near to seeing a different, non-humanist Vermeer, more akin to the painter who has appealed to later art lovers. But ironically he did this when commenting on a picture that we now know to have been painted not by Vermeer, but by a late eighteenth-century imitator of the Dutch golden age." Thoré did see this "different" Vermeer more than once, and from the very beginning.

The first time Thoré mentions Vermeer's works, in his first volume on Dutch museums (1858),* he introduces him as a great but strange painter, and the now-famous cityscape, the *View of Delft* in The Hague, is the only picture he describes. Here is his account of the picture in full:

> In the picture at The Hague, *View of the City of Delft from the side of the canal,* he has pushed the impasto to an exaggerated degree such as we occasionally find today with Monsieur Decamps. It seems as if he wanted to build his city with a trowel; and his walls are made of real mortar. Too much is too much. Rembrandt never fell into such excess; if he uses impasto in the light areas, when a strong ray sets a form into relief, he is sober in the middle values, and he obtains the deepness of shadows by simple and light scumbling.

* W. Bürger, *Musées de la Hollande* (1858–60), vol. 1.

In spite of this masonry, however, the *View of Delft* is a masterly painting and a very surprising one for art lovers who are not familiar with Van der Meer.

It is clear from this that Thoré thinks of Vermeer in modern—almost in avant-garde—terms, and that he was shocked by him the way one is shocked by a radical contemporary painter. Decamps, of course, was hardly avant-garde in the 1850s, but Courbet, too, was accused precisely of painting with a trowel. Admittedly, it is hard for us today to see this roughness in a picture that Proust, among others, admired for the supreme refinement of its painted surface.

Later, in Thoré's monograph on the Dutch master, a chapter starts with this paragraph: "Vermeer's most prodigious quality, taking precedence even over his physiognomic instinct, is the quality of light." He elaborates upon this for many pages, and at one point comes reasonably close to Proust's *"petit pan de mur jaune."*

> As a painter of little familiar scenes, Vermeer has his equals. As a painter of cityscapes, he is unique. . . .
>
> The most extraordinary work in this vein is the *Façade of a House* (Six Gallery) [now at the Rijksmuseum, Amsterdam]: a worker's house in Delft, seen full front, the roof cut off by the frame; just barely a glimpse of the sky, above a courtyard; in the foreground, the paving of a kind of sidewalk in front of the door, where we see a woman sitting. Nothing but a wall, and a few casements without any ornament. But what color!

The reasons why Thoré turned to the study of Dutch painting were, indeed, intimately connected with the advanced contemporary art, from the Romantics to the early Impressionists, which he championed so effectively for many years. Some of these reasons were political—a bourgeois art, represented both by the seventeenth-century Dutch and the nineteenth-century Realists, was opposed to the aristocratic art of the Italian Renaissance and the official "Classical" art of the nineteenth century. Other reasons were ethical—Thoré preferred an art that pictured everyday life to religious art or to the historical glorification of battles and coro-

nations. Inseparable from these reasons were others that may be called artistic. We can see how firmly bound up was his interest in the Dutch, Vermeer in particular, with his appreciation of the most avant-garde art even at the end of his life by comparing how he talks about both. In 1862, he wrote:

> The Dutch painters of the great age possessed a quality lost today, a way of expressing something which is nothing, which at least escapes our eyes—they caught the air; and this invisible agent puts all visible things in their place. This was the secret of Pieter de Hooch and of Van der Meer of Delft, of Van Ostade and of Jan Steen, as of the whole school of Rembrandt, who is largely responsible for its invention.*

In 1868, we find in his review of Manet:

> The principal merit of the portrait of M. Zola, as of the other works of Edouard Manet, is the light that circulates in this interior and which distributes the modeling and the relief everywhere.†

One could say, in fact, that his campaign in favor of the Dutch school as against Italian painting is to be understood, at least in part, as a campaign for the modern as such. That, in fact, was his own claim:

> Raphael looks backwards; Rembrandt looks forwards.
> Dutch art is the first that gave up all imitation of the past, and turned to the new.

In the introduction to his book on Dutch museums, he makes the modern relevance of his study explicit:

> Why, indeed, should critics observe, at every exhibition, that so-called religious painting is becoming impossible, that mythological and heroic painting is becoming ludicrous, but that genre painting and landscape invade everything? And who are the most univer-

* *Salons de W. Bürger 1861–1868* I (1870), p. 225.

† Ibid., II, p. 532.

sally sought-after contemporary painters? Those similar to the Dutch masters, both in subject matter and in execution.

All visual signs, and all intellectual signs concur in foreseeing a transformation of European art. And the new principle, in this irresistible metamorphosis, is precisely the principle of Dutch art: to paint what one sees and what one feels.

This passage betrays its contemporary engagement, even in its gross bias. For, indeed, by 1860, Ingres, hardly an emulator of the Dutch, was as universally sought after as any painter. Thoré's argument is also tricky because it is a little ambiguous: anxious here to enroll the modern in favor of the old, Thoré appeals partly to the popular taste for landscape as well as for the genre scenes of an artist like Ernest Meissonier, who painted very much in a Dutch manner. But then he turns to prophecy, to the principle of an artistic revolution, holding up Dutch art as an early manifesto of the Realist creed.

Nevertheless, as Haskell says, Thoré was not altogether comfortable with the masters of the Realist movement, and occasionally he seems to support them programmatically for social and ethical reasons rather than anything else. But from 1849 to 1859 he was exiled, living in Belgium after brief stays in Switzerland and England; unable to go to Paris, he could hardly function as a critic of modern art, and this accounts for his increased concentration on the old Northern schools. His having missed those critical years of Realist art helps to explain his uneasy feeling when he saw the latest work on his return to Paris. Indeed, no longer young, he was to a certain extent still attached to the art of his youth. It is even fair to say, as Haskell does, that "he writes with greater spontaneity of the neo-Romantic melodramatics of Gustave Doré" than of Courbet or Millet. (It is, by the way, remarkable how Doré took people in, and does again today.) Clearly, however, Thoré thought that Courbet and Millet were more important artists than Doré. When he praises Doré, there is something ironic in his tone, like an apology for what he considers a weakness of his own taste. On the other hand, he writes of the Realist masters, even of Manet, at much greater length, with real

admiration and respect and occasionally with enthusiasm—not as often, no doubt, as they would have liked.

In general, Thoré is a complex and very sophisticated writer. His split critical personality was sufficiently pronounced and sufficiently conscious for him to write under two different names, which corresponded in his own mind to two distinct critical temperaments: Théophile Thoré, the old romantic; and William Bürger, the defender of Realism. And even this is a crude simplification. Haskell has put his finger on something profound: growing old, Thoré found it naturally hard to adjust to the latest developments of modern art. But it is significant that he tried and succeeded. (Indeed it would be surprising if the old Thoré had been entirely comfortable with the provocative art of Manet.) Though he sincerely admired the Realists, Manet included, he missed in them, and of course especially in Manet, certain human qualities that were important to him. He disliked the fact that Manet paid the same attention to a hat as to a face. In Vermeer or in Hals he could find the pictorial qualities that made the moderns outstanding—and others as well: he admired Manet, but he loved the old Dutch masters. Yet it must be added that he also looked for, and found, in Vermeer and Hals some of those qualities for which he had been fighting in behalf of his Realist friends; he was thus able to view the seventeenth century in a new way, and appreciate what few had understood before him.

The tension between Thoré's habits of taste and his conscious fight for Realism brings us to another generally accepted idea that Haskell wants to overthrow: the belief that Thoré was a remarkably "objective scholar." He claims that Thoré's work on Vermeer "was anything but objective. Thoré was determined to turn his beloved Vermeer into a painter of the human condition, and it was because Rembrandt was the most humane of Dutch painters, rather than because he was persuaded by any purely 'visual' evidence, that Thoré claimed that Vermeer was a follower of Rembrandt." But Thoré's perception of the artist must have been very different from ours, and he must have seen affinities that escape us, partly because of our own biases. Odd as it may seem today, Thoré's belief that Vermeer belonged to the School of Rembrandt

was, indeed, based on visual characteristics. Thoré detected a relation between Vermeer and Rembrandt in Vermeer's cityscapes as much as in the genre scenes, and it was much more the striking use of light than the "humanity" of the two artists that bound them together in his mind. Aware of recent developments in the history of art, he made a deliberate effort to be as systematic and objective as he could. This affected not only his work on old masters but also his writing as a critic of modern art. Indeed, he may well have felt that a more systematic and learned criticism would help him overcome his mixed feelings about the new art.*

When Haskell explains why a picture-dealer like Le Brun, early in the nineteenth century, had failed to restore Vermeer's reputation, he gives a brilliant and satisfactory answer: the collector of 1800 would have asked himself, "Why buy an obscure Vermeer when a prestigious Metsu is available?" Unfortunately Haskell does not go on to ask why Thoré was able to succeed so triumphantly. We might say that Thoré was capable, through a more developed method of art history—call it objective or not—to give a much fuller account of Vermeer than had been possible for Le Brun. But this alone will not do. An explanation of Thoré's success is necessarily bound up with a different question: why, in fact, was Vermeer ever forgotten? A successful painter in his own day, he disappeared for more than a century. (It is difficult to write the history of taste without assessing the character of the works forgotten and then rediscovered.)

We cannot understand what happened as long as we think of Vermeer simply as an ordinary seventeenth-century Dutch genre painter, distinguished from others like Metsu only by his greater mastery and perfection. When first introducing Vermeer in 1858, Thoré himself had called him "bizarre," and had not been alto-

* It is unfortunate that he did not complete the preface to his late *Salon* reviews, where the old Thoré discusses the writings of the young Bürger, as in 1868 the latter had prefaced the *Salons* of Thoré. One phrase is tantalizingly incomplete: *"Autrefois nous avions peut-être de l'esprit. Vous, vous avez remplacé l'esprit par . . ."* The 1870 editor, Chaumelin, conjectured *"par la science"*—a fair guess. But of course the blank left in the paper reflects Thoré's difficulty in articulating his new position.

gether comfortable with his figure paintings; he did not, in fact, find them particularly humane. On the contrary, he wrote that Vermeer "handles his characters with a certain violence which is very idiosyncratic and very fantastic."

There is in Vermeer not only an extraordinary rendering of light and a special concentration on optical effects that make him attractive to modern sensibility, but also, in the genre scenes, a certain alienation or remoteness—at once dispassionate and intense—a departure from the kind of straightforwardly anecdotal painting that was cherished by eighteenth-century collectors of seventeenth-century cabinet pictures, and against which Thoré's Realist friends rebelled.

It may be old hat, but we are still convinced that the accepted view is basically correct: the peculiar qualities Thoré discovered in Vermeer were present in the advanced art of his own time. Thoré's contemporary Eugène Fromentin, painter, novelist, and critic of seventeenth-century Dutch art, claimed that the recent vogue of Vermeer arose principally because of his work's affinities with the advanced Realist painting of the nineteenth century; he even said that Vermeer was fashionable because his paintings looked like Millet's!

Thoré's position, however, is paradoxical, and Haskell's observations help us greatly to understand it. For there is no doubt that in his final view of Vermeer, Thoré pushed him "unobjectively" in the direction of being a very humane painter, a painter who possessed a quality the critic found painfully lacking in the moderns he defended. All the while, his greatest insistence is on the virtues that he feels Vermeer shares with the Realists—light, color, atmosphere. We have seen that initially Thoré had to overcome a certain reluctance about Vermeer, not so different from his problem with Manet, but he was able to overcome it and, in fact, perhaps hide it from himself by distorting Vermeer, by adding to him the humaneness he believed was necessary to make a truly great painter. Nevertheless, Thoré was able to give Vermeer a new eminence precisely because Vermeer's work seemed to possess many of the important characterics of avant-garde art—including some

of those Thoré disliked in the moderns. This is what set Vermeer outside the run of seventeenth-century Dutch painters.

Finally, why was Thoré able to convince others, and eventually to *sell* Vermeer's paintings to collectors who, in some cases at least, probably despised Manet and the likes of him? The collectors belonged to the same world as the modern artists, and we have to assume that to a certain extent they shared in the new sensibility. Although proudly impermeable to modern art, they quietly enjoyed certain aspects of it in old works.

In general, Haskell presents the vagaries of taste as subject to causes or forces that are fragmentary and independent, and do not form a coherent system. The political, social, national, commercial, or personal factors that have an impact on taste are conceived as disparate, unconnected, and often contradictory; they appear as chance occurrences essentially unrelated to the nature of the work of art, a nature that they tend either to reveal or to keep in obscurity. Haskell's empirical attitude, that of an observer who refuses to impose too much order on what he apprehends, is at the heart of this presentation, but it also involves at least one serious decision about the nature of our artistic experience.

We are given the impression that the reasons for Thoré's rediscovery of Vermeer, and for his success in making the Dutch master popular, have rather little to do with the art itself. For this to make sense, however, we must assume that Vermeer has an intrinsic, permanent, and, so to speak, absolute aesthetic value outside history that makes it possible to appreciate him, given favorable *external* circumstances. If we did not make this assumption, taste would be totally gratuitous, and clearly Haskell does not believe that. For him, Thoré's rediscovery has lasting value, in spite of the apparent haphazards of his reasons for that rediscovery. Buried under Haskell's skeptical empiricism there lies a fundamental aestheticism—a belief that the aesthetic value exists independently of all others, and that one should attempt to isolate, appreciate, and cultivate it, unaffected by anything external. While Haskell may not explicitly adhere to this creed, it is implied by what he writes. This is all the more important since Haskell is

concerned with the present as well as the past. He has described mechanisms that came into being during the period he studied and that are still at work today. In particular they apply to our own reception of nineteenth-century art.

What is at stake, perhaps the most current issue for Haskell, is the "rediscovery" of nineteenth-century academic art. At the end of his book, Haskell writes about Delaroche in the Ecole des Beaux-Arts hemicycle representing a pantheon of famous artists: "It would not, in any case, surprise me if . . . [it] were, before very long, to be considered, in the words of a critic writing about it in 1841, as an example of 'a masterly work which is by no means inferior to the prototypes left to us by Italy.' " Note that Haskell is not prepared to commit himself too far. Indeed, he leaves the reader in doubt. Is he prepared to believe that Delaroche's work might turn out to have a strictly aesthetic value not inferior to that of Raphael's *Parnassus,* for instance, to which only circumstances make us blind? Does he think that if we could only see the aesthetic value in Delaroche again as Thoré saw it in Vermeer, we could then quietly enjoy his work alongside that of Courbet and Manet without altering the other values that affect our lives? This does not seem tenable, and we are convinced there is a greater coherence and direction to movements of taste than Haskell indicates. The decline of Delaroche's reputation after 1850 and the rediscovery of Vermeer are part of the same general movement in art criticism.

VIII

THE IDEOLOGY
OF THE
LICKED SURFACE:
OFFICIAL ART

1

"Official art" has a nasty ring to it. Yet much of the greatest art we know is official, paid for by governments, encouraged and commissioned by ruling powers: the sculpture of Phidias for Pericles, the great art of the medieval cathedrals, the Vatican frescoes of Michelangelo and Raphael, the Hapsburg portraits by Velázquez. We may even suspect that the artists of the Lascaux caves were not exactly bohemian rebels.

Still, the dominant myth of the inferiority of official art begins early in the nineteenth century with the novel Romantic figure of the artist as alienated individual. Many recent publications and exhibitions have attacked the soundness of this myth, which causes us to see all important nineteenth-century art as avant-garde. The most significant of the exhibitions was held in Paris in 1974, the centenary year of the first Impressionist exhibition. "The Museum of the Luxembourg Palace in 1874" was a vast presentation of the official art of that time, and of the pictures that could be seen in 1874 in the Palais du Luxembourg, which was France's official museum of modern art from 1818 until 1937. It was an excellent idea to re-create the atmosphere of the nineteenth-century contemporary art museum. The research of Geneviève Lacambre was nothing less than heroic. She managed to track down most of the paintings from the old Luxembourg, and she set forth her findings in a catalogue at once dispassionate and sympathetic that will remain indispensable to scholars of the period.

An artistic career in nineteenth-century France followed a set pattern: several years at the Ecole des Beaux-Arts; a scholarship in Rome at the Villa Medicis for the most promising students; the admission of one's pictures for display at the annual (sometimes only biennial) Salon, which was a kind of public proving ground; and then the Luxembourg, which represented official acceptance. Last of all, there was election to the Academy, the national conscience of art and the guardian of tradition. Ten years after his

death the artist was judged to see if his works should be taken from the Luxembourg to the Louvre or consigned to a less glorious fate in the provinces.

Almost everything seen at the Luxembourg in 1874 is unfamiliar today (except for what appears in the pages of the old Larousse dictionaries) and is held in low esteem by most people interested in art. Not all the paintings were shown in the 1974 exhibition, but enough to give us a fair idea of the whole, and to reconstruct a historical moment, which had an important relation to the first exhibition of Impressionist art. Should we admire at least some of these faded splendors, or should we simply send these paintings back to the cellars, provincial museums, and ministry halls where they were found?

In the catalogue's preface, full of nuances and reservations, Michel Laclotte, chief curator of painting at the Louvre, enumerates the most recent revisions of taste and historical perspective—the rediscovery of Puvis de Chavannes, of Gustave Moreau and the Symbolists, the revival of Art Nouveau. These artists and movements have as much right as the Impressionists to be called avant-garde, he points out. What has been neglected until now is the art most honored by the Salons, most strongly supported by the Academy of Fine Arts, and most richly subsidized by the government. Without exaggerated claims, Laclotte would like to find a marginal place for it in the new museum of nineteenth-century art planned for the Gare d'Orsay.

The catchall name for the "official" artists is *"pompiers"*—the fashionable nineteenth-century painters who won the most prestigious government commissions and who were favored by the Academy of Fine Arts and the juries of the official exhibitions. The origin of the appellation *"pompier"* ("fireman") is uncertain: it is supposed to come from Jacques-Louis David's painting of classical nudes wearing only what look like firemen's helmets, but the suggestion of pomp in *"pompier"* was certainly an influence. Whatever the origin, the *pompiers* were, in general, painters of brilliant reputation during their lifetimes who specialized in large historical and religious pictures—the so-called *grandes machines;*

their prestige declined rapidly, and by the end of the First World War their work began to disappear from the walls of museums. Once-glorious names like Jean-Paul Laurens, Paul Baudry, and Benjamin Constant (not the novelist) became unfamiliar even to students of art history.

The attempt to resuscitate the firemen dates largely from the 1970s, although it was quietly brewing before. The movement was brilliantly summarized by Professor Jacques Thuillier's article *"Pompiers"* in the *Encyclopedia Universalis* (Supplement, 1980). Thuillier is elaborate, circumspect, and provocative. His most effective point is his prediction that, just as many stylistic terms for large periods—"Gothic," "Baroque," "Mannerist"—were once pejorative and then came to be neutral or even eulogistic, so one day the art of much of the nineteenth century will be called *Pompier,* and the Impressionists, along with Seurat, Gauguin, and others, will be considered individual versions of *Pompier* style.

2

Given the unthinking contempt in which the *pompiers* were held for more than half a century, it is understandable that some recent scholars should wish to wipe the slate clean and start afresh. Historians reasonably argue that we should at least understand why the works of these artists were once so highly prized. They wish to reexamine not only the later nineteenth century, with which Thuillier's article is mostly concerned, but also many discredited artists of an earlier generation. An exhibition of Gérôme in 1972 tried to bring his iced, off-color scenes into fashion again. There have been retrospectives of William Bouguereau, Charles Gleyre, and Horace Vernet, and others have been promised. In 1975, the Museum of Modern Art in New York cast its beautiful show of architectural drawings of the Beaux-Arts school as a flashy and provocative attack on modern architecture.

The most obvious weaknesses of the movement were revealed by the 1975 show of William Bouguereau at the New York Cultural Center, which gave the public a chance to form an opinion of this artist based on first-hand experience. The exhibition was surprising in a minor way: one or two early pictures were not so bad as the later and better-known works had led one to expect. Nobody who saw *Zenobia Found by the Shepherds on the Shore of the Araxes,* the competition piece of 1850, could feel that Bouguereau was without talent: the composition is truly inventive, the arbitrary use of light most effective, the color and general feeling not unworthy of Chassériau. *Canephore* of 1851, though not so successful, is more original: for a moment it seems as if Bouguereau is developing a style comparable to that of Feuerbach. The abstractness of the color, in particular, is impressive.

After this Bouguereau settled on his special blend of classic forms, high finish, and surface realism, all glued together by oozing sentiment. *Early Morning* of 1865 is typical: a Raphael Madonna is recast into a picturesque full-featured modern Italian girl. Bouguereau does his best to retain the spiritual content of the original: in case the message of the radiant light on the baby's face is missed, Bouguereau nails it down with another angelic child, its wee hands joined in prayer.

One observation in the catalogue by Robert Isaacson demands to be quoted: "Bouguereau's studio was often filled with wriggling, obstreperous infants, with whom he loved to frolic, though admitting that he could use them for very little other than color, having to go to the Louvre to make drawings after the antique for the poses." There is a picture by Bouguereau, *Alma Parens,* which is indeed full of wriggling, obstreperous infants, but the poses do not come just from the Louvre: Bouguereau must have ransacked the museums of Europe (or at least his collection of engravings) for them. One chubby rascal is climbing onto the lady's lap in a convincing imitation of the best-known figure from Michelangelo's *Battle of Cascina,* while other children strike attitudes copied from Raphael.

Bouguereau is, in fact, a more interesting artist than this cata-

ABOVE LEFT, *Adolphe William Bouguereau,* Early Morning. RIGHT, *Adolphe William Bouguereau,* Alma Parens. *The painting was exhibited at the Salon of 1883, the year Manet died.*

logue made out, but certainly not as the representative of high art and the great tradition which he himself thought he was. He elaborated a very original form of *kitsch* which appeals directly and powerfully to the emotions. He took from his *juste milieu* predecessors the instant readability of the image. His figures (mostly life-size) are painted with a skillful photographic rendering, but this realism is attenuated by the artfully academic poses, and by the waxy complexions imposed by the slick surface of the painting: his most striking pictures often look like *tableaux vivants.* The effect is impressive, disquieting, and, above all, modern, with nineteenth-century faces clearly painted from the model. This made his adaptations of classical attitudes immediately available

for commercial exploitation: a brilliant study by Louise d'Argen-
court (which will be partially published in the catalogue of a new
Bouguereau exhibition planned for the end of 1983) demonstrates
the extraordinary influence that many of Bouguereau's paintings
had on the sentimental postcards of the early twentieth century.
Bouguereau was, in fact, one of the few artists to contribute to the
creation of genuinely popular commercial style. As inheritor of
the great tradition of painting, Bouguereau may be more than a
little absurd, but as an inventor of late-nineteenth-century imag-
ery, he is an important figure.

As long as historians insist on rigidly maintaining the snobbish
professional distinction between high art and low art (a distinction
which must, indeed, be kept in mind if we wish to understand the
nineteenth century, but to which we need not surrender), the his-
torical importance of the *pompiers* will never be understood. We
may recall Philipp Otto Runge's words, quoted near the opening
of this book (p. 11), when he predicted that in order that some
good might come out of art in the future, it must either become
despised or be applied to everything: in other words, it must either
provoke rejection or else disappear, absorbed into the course of
everyday life. The split between avant-garde and "official" art
generated a paradoxical development. It was the controversial
works of the late-nineteenth-century avant-garde painters that
continued a tradition of high art (which they themselves often
subverted as well as admired), while it was the inventions of the
pompiers that soon appeared transformed on chocolate boxes,
bottles of White Rock soda, magazine covers, and so many of the
other images of daily life, including the television commercials of
our own time. In this sense, it was the avant-garde that was reac-
tionary, backward-looking. The paintings of the Impressionists
were not employed in advertisements, as far as we know, until
the 1960s, when the high prices they brought at auctions made
them a symbol of cultural prestige and its monetary value: the
pompiers did not need to wait so long before their influence be-
yond the limited world of art was felt everywhere. They sur-
vived outside the museums, whose walls had been stripped of
their paintings.

3

The movement to revive official art is not limited to the visual arts. Parallel efforts can be found in music to rescue salon pieces, virtuoso works, and grand opera from oblivion. There are demands for a reevaluation of Meyerbeer, Kalkbrenner, Hummel, and Tausig. In literature these rehabilitations are less frequent, but the stock of certain official writers, like Victor Cousin or Alfred Tennyson, has clearly risen. Still, the movement is really at home in the field of painting. Monumental sculpture is too cumbersome for exhibitions; nor is it possible to cast a quick glance at the enormous musical compositions of the nineteenth century: performance unfortunately takes time.

The different motivations for this revisionist movement may appear strangely incompatible. First of all, there is often a hostility, open, repressed, or even unconscious, to modern art. Curiously enough, however, the new interest in academic art is supported by the so-called avant-garde of contemporary art; this is promising, since revisions of taste are rarely if ever significant, except as they bear on living art. The smooth and finicky Salon painting of the 1870s has something in common with the work of a Pop artist like Rosenquist and with "New Realism." Disgruntled avant-garde critics have accused the rehabilitation of being nothing more than a giant promotion scheme to exploit still another important source of merchandise; but the triumph of Impressionism was itself once explained as only a dealers' conspiracy. It has, of course, become difficult to discover valuable and interesting works of art in the usual places. But art historians themselves are also in search of new subjects. To dedicate oneself to the study of paintings acknowledged to be less than mediocre is a depressing prospect, and the desire to reestablish the prestige of Salon art is understandable enough.

A genuine feeling for history also comes into play, a sense that it is indefensible to scorn Salon painting without understanding what contributed to its success at the time. Critics have justifiably demanded a perspective that does not discount what was most ad-

mired in order to concentrate only on the most controversial, even
if the art of the opposition has nearly succeeded in making us for-
get its discredited rival. Nevertheless, it is important to recognize
that the attempt to rehabilitate official painting is a provocation, a
challenge to the still-dominant myth of the avant-garde and to the
theory that the torch of art passed from the hands of Ingres and
Delacroix to Degas and the Impressionists, and thence—by way
of Cézanne, Gauguin, and Seurat—to the Fauves and the Cubists.
This reevaluation is sometimes presented as a conservative move-
ment in the name of an old and lost tradition. But its claims can be
granted only by displacing another tradition that has been going
on now for more than a century.

Courbet and the Impressionists did not work on the margins of
so-called official art, but against this art; their painting denies the
system of values that fed the celebrities of the Salon. Realist
painting (which in its broadest sense includes Manet, Degas, and
the Impressionists, who considered themselves Realists) did not
present itself merely as an alternative to the Salon, but as the true
inheritor of the tradition of Ingres and Delacroix, as well as of
Poussin and the Renaissance. If we were to give Gérôme and Bou-
guereau a significant place, even if not a central one, we would call
into question our whole aesthetic and all of the painting we see as
making up the great tradition. This would no doubt be a healthy
project, but the aesthetic standards for rehabilitating official art
still remain shadowy.

It is often said that the *pompiers* continued to preserve the valu-
able tradition of the grand style of the sixteenth to eighteenth
centuries. In Albert Boime's view, for instance, it is "clear from
the most cursory examination that types like the *pompiers* had a
profound grasp of Renaissance and Baroque design principles."*
Unfortunately, only the most cursory examination would allow one
to retain this opinion. The *pompiers,* indeed, had a knowledge of
traditionally taught principles of design, but "a profound grasp" is
another matter; most critics of the nineteenth century who were
attached to the grand tradition, like Paul Manz, felt that the mod-

* Letter in *The New York Review of Books,* October 21, 1982, p. 50.

ern representatives mostly came far short of expectations, and complaints about the death of history painting are a constant refrain of Salon criticism. To credit the *pompiers* as true heirs of Renaissance and Baroque style reveals a weak appreciation of Raphael, Poussin, or Rubens.

This is a point already implied by Francis Haskell in a discussion of French religious painting of the eighteenth century (another category of large canvases currently being promoted):

> If one compares almost any of the French religious or historical pictures discussed by Conisbee with works by their Italian contemporaries, it is surely the lack of fluency, the sense of strain, which are most immediately striking—weaknesses which are quite absent from the mythologies or allegories of Boucher or Fragonard. It is as if the more elevated the subject the more self-conscious the effort that had to be made to live up to it, and to earlier traditions depicting it (though, ironically enough, an authentic sense of gravity now seems to us to be just the quality most lacking in such pictures). This was certainly true of most religious painting of the nineteenth century, but it may already have been the case a hundred years earlier.*

In an earlier passage he places a finger directly on the central problems of such revivals:

> The aesthetic consequences of a historical reappraisal do, in fact, present very great difficulties. . . . The main problem is this. While "the Goncourt revival" was certainly misleading, it was not wholly arbitrary—even when judged against the standards of the eighteenth century itself. It is true that "history painters" (taken here to include painters of serious allegory and of religion as well as of history) were honoured more, encouraged more and often paid more than the "painters of minor genres" . . . , but it is also true that, for most of the eighteenth century, these history painters were nearly always felt to be lacking in stature. They were needed to some extent—for official decoration and, above all, for the production of altarpieces—but their works only very rarely attracted great enthusiasm. (Ibid.)

* Review of Philip Conisbee's *Painting in Eighteenth-Century France*, *London Review of Books*, March 18–31, 1982, p. 14.

This assessment could easily be applied to the nineteenth-century art of the *pompiers,* with a few exceptions like Paul Delaroche and Horace Vernet, who attained their enormous popularity by debasing the grand historical style into an anecdotal genre.

Haskell's observations also touch upon some important principles of historical interpretation. While a purely modern point of view that disregards contemporary evidence is obviously unhistorical, it is unwise to attempt to read the art of a period only on the basis of contemporary views. The choice we are sometimes offered—of imposing our own modern standards on the works of the nineteenth century, or of bowing to standards in sway at the time—is a false one. Both attitudes are uncritical, and neither allows us to grasp the development of new ideals from earlier ones, or to understand what was latent within the era, as important to its history as that which lies on the surface. The Goncourts certainly gave a distorted view of the eighteenth century, but they wrote about art they loved, and they articulated certain aspects of it better than eighteenth-century writers had; in a few of the eighteenth-century critics, one can find suggestions of what the Goncourts saw (sometimes more in the tone than in the words themselves), but to some extent even here, the Goncourts and the scholars who came after them have taught us what to look for in the criticism. Furthermore, the Goncourts have interposed themselves between us and the eighteenth century in a way that can be partially corrected but not entirely exorcised. Art history must be concerned not only with the contemporary reception of a work but with its subsequent fortune. No work was ever completely understood either by the painters' contemporaries or by their posterity.

The rehabilitation of the *pompiers* is sometimes made in the name of total objectivity. The claim is to reexamine the nineteenth century with no preconceptions, simply to throw everything into the pot and see what comes out.* This kind of objective detach-

* See Pierre Vaisse, *"Les Raisons d'un retour: retrouvailles ou rupture,"* *Le Débat* 10 (March 1981), pp. 10–28.

ment or emancipation from history is an illusion.* A more tenable approach claims for *pompier* art an aesthetic of its own, different from that of the Renaissance and Baroque, different, too, from that of the modern movement, but not incompatible with it. The late nineteenth century would then be comparable to the early seventeenth century: we can appreciate both the school of Caravaggio and that of the Carraccis although they not only were competing styles but were understood at the time to be mutually exclusive. Such an approach cannot be simply dismissed out of hand, but a number of factors make it unlikely that this point of view has much of a future.

The most revealing of these factors is the lack of enthusiasm shown by the most distinguished revisionist art historians for their favorite *pompiers*. In all of his hundreds of thousands of words on Couture, Boime cannot bring himself to say that Couture was wonderful. His inability to work up much interest in his hero except as a historical influence is disarming, but this lukewarmness is typical of the present revival of the *pompiers*. Francis Haskell is keenly interested in Paul Delaroche; Jacques Thuillier seems to enjoy the work of Léon Bonnat. Yet neither has ever claimed in print that Delaroche and Bonnat were major figures, that their achievements were better than—or even merely equal to—those of Delacroix and Cézanne. Here are perhaps the most important scholars concerned in the renewal of interest in the *pompiers*—brilliant, learned, widely and justly admired. All they can muster is an occasional hint that the work of such artists is not so bad as we used to think. We miss the fervor with which they write about the great figures of the Baroque.

* Such a project would be practicable only if one were assured of a supreme and permanent system of artistic values—one based on Nature, as was believed during the eighteenth century and before. According to this belief, each painter—whether Raphael, Cézanne, or Bouguereau—is or is not great for all time, independent of the prevailing system of values and of all other historical considerations; even if they are not appreciated, their value is like an object that exists immutably, of which we only have to become aware (even though it is granted that this awareness is not always easy to gain). Few people today would agree that such a universal aesthetic exists.

What has happened to the old revivalist enthusiasm? When Gothic architecture was taken up by Romantic critics, they declared boldly that the great cathedrals were sublime, inimitable, far surpassing the buildings of the classical Renaissance. When sixteenth-century Mannerism was revalued in the first decades of our century, Max Dvořák produced the most extravagant claims for El Greco, as if his spirituality put the whole of the High Renaissance to shame. Robert Rosenblum, it is true, has written, in his introduction to the catalogue of the Vernet retrospective, that in front of the early paintings of Vernet "the least curious of twentieth-century spectators finds again the pleasure he feels before the great Romantic contemporaries Géricault and Delacroix." Rosenblum's view of the nineteenth century, however, has always been characterized by a deep and infectious appreciation of *kitsch,* a taste that is intimately related to his understanding of recent trends in New York painting. Nevertheless, Rosenblum's enthusiasm makes him a maverick among neoconservative art historians, most of whom see their position as a great plea for sanity, a return to the grand tradition, and a more impartial view of history.

It may be unreasonable to expect any critic to take up the cudgels for Ary Sheffer and Bouguereau as Théophile Thoré fought for his rediscovery of Frans Hals and Vermeer, as Ruskin and Pugin battled for Gothic art. But this lack of fervor, this too easily assumed objectivity, suggests that the promoters of revision are less eager to convince us of the value of a *pompier* aesthetic than to claim that there is no serious distinction between the avant-garde and the *pompiers*. (This claim is, indeed, explicitly made by Thuillier, among others.) We have tried to indicate the nature of the continuity and the coherence of the avant-garde in this book, but it remains unclear whether a similar enterprise would succeed for "official" art. Nevertheless, if the *pompier* aesthetic lacks coherence, the outlines of its ideology can be discerned.

4

In this respect, the exhibition "The Museum of the Luxembourg Palace in 1874" was indispensable. At the very least it allowed us to appreciate the values that gave the official painting of the late nineteenth century its moment of glory, and we can understand why, when these same values were later condemned, it disappeared from galleries and museums.

If it had been the Luxembourg of 1873 that had been shown, the impression would have been very different. We would still have seen the works of painters who had been dead for some time—ten paintings by Ingres, five by Delacroix, and two by Théodore Rousseau. Thus 1874, the date when these works were sent to the Louvre, is both a revealing and an unlucky choice: unlucky, to the extent that the museum's selection, in our eyes, became particularly catastrophic; revealing, not only because we therefore have a striking historical contrast with the first Impressionist exhibition, but also because it is the moment at which the museum seems to have been most homogeneous, when the system of exclusion that determined entrance into the Luxembourg was apparently most rigid.

The Luxembourg had not always been cut off from the art that was destined to survive. Its doors had been opened in 1818, and by 1822 eight paintings by David were exhibited there in spite of his political exile in Brussels; there were representative works by Girodet, Guérin, Prud'hon, and even the very recent and violently contested *Barque de Dante* by the young Delacroix. Ingres, still a very controversial figure, entered the following year. Notwithstanding certain important omissions, the modern French school was well represented.

In 1874 nothing of the sort could be said. Manet, who had been exhibiting masterpieces at the Salons for ten years but who remained as controversial as Ingres in 1823, was not represented, nor was Degas, who had long since disdainfully refused even to send his pictures to the Salons but who was an important force in the artistic scene. More astonishing, you could not find at the Lux-

embourg either Courbet, whose importance was recognized, or Millet, whose fame was then enormous. Millet entered only in 1875, the year of his death.

Over the course of the century, the taste of the Luxembourg had become purified—its aesthetic had hardened—and a gap had opened like a trench between the museum and the new art. In 1850, a painting like Courbet's *After Dinner at Ornans* could still be bought for the Luxembourg; but, significantly, after much hesitation it was then sent to the museum at Lille, where it still remains. During the Second Republic (1848–52), there was both an effort toward renewal and finally an obvious and growing rift. After this time, there was a total exclusion of the work that future generations were to admit as the finest, except for acquisitions from elderly painters who had already made their reputations before 1848.

Furthermore, the critical confusion of the Beaux-Arts administration was flagrant: in 1874 the museum of contemporary art contained 240 paintings by 184 painters. Only one artist had four works exhibited; the others had no more than three. At any given moment in history there are hardly more than a handful of painters of the first rank, and perhaps a few dozen of some interest. Such a vast sampling would automatically seem to guarantee failure—even if not the spectacular failure of the Luxembourg.

Before we agree hastily to a revision of cultural history and to a renunciation of the myths that have sustained art for the past century, two related questions present themselves too obviously to be pushed aside. Why did the French government, from 1850 on, refuse to commission or buy works by all the artists who were going to be accepted by their immediate posterity and for several generations afterward as the sole inheritors of the great Classical tradition, the only ones of their time worthy to be placed beside Poussin and David in the Louvre? And, even more oddly, why did artists as skillful as Courbet, Degas, and Monet consistently refuse to paint the kind of picture that the government would pay for? This incompatibility between official taste and a radically important group of artists, however small their number, still remains to be elucidated.

5

What is it that made up official taste and governed its choice of paintings? In spite of the variety of styles, the Luxembourg exhibition gave a definite impression of unity. In general, there are two elements that we can distinguish: the subject matter; and the *fini*, that is, the polished, or "licked," surface of the painting. They are, as we shall see, intimately related.

As for subject, the official administration in Paris was particularly worried by the decline of large-scale painting and tried its best to save the traditional hierarchy of genres. The portrait was more or less excluded. There were only a few still lifes, mostly large and artificially arranged pieces. The preference went to historical painting, to subjects drawn from sacred and profane history and from ancient mythology. These are the famous *grandes machines*. They represent an entire branch of art which, though official, was unpopular with the general public and with connoisseurs of art. The very curious note on Auguste Glaize in the catalogue shows him struggling to survive, trying for many years to have one of his works bought by the state. He went so far as to dispatch his wife to the director of the Beaux-Arts, the notorious Nieuwerkerke. "My type of painting," he confessed, "and the nature of my experiments do not even allow me to sell my pictures to the general public, and I can live only through the encouragement of the State."

This is an extreme case, but characteristic: it shows how precarious the position of large-scale painting was, how much at the mercy of the government. In the Luxembourg we can also see a curious slide from historical paintings to the genre paintings—standard scenes from everyday life—which were most appreciated by art lovers of the period. Even certain *grandes machines* are no more than genre scenes treated on a large scale and in a historical setting. *Romans of the Decadence* by Thomas Couture, commissioned in 1846, was still sustained by an elevated moral idea; *Slave Merchant* by Victor Giraud, acquired in 1867, is nothing but the inflation of a titillating anecdote, despite its enormous

Victor-Julien Giraud, Slave Merchant. *Painted for the Salon of 1867, where it was bought for the Luxembourg Museum. It was admired by Gautier and other critics.*

size. We see historical subjects treated as genre scenes (*Molière and Louis XIV* by Vetter is typical) and genre scenes dressed up in historical costume. Gérôme was expert at these compromises.

What all these diverse subjects have in common is that they stand at a great distance from ordinary experience. Even landscape, the only honorable concession to the modern spirit at the Luxembourg, undergoes the same metamorphosis. Artificial, exotic landscapes, Oriental scenes, all betray a desire to move away from daily reality. The subtlest manner of marking that distance was perfected by Meissonier, who achieved the effect of irreality by an extreme minuteness of detail in a very reduced format.

Meissonier's contemporaries did not misunderstand this effect. In 1849, the critic Lagenevais said of the figures in Courbet's *After Dinner at Ornans* that they ought to have been represented, in the Flemish manner, as if through the small end "of a lorgnette, which poeticizes them as it removes them to a distance." Lagenevais added: "It is difficult to explain why M. Courbet has done a genre painting on such a large canvas. The interior of a kitchen,

which would be pleasing in a narrow frame, loses its charm when given its natural proportions."* We can see that in the second half of the century the traditional hierarchy threatened by Courbet (who gives a "genre" painting the dimensions of a historical painting) explicitly served to reinforce the tendency to keep the real world at a distance.

The meaning of subjects changed in the course of the nineteenth century. The theme of the Orient, for example, which at the beginning of the century, particularly in Géricault's work, evoked an idea of essential freedom, of an innocent humanity and a virgin space, was in 1874 no longer anything but picturesque; in other words, like the miniature, it was a way of holding reality at a distance, of providing a "poetic" image of the world, of sequestering art in dream. Historical reconstruction, with the German Romantic painters and again with someone like Hendrik Leys, was associated with the awakening of national conscience; for Tissot (whose painting in the Luxembourg, by the way, is quite attractive) it was nothing more than an escape into past time. The work of the artist, which consists of putting reality to the side, is so thorough that it allows even the most indelicate subjects to be represented without being shocking, as for example a brothel scene by Gérôme modestly entitled *Greek Interior*.

The *fini* of the Academy paintings is also an estrangement, an alienation, not only from the reality that is represented, but from the reality of art. The *fini* is not only the finicky detail, but even more a smooth and glossy painting, with shadings, transitional gradations between colors, and unbroken modeling of forms. This *fini* is associated with the qualities of probity, assiduity, professional conscience—and also discretion.

We can better understand the function and meaning of the *fini* by looking for contrast at Courbet's painting, especially the works that were considered to be the most shocking, like *A Burial at Ornans*. If the reality of the subject strikes us forcefully and directly, the material substance of the painting and the work of the

* *Revue des deux mondes*, August 15, 1849, p. 578. Quoted by T. J. Clark in *Image of the People* (1973), p. 69.

painter are almost indecently flaunted. Delacroix's touch, which is inseparable from what is "modern" in him, was nevertheless fluid, flowing with color and light, and gives an impression of virtuosity and ease. Courbet, on the other hand—although his extraordinary technical ability was obvious to a critic with any sensitivity—lays on the paint heavily and thickly, and allows the pigmented substance to show through like mortar, like a common material.

6

The artist in nineteenth-century mythology is a suspicious and dangerous character, a bohemian who demands a lot of money for a few slapdash brush strokes. (To a large extent this was still the issue in question at the unfortunate Ruskin-Whistler trial.) The Romantics, even Delacroix, often cultivated this myth, which for them was tied to the need for spontaneity and originality, to the role of the inspired artist. After 1850 this myth weakened and the character of the artist became disturbing primarily because it seemed to contradict the work ethic. The *fini* became the guarantee for the bourgeois, and especially for the great bourgeois known as the state, against being swindled. "You know," writes Madame Glaize to the Superintendent of Fine Arts, "that *Les Ecueils* is one of the best and most conscientious works by Monsieur Glaize. . . ." The *fini*, which has the advantage of being easy to appreciate—unlike real technical virtuosity—symbolizes careful work and is a pledge of social responsibility.

But if the academic *fini* is work, it is shameful work. It cleans up, rubs out the traces of the real work, erases the evidence of the brush strokes, glosses over the rough edges of the forms, fills in the broken lines, hides the fact that the picture is a real object made out of paint. Art, now become the slave of the rendering of texture and surfaces, turns itself into a transparent medium for an imaginary world. The function of the *fini* is ambiguous: it guarantees both the amount of work done and the quality of execution, which ought not to show; it gives value to an object whose physical

properties it camouflages. When Baudelaire defended Corot against criticisms of his execution, he wrote, "There is a great difference between a painting *done* [*fait*] and a painting *finished* [*fini*]. . . . The public's eye has become so accustomed to these shiny, clean* and industriously *polished* [*astiquées*] pieces that he [Corot] is always reproached with not knowing how to paint." *"Astiquer"* means to make things shiny by rubbing, and the domestic metaphor shows that Baudelaire clearly sensed the symbolic meaning of the *fini*.†

The *fini* painters sometimes emphasized and called attention to the surface of the painting, but once again by means of a transposition: the surface is not affirmed as a painted surface, but suggests to the imagination a precious substance, an enamel. In the still lifes by Desgoffes, in which we can see sixteenth-century gems and enamels, the metaphor of painted surface/precious object is married to what is represented in order to reinforce the "illusion."

In Courbet's Realism, and later in the work of the Impressionists, the use of artifice is proclaimed, the physical presence of paint is celebrated, and the picture openly sets itself up between the spectator and what is represented. The act of painting remains a kind of work, a work like other work (it was often said of Courbet that he painted with a trowel), but its value has been increased and made into something that gives pride.

The painting as an object that mediates between the object represented and the spectator was, as we have said, of the greatest importance for Realism (especially for Courbet, who was always more radical in this respect than Millet or Bonvin), and it increased the tension between the painted surface and the three-dimensional pictorial world that is projected upon it. In this way, Realism explored an aspect of the traditional way of formulating

* *Salon de 1845* V, "Paysages."

† Even a pupil of Gérôme, like the young Thomas Eakins, was affected by this significance of the *fini*. When his sister visited him in Paris in 1868 she wrote home in a letter, "Yesterday morning we went to his studio. He had not yet finished any of his paintings (that is lady's work, he says) and of course they are rough looking." (Quoted in the catalogue of the Eakins exhibition of the Philadelphia Museum of Art, 1982.)

the problems and the goals of painting that was evaded by the heroes of the Luxembourg.

The principle of the transparency of art, of the painting as window, had no doubt been expressed in theoretical writings since the Renaissance, but from the sixteenth century on it had been consistently contradicted in practice. In this sense, nineteenth-century Realism was the legitimate heir of the post-Renaissance pictorial tradition. But it gave it a new twist. The emphasis on the act of painting itself, on the painting as artifice, and, in the end, on the intervention of the artist through his labor does not diminish but increases the impression of reality given by what is represented. By emphasizing the painting as representation, the artist confirms the existence of what is behind the representation. In *fini* painting, on the other hand, the transparency of the painting—its lack of resistance—emphasizes the fictive character of what is represented. Thus, treatment and subject, the *fini* and the exclusion of everyday life, serve the same purpose in the strategy of official art.

In *The Absolute Bourgeois* (1973, p. 96), T. J. Clark quotes a contemporary of Millet who praised him for "the way he set the scene so as to push back his characters and to keep them at a proper distance." Clark interprets this to mean only that Millet's methods were more traditional than those of Courbet, and that "the connoisseur is still in a world that is familiar to him." But Courbet's innovations were not only effective because they broke with tradition, but also inherently disturbing. For example, Clark observes finely and cogently that when, in his Salon pictures, Courbet used forms derived from popular prints and from naïve engravings made for peasants and workmen (as in *A Burial at Ornans*), he did not intend to "revive the puffed-up forms of high art," an accepted and traditional process, but, on the contrary, exploited high art in order to revive popular art.

This was surely Courbet's intention, and, up to a certain point, the secret of his power.* But Clark evades a discussion of how the

* See Meyer Schapiro's important article, "Courbet and Popular Imagery," *Journal of the Courtauld Institute* 4 (1940–41).

imagery functions, of the way in which the motifs and schemata were eventually put into the work. Like the handling of paint, these awkward patterns, which are both simple and striking, draw one's attention to the artificiality of the means of representation, which makes the objects represented seem even more vividly present. This is why the critics were shocked by the reference to popular imagery, and they expressed their bitterness when they declared that Courbet was neither so naïve nor so simple as he seemed.

This relationship between realistic art and the artificiality of the means of representation was sometimes well understood in the nineteenth century. The great Realist critic Théophile Thoré, champion of Courbet and even of Manet, Monet, and Renoir, expressed it in his attacks against the *fini:* "But this curious quality of the infinitely small is perhaps in opposition to the true essence of painting, which is an *artifice* quite separate from reality. Really, can and should one emphasize on the plane surface of a canvas these thousand little reliefs of bodies placed at all distances?"* We can see here that for Thoré the evidence of artifice, the tension between the painted surface and depth, are directly tied to the Realist cause.

Nothing reveals more clearly the ideological force the *fini* gradually developed during the nineteenth century than its use by the Pre-Raphaelites, who had an ambiguous relation to Realism: in their works, an occasional choice of everyday subjects and of realistic detail is combined—in contrast with the French Realist practice—with a high degree of finish. Paradoxically, an analogous significance is being conveyed, and the ideological bias is even more obvious when the differences between Pre-Raphaelite style and the French academic *fini* are noted. With the Pre-Raphaelites, the meticulous execution is an open reference to fifteenth-century painting, to the Italian Primitives, to manuscript illumination, and even sometimes to stained glass. These references conjure up a mythical past when art was—supposedly—a craft and careful, decent craftsmanship was a warrant of sincerity. (Only Ford

* *Salons de W. Bürger, 1861–1868* I, p. 414 ("Salon de 1863").

Madox Brown at his greatest transcended this retrospective senti-
mentality, and he was not a member of the Brotherhood.)

The *fini* of the Pre-Raphaelites was an essential part of their
program to restore to the artist the imagined dignity of the medi-
eval craftsman, to re-create a lost precapitalist world. The French
Realist painters, less nostalgic, were at one and the same time
more ambitious and more down-to-earth. Courbet in *Bonjour,
Monsieur Courbet* and *The Artist's Studio* isolated the artist and
placed him by his genius above common humanity: he bravely and
sometimes comically carried on the Romantic tradition of the art-
ist as hero. He did not, however, seek to idealize the material na-
ture of his work, which is as physical as that of his stonebreakers.
Some critics had called Courbet's portrait of Baudelaire "materi-
alist," and Clark objects that Courbet did not try to "evoke the
material substance of the model or of the objects" (*Image of the
People,* p. 75). However, the "materialism" of the portrait does
not consist in its transmitting the material presence of the objects,
but in the coercive material presence of the painting itself. This is
why the *fini* is so important for academic taste.

It must be emphasized that the meaning of the finished, licked
surface (as well as its aspect) changed continually throughout his-
tory. Our analysis here is intended to apply only to the period from
1848 to 1880. By contrast, the smooth, hard surface realism cul-
tivated by David in the late eighteenth century was one move in
his break with an earlier academic tradition: it was part and parcel
of his radical ideal of "purity," and it brought conviction to his
new vision. It is largely based on a particular kind of seventeenth-
century Dutch painting, of which Adriaen Van der Werff is char-
acteristic: although the source of inspiration was surely conscious,
there is no attempt at nostalgic reference.

Historically, there was nothing new about the taste for the "un-
finished" texture. It had become more and more common over the
course of the eighteenth and nineteenth centuries. But it was con-
fined to studies and sketches—in other words, private works not
specifically intended for the public; in principle at least, but not al-
ways in practice, the artist did not feel obliged to eradicate the

traces of his effort by making an extra effort that could be appreciated but was not apparent. This is the myth of the artist caught at work.

Constable upset this arrangement by producing a great many sketches that were not intended for a specific work and, above all, by attaching great artistic value to the next-to-last stage of the elaboration, to a canvas that had the same large dimensions as the picture to be exhibited but lacked its meticulous texture. Even the final pictures that Constable exhibited, however, seemed unfinished to many contemporaries. It is important to remember not only the impression made by Constable on painters like Delacroix but also the virulent attacks on his work by French academic critics.

Constable, Turner, and others were able to alternate between two visions, the *fini* and the rough. In an interesting book, *The Academy and French Painting of the Nineteenth Century* (1970), Albert Boime has shown what the most advanced painters owed to academic instruction (or to the similar instruction of semiacademic artists like Couture) from a technical point of view. But Boime associates freedom of execution with the values of originality and spontaneity. This meaning, which reflects the ideas of the Romantics at the beginning of the century, was never lost; but when artists rejected the *fini*, when the broad, rough, and visible *facture* held the stage alone for the greatest artists, its significance had changed.

Ruskin showed how unwieldy the opposition of "sketch" to "finished picture" had become. In the controversy, which he said in 1855 divided all of the artists of Europe, he took his stand on the side of the completed picture; in spite of the ability of the sketch to stimulate the imagination, he wished for the realism of the greatest possible amount of detail. Nevertheless, he opposed both illusionism and polish: Ruskin's "finished picture," therefore, cannot be identified with either the "unfinished" texture or the academic *fini*. Like Thoré, Ruskin explicitly recognized the tie between realism and the assertion of the artificiality of the work of art: "So that although the perfection of art will always consist

in the utmost *acceptable* completion, yet, as every added idea will increase the difficulty of apprehension, and every added touch advance the dangerous realism which makes the imagination languid, the difference between a noble and ignoble painter is in nothing more sharply defined than in this,—that the first wishes to put into his work as much truth as possible, and yet to keep it looking *un*-real; the second wishes to get through his work lazily, with as little truth as possible, and yet to make it look real."*

The opposition between "finished picture" and "sketch" is, in fact, somewhat misleading: there were many kinds of sketches, including what was called a finished sketch (*esquisse terminée*). Boime gives a valuable account of the various types. The best classification, even if grossly oversimplified, is a triple one: sketch, "full-size sketch" or "unfinished" picture (*ébauche*, often of large dimensions), and final work. By the end of the nineteenth century, the central member of this triad took over the functions of the others, but for the artists around 1800, each stage (although part of an interdependent process) had a value of its own. In the 1830s, friends of Théodore Rousseau preferred his sketches to the finished works. Turner divided all his works into the three categories and at the end of his life planned three separate public exhibitions, but by then the categories had changed in meaning, appearance, and relationship.

Boime believes that sketching techniques are eternal and lie outside history. Even if this were true, their values and the associated meanings are subject to considerable alteration—so considerable, indeed, that however the free technique of Courbet, Manet, and others may derive ultimately from the academic sketch, the works produced by this technique could no longer in 1850 be considered sketches in any sense. To identify the "unfinished" execution with the academic sketch is to perpetuate the worst misunderstandings of the average nineteenth-century Salon criticism. The most unconvincing aspect of Boime's book is his contention that the sketches of the *fini* painters Gleyre and Bou-

* *Modern Painters* II, "Of the Use of Pictures."

guereau resemble the public works of the avant-garde artist. To our eyes they do not.

The *fini* and the "unfinished" texture are both actually forms of realism—rival forms that in 1850 implied different views of reality. The realism of the academic *fini* consisted in an illusionistic and faithful representation of the material object in all of its details along with an idealization—a spiritualization, even—of the means of representation. (The illusionism of the *fini* was explicitly tied by Ingres to the idealization and spiritualization of the medium when he wrote: "The brush stroke, as accomplished as it may be, should not be visible: otherwise it prevents the illusion, immobilizes everything. Instead of the object represented, it calls attention to the process: *instead of the thought it betrays the hand.*") The "unfinished" texture, on the other hand, implied a phenomenological realism, a faithful representation of the process of vision and an emphatic sense of the material presence of the work of art. The academic painters conveyed the tangible solidity of the exterior world, generally an imaginary world of the past—one may easily understand how this would appeal to the state. By contrast, the so-called Realists were increasingly concerned with the painting of light, the experience of seeing, and, at the same time, with asserting the independence of the work of art itself.

Just as the *fini* is not the same with David and with Gérôme, the rough texture is not the same with Decamps and Couture or with Delacroix and Manet. It became charged with the ideological sense that we have tried to elucidate. The refusal to use the *fini* necessarily had a political meaning, which was independent of the individual opinions of the artist, who could be right-wing, like Degas, or left-wing, like Pissarro. Rejection of the licked surface proclaimed opposition to the Academy and to the government as represented by the Ministry of Fine Arts (an opposition that could at times come from the right as well as the left) and indicated a refusal to hold everyday reality at a distance by a process of idealization. The rehabilitation of official art today consequently takes on a political coloring independent of the very diverse tendencies of the people behind it.

7

These are the general principles that governed the selection of works in the Luxembourg Museum of contemporary art in the later nineteenth century. However, there were a good ten paintings or so included that need no rehabilitation and that more or less escape this limiting aesthetic. When we look a little more closely, we see that these paintings—for example, the ones by Gigoux, Flandrin, Rosa Bonheur, and Hébert—are quite a bit older than the others, and most were acquired more than twenty years before 1874. One has to go back to 1857 for *Spring* by Daubigny, and the only Corot was bought almost accidentally by the state in 1851. (Corot had been treated rudely at the Salon and the purchase was a kind of apology.)

What was the result of this official policy of aesthetic coercion, and how did it influence the development of art? Much work remains to be done on these questions, but the answers are not likely to reveal any great effectiveness in the administration of patronage. T. J. Clark, in *The Absolute Bourgeois* (1973), a remarkable study of state patronage during the Second Republic, shows that despite sincere efforts, the habits of the July Monarchy (1830–48) had not been changed. Painters who refused to conform to the preferences of the administration, and who were less and less attracted by the type of commissions it offered, looked for a new clientele.

Courbet envisioned, at least for a short while, a clientele that would be made up not of connoisseurs but of a wider, even a popular, audience that could keep him alive by paying to see his works, not by buying them. David was supposed to have collected more than 60,000 francs from showing *The Sabine Women,* and Géricault had allowed such paying exhibitions of *The Raft of the "Medusa"* to be organized in England, where the practice was usual, although considered degrading for the artist. Courbet showed a group of works which included *A Burial at Ornans* at Ornans itself (where the exhibition was free), at Besançon (where he made a profit), and at Dijon and Paris. This effort by Courbet to transform

the economics of art represents little more than a fleeting dream.

The official painters did not worry about such utopias. Thoré stated things a bit crudely perhaps, but left no doubt about what should be understood by the term "official art":

> A single comment: this detestable art, which provides pictures for the court, the state, the museums, monuments, palaces, and châteaux, carries a high price tag for the French: since the dignitaries, the functionaries, and most figures of high rank, who live high and spend high, draw their salaries from the national budget. Who pays for these official portraits? Who pays for the *Siamese Ambassadors* by M. Gérôme? Who paid for the *Sphinx* by M. Moreau last year? Who will pay for the *Five Senses* by M. Henri Schlesinger this year? Who pays for all the acquisitions of the Maison de l'Empereur and the Ministry of Fine Arts, the crown, the princes, the different ministers, the prefecture of the Seine, etc., etc.? And who pays the salaries of the administration of the so-called *fine arts*—from the minister and the director down to the lowest clerks? The financial question is directly connected in this way to the question raised by Louis Viardot's pamphlet: How Should We Encourage the Arts? The answer should be: Leave them alone.*

"Detestable" goes perhaps too far. Certain painters from the Luxembourg have great merits. It would be pleasant to hang a Gérôme on one's wall if the price were not too high; Henner and Ribot are both agreeable artists, and the little genre scenes by Meissonier often attain an exquisite perfection.† In any case, everyone will have his own favorites; it is even possible to be touched by the dignity and worthy intentions of Paul Chenavard, if not by his talent. But in the end, one understands why Thoré found that it all really cost the taxpayers too much.

The official painters of the Second Empire were no worse than

* *Salons de W. Bürger, 1861–1868* II, p. 168 ("Salon de 1865").

† The Luxembourg is not the best place to judge all of these painters. Baudry, who proved to be an excellent decorator of the Opera, discredits himself here with an absurd pastiche of Titian.

certain artists of other periods who have had success with the public. In spite of the countless commissions of Neri di Bicci and the painters who came after him, no one dreams of elevating them to the heights of Masaccio or Fra Angelico. What is exceptional after 1850 is the poverty, the exclusiveness of official taste. The Luxembourg show gave a particularly clear, even purified version of this taste. We cannot but notice, for example, the absence of Puvis de Chavannes, a painter of great power, who had received many commissions for decorative work. A friend of Degas and admired by Gauguin, he was a controversial painter but nevertheless one who had arrived, an official painter if there ever was one, and prominent since 1863. Puvis is a reminder that we cannot confine ourselves to the Luxembourg to have an idea of official art; but his activities outside the museum only serve to emphasize the crisis of this art. The second half of the nineteenth century had some talented and very active decorators. The study of their work is well worth the effort, and it would be a pity if the decorations they have given us were abandoned to the bulldozers of urban renewal. But Puvis clearly shows us the distance that separates the facile practitioners, like Paul Baudry or Jean-Paul Laurens, from an original and profound artist who rethought all aspects of the problem of decoration. Although the Musée du Luxembourg defined a direction of taste, there was still no official "style."

Historians must rejoice at the Luxembourg exhibition, while remaining skeptical over the idea of rehabilitation. It is important to study the official art of the nineteenth century, the administrative groups, the mechanics of artistic life, if only to understand the system that so deeply affected Manet. Even though the history of painting does not seem to have been greatly changed by this art, it still has had an influence in other areas: on the great film spectacles of directors like Cecil B. De Mille, for example. Much remains to be done; we should be grateful to those who have taken on this thankless task with so much scholarship and intelligence.

NOTES ON THE ILLUSTRATIONS

Page

canvas, 45 × 33.5 cm., Berlin, Schloss Charlottenburg, Photo Jörg P. Anders.

65. Friedrich, Caspar David, *The Ages of Man*, c. 1835, oil on canvas, 72.5 × 94 cm., Leipzig, Museum der Bildenden Künste.

76. *The Shipwreck*, engraved by B. Roger after a design by Pierre-Paul Prud'hon, an illustration for the fourth edition of Bernardin de Saint Pierre's *Paul et Virginie*, published by Pierre Didot l'aîné in Paris, 1806.

77. *The Shipwreck*, illustrations designed by Tony Johannot and engraved on wood for *Paul et Virginie*, published by Curmer in Paris in 1838.

78. Delacroix, Eugène, *Mephistopheles Hovering over the City*, lithograph, 27 × 23 cm., frontispiece of a French edition of Goethe's *Faust* published in 1828.

80. Gérard, Jean Ignace Isidore, called Grandville (1803–47), *The Steam-powered Concert*, wood engraving, 20.1 × 15.6 cm., an illustration from *Un Autre monde*, (Paris, 1844).

82. Grandville, *The Finger of God, a colossal work*, wood engraving, an illustration from *Un Autre monde*.

83. Page 57 of Grandville's *Un Autre monde*.

87. Bewick, Thomas, *Dog Baying at the Moon*, wood engraving, 1⅞ × ⅞ inch; 2½ × 1⁵⁄₁₆ inches. From *The Fables of Esop* (Newcastle, 1818).

90. Bewick, Thomas, *Two Horses in the Rain*, wood engraving, 2½ × 1⁵⁄₁₆ inches, *A History of British Birds* (1805).

94. Géricault, Théodore, *Horses of Savoy*, lithograph, 23 × 18.8 cm., part of an album of twelve *Etudes de chevaux d'après nature*.

95. Delacroix, Eugène, *The Death of Sardanapalus*, 1828, oil on canvas, 395 × 495 cm., Paris, The Louvre.

96. David d'Angers, Pierre Jean (1788–1856), *Paganini*, 1830, bronze, height 57 cm., Angers, Musée David d'Angers.

102. Valenciennes, Pierre-Henri de (1750–1819), *Study of the Sky at the Quirinal*, oil on paper, 25.6 × 38.1 cm., Paris, The Louvre.

103. Valenciennes, Pierre-Henri de, *Landscape with Biblia Changing into a Fountain*, 1792, oil on canvas, 54 × 79 cm., Quimper, Museum.

104. Cogniet, Léon (1794–1880), *At Lake Nemi, near Rome*, oil on paper, mounted on panel, 22.2 × 17.4 cm., Orléans, Musée des Beaux-Arts.

Page

105. Cogniet, Léon, *Tintoretto Painting His Dead Daughter*, oil on canvas, 144 × 164 cm., Bordeaux, Musée des Beaux-Arts.

120. Delaroche, Hippolyte, known as Paul (1797–1856), *The Little Princes in the Tower of London*, oil on canvas, 178 × 214 cm., Paris, The Louvre.

126. Chardin, Jean Baptiste Siméon (1699–1779), *Blowing Bubbles*, oil on canvas, 61 × 63.1 cm., New York, Metropolitan Museum of Art.

126. Couture, Thomas (1815–79), *Blowing Bubbles*, 1859, oil on canvas, 130.8 × 98.1 cm., New York, Metropolitan Museum of Art.

127. Manet, Edouard (1832–83), *Soap Bubbles*, 1867–68, oil on canvas, 100 × 82 cm., Lisbon, Gulbenkian Foundation.

136. Cuisin, Charles (1815–59), *View of Troyes from the Place du Préau at Evening*, oil on canvas, 32.5 × 40.5 cm., Troyes, Musée des Beaux-Arts.

140. Delacroix, Eugène, *Studio Corner: the Stove*, oil on canvas, 50 × 43 cm., Paris, The Louvre.

140. Tassaert, Octave (1800–74), *A Corner of His Studio*, 1845, oil on canvas, 46 × 38 cm., Paris, The Louvre.

141. Ribot, Théodule Augustin (1823–91), *The Cook Accountant*, oil on canvas, 47 × 38 cm., Marseille, Musée des Beaux-Arts. Photo Yann Thibault.

148. David, Jacques-Louis (1748–1825), *The Oath of the Horatii*, 1784, oil on canvas, 330 × 427 cm., Paris, The Louvre.

149. Courbet, Gustave (1819–77), *The Wheat Sifters*, 1855, oil on canvas, 131 × 167 cm., Nantes, Musée des Beaux-Arts.

152. Courbet, Gustave, *A Burial at Ornans*, 1850, oil on canvas, 315 × 668 cm., Paris, The Louvre.

154. Courbet, Gustave, *The Bathers*, 1853, oil on canvas, 227 × 193 cm., Montpellier, Musée Fabre.

162. Delacroix, Eugène, *Women of Algiers in Their Apartment*, 1834, oil on canvas, 180 × 229 cm., Paris, The Louvre.

166. Antigna, Jean-Pierre Alexandre (1817–78), *The Fire*, oil on canvas, 262 × 282 cm., Orléans, Musée des Beaux-Arts. Photo P. Delatouche.

168. Millet, Jean-François (1814–75), *The Angelus*, 1857, oil on canvas, 55.5 × 66 cm., Paris, The Louvre.

169. Bastien-Lepage, Jules (1848–84), *The London Bootblack*, 1882,

Page

oil on canvas, 132.5 × 89.5 cm., Paris, Musée des Arts Décoratifs. Photo L. Sully-Jaulmes.

171. Manet, Edouard, *Olympia,* 1863, oil on canvas, 130 × 190 cm., Paris, Musée d'Orsay.

173. Couture, Thomas, *Romans of the Decadence,* 1847, oil on canvas, 466 × 775 cm., Paris, The Louvre. Photo Alinari-Giraudon.

175. Meissonier, Jean Louis Ernest (1815–91), *The Ruins of the Tuileries,* 1871, oil on canvas, 136 × 96 cm., Compiègne, Musée National du Château de Compiègne. Photo Hutin.

177. Courbet, Gustave, *The Trout,* oil on canvas, 52.5 × 87 cm., Zürich, Kunsthaus. Photo Walter Dräyer.

209. Bouguereau, Adolphe William (1825–1905), *Early Morning,* 1865, oil on canvas, 99.6 × 88.3 cm., Washington, National Collection of Fine Arts, Smithsonian Institution.

209. Bouguereau, Adolphe William, *Alma Parens,* 230.5 × 139.6 cm., New York, Stuart Pivar Collection.

220. Giraud, Victor-Julien (1840–71), *Slave Merchant,* 238 × 445 cm., Sermaize-les-Bains, Mairie.

INDEX